THE PEN & INK BOOK

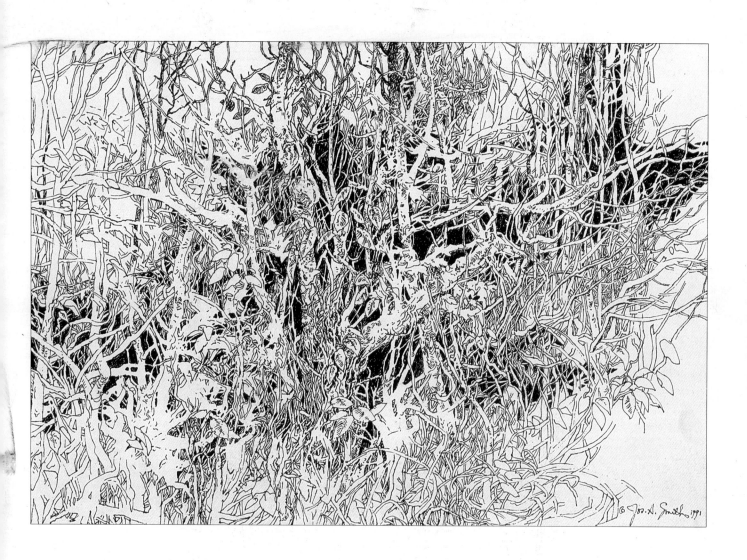

THE PEN & INK BOOK

Materials and Techniques for Today's Artist

JOS. A. SMITH

WATSON-GUPTILL PUBLICATIONS/NEW YORK

JOS. A. SMITH got off to an early start as an artist, illustrating three books for national publishers before he completed high school. He went on to study illustration at Pratt Institute, graduating with the Dean's Medal. During the summers he studied painting with Hobson Pittman of the Pennsylvania Academy of Fine Art. After serving in the U.S. Army, Smith returned to Pratt Institute and has been a member of its faculty since 1961. He has taught drawing, painting, and figure sculpture.

Smith has had 14 solo exhibitions and has been included in over 80 group exhibitions in galleries and museums nationally. His political cartoons have been included in *Time* and *Newsweek;* he was *Newsweek*'s courtroom artist for the Watergate trials. He has also illustrated numerous books for adults and for children, and is listed in *Who's Who in American Art* and *Who's Who in the East.*

Art on first page:
WOODLAND
Mecanorma 1.0 technical pen; Higgins waterproof black india ink; Twinrocker paper, 7 × 10" (18 × 25 cm). Collection of Jacob Landau.

Art on opposite page:
DRIED ROSE
Hunt drawing pen #99; Higgins Black Magic waterproof drawing ink, Denril Multi-Media vellum, 11 × 11" (28 × 28 cm).

Photographs on title page, pp. 10–11, 50–51, and 86–87 by Tom Haynes.

Copyright ©1992 Jos. A. Smith

All artwork in this book, unless specifically attributed to other artists, is copyright © Jos. A. Smith.

Charissa Baker photographed all of Jos. A. Smith's artwork and that of most of the other artists as well.

First published in 1992 in the United States by Watson-Guptill Publications, a division of BPI Communications, Inc., 1515 Broadway, New York, N.Y. 10036.

Library of Congress Cataloging-in-Publication Data

Smith, Joseph A. (Joseph Anthony), 1936–
 The pen and ink book : materials and techniques for today's artist / Jos. A. Smith.
 Pbk. Ed.
 p. cm.
 Includes index.
 ISBN 0-8230-3986-2
 1. Pen drawing—Technique. I. Title.
NC905.S6 1992
741.2'6—dc20
 92-4916
 CIP

Manufactured in Malaysia

First paperback printing, 1999

1 2 3 4 5 6 7 8 9 10 / 05 04 03 02 01 00 99

I owe a debt of gratitude to more friends and fellow artists than I have room to include. Thanks to:

My ex-student, Gregory Hengesbaugh at Koh-I-Noor Rapidograph, Inc., for introducing me to some materials that have become part of my daily studio life.

Wendell Upchurch, Manager of Educational and Technical Services at Winsor & Newton, one of the most knowledgeable artists I know.

Several helpful people at Sheaffer Pen, 301 Avenue H, Fort Madison, Iowa 52627, for their assistance.

Jeanne Shapiro at New York Central Art Supply, 62 Third Avenue, New York, New York 10003, for showing patience and great generosity with her expertise in paper. She is an invaluable resource for countless artists.

Thanks to those friends who read the early drafts: Maura Kelleher, whose laughter made me aware that I have the ability to write like a bad translation from German when writing in my own language; Sarah Rosenfield, Ph.D.; Joyce Tanner, Ph.D.; and Charissa Baker, whose photography and assistance helped me get through it all.

Thanks also for the significant contributions and professional skill of Candace Raney, Janet Frick, and Areta Buk. When it felt as if I was giving birth to a herd of elephants, they gently but firmly showed me that indeed I was, then proved that nothing is so large that it can't get smaller.

Finally, thanks to all the artists who contributed their work to this project, especially to the many talented people whose work finally could not be used for lack of space.

I dedicate this book to my parents, Frieda and George Smith,
who gave me a pen and a bottle of ink and an entire white wall with no restrictions
when I was a kid—and to Calvin Albert, Richard Lindner, and Hobson Pittman,
who showed me years later what a rich gift that was.

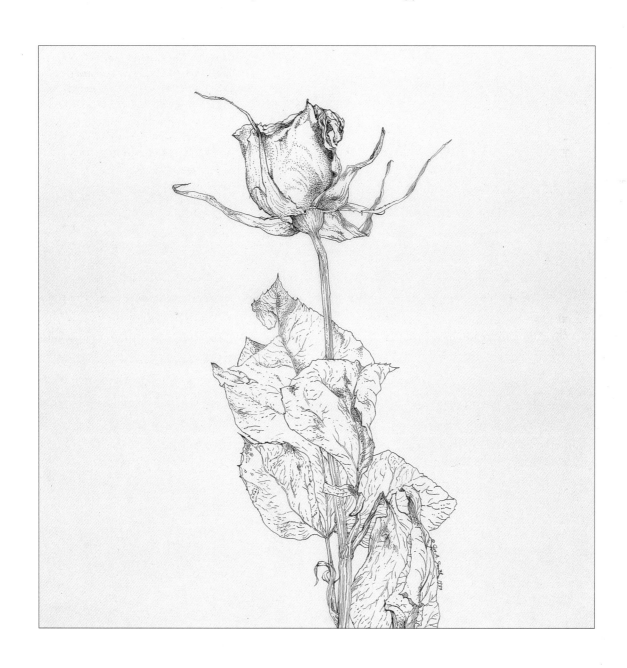

CONTENTS

INTRODUCTION

Artists and writers on art have stressed the importance of drawing since the fourteenth century. Some have even referred to drawing as the mother of the arts and sciences. While that may strike you as a sweeping statement, the scope and utility of drawing can hardly be questioned.

Thousands of drawings may be made in the planning and production of an animated film or in the design stage of new model car. Drawing is an indispensable tool for visualization in any creative act—from fashion or costume design to architecture, from sculpture, painting, or illustration to the making of "finished" or presentation drawings intended to stand as works of art on their own.

My intent in this book is to focus on one important material—ink—with which drawings have been made. We will explore the unprecedented varieties of inks and ink-related materials available to the artist today and look at the diverse techniques that they make possible.

The first section of this book provides a useful overview of materials. You will read about and see photographs of supports (papers, boards, and so on), a variety of inks, and instruments for applying the inks to the supports (such as pens and brushes). A book of this length cannot possibly include all such materials on the market, but at least those shown will give artists a good idea of where to start—and what questions to ask in choosing materials on their own.

The second section of this book provides clear instruction in the techniques of ink drawing. How can you create a gradual change in value, from black through a series of grays to white, with pure black ink? How can you use cross-hatching to suggest a curved surface? How can you prevent stippled dots from accidentally forming "rivers" of conspicuous white space? The answers to questions like these are illustrated with many examples.

The final section of this book discusses the thought process of drawing itself. In my 30 years of teaching at Pratt Institute, I have found that a facility with art materials—the *craft* of drawing or painting—is only one part of the formation of an artist. The rest has to do with thought, both conscious and unconscious. The artist must make certain key decisions when beginning any drawing. The drawing process may be meticulously planned or quite spontaneous. The interaction between format and image, the choice of scale, even the relationship between the drawing's space and the viewer's space are issues an artist must consider. Should the drawing be linear, tonal, or a combination of the two? The third section of this book takes a close look at these kinds of strategic decisions made by the artist, as well as the visual elements from which all drawings are built, and gives numerous examples of finished drawings that use these factors to achieve radically different emotional and visual impacts on the viewer.

Ink is a wonderful drawing medium that offers all kinds of possibilities. I hope this book will help some artists discover techniques they never thought about before, and that those techniques become a bridge between mind and paper to let the invisible become visible.

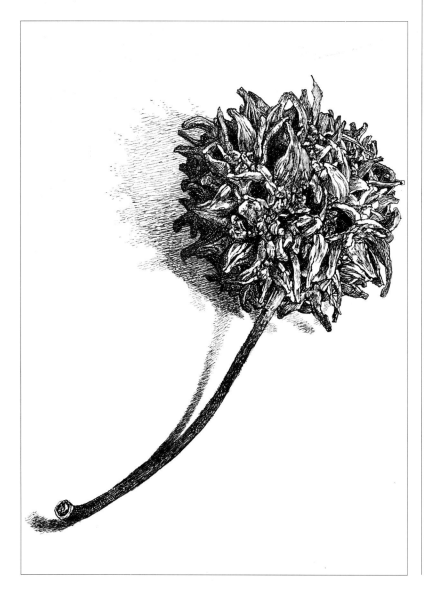

SYCAMORE POD
Koh-I-Noor Rapidograph technical pen 3×0; FW nonclogging waterproof india ink; Twinrocker handmade stationery, 5 1/2 × 8 1/2" (14 × 22 cm).

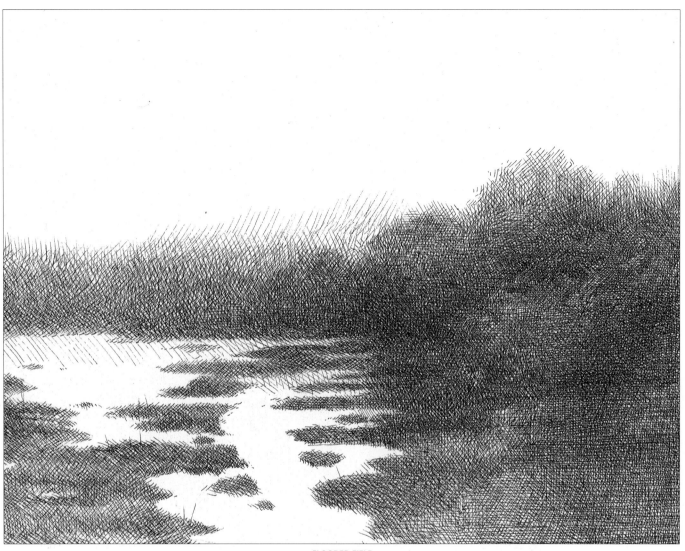

FLOODED FIELD
Koh-I-Noor Rapidograph technical pen;
Koh-I-Noor Rapidograph Ultradraw
waterproof black india ink;
Svecia Antiqua laid stationery,
8 ½ × 11" (22 × 28 cm).

MATERIALS AND TOOLS

Most artists who put time and effort into creating drawings care about the life expectancy of those drawings. Long before you complete a drawing, its potential longevity will already be partially determined: It can be only as durable as the materials you use. The chemical and physical stability of each of your materials must be considered unless the drawing is a throw-away exercise or experiment.

Know your materials before you buy them in quantity. Start by ranking your requirements for a material. What minimum needs must it meet? When you know what you want in a product, the selecting process is simpler.

What does archival quality mean? For a material to be archival, it must not undergo any adverse deterioration with the passage of time. If an art material meets archival standards, it is considered permanent. It must remain stable for an indefinite period of time. Its desirable characteristics—color, adhesion, flexibility, opacity, and so on—must not change. In addition, an archival material must not damage another material when the two are used in combination.

Take the word of someone who learned the hard way: Watching a prized drawing deteriorate is not the way to learn about selection of materials.

HANDMADE PENS

Handmade pens have been used for centuries. They include quill pens, reed pens, and cane pens. All three categories of drawing instruments periodically need to be resharpened by the artist. Each of these can be cut to customize the line for individual drawing preferences.

REED AND CANE PENS

The earliest known pens were made from dried reed and cane shafts. Reed pens were cut from common reeds, a hollow-barreled grass that grows along streams and lakes throughout the temperate zone. Cane pens are cut from the stems of members of the bamboo family.

Both reed pens and cane pens are rigid and give a line of limited flexibility that is best suited for a bold, simple drawing style. They are not capable of making delicate, flowing lines; lines that change from thin to thick with fluidity; or areas of controlled modeled tone made from closely spaced hatching. These pens create drawings that fall somewhere between brush and metal pens in their visual weight and feel.

Artists such as Rembrandt, Vincent van Gogh, Henri Matisse, and George Grosz used reed pens. In the drawings of van Gogh, the nature of the reed pen line is so intimately a part of his drawing style that it is difficult to conceive of them retaining their intense energy if translated into the more controlled lines of a metal pen.

Reed and cane pens develop internal variations in line quality not from a fluid change of line width in response to variations of hand pressure, but from the rate and manner in which the ink is transferred from penpoint to paper as the pen is used.

When a reed or cane pen is first dipped into the ink, the ink flows freely onto the paper and deposits a heavy blotlike line that rapidly exhausts the pen's ink supply. Within the space of a relatively short stroke, the line becomes lighter and, if not recharged with a fresh supply of ink, soon gives a pale drybrush type of line.

Reed pens are still available in some of the better art supply stores. You can also make them in your studio. Florists or hardware stores that carry gardening supplies carry Japanese reeds, which are used for plant supports. These are pre-dried and ready for cutting into pens. They make an inexpensive source of good-quality drawing pens. Don't be put off by the green stain that is meant to make them inconspicuous in your garden. It won't affect their performance as art materials.

Because the fibrous structure of the dried reed is so absorbent, it becomes soft and blunted quickly if you try to sharpen it to too fine a point. Also, as you use the pen, the point will gradually wear away and need to be reshaped by recutting.

Bamboo pens are now imported from the Orient. They are similar in type to reed pens but are much stiffer in handling. They are available in a wide variety of sizes, from narrow reedlike pens to heavy-shafted pens that measure more than an inch in diameter. Bamboo pens produce broad lines that are coarse in contrast to other pens but are highly expressive when used with the proper élan.

QUILL PENS

The least expensive quill pens, those most commonly found in art stores, are turkey feathers. Goose feathers are more expensive but worth the difference.

Because the feathers used are primaries from the outer wings and are curved accordingly, right-handed artists should choose feathers from the left wing, and left-handed artists, from the right wing. The quill tips are soft and must be recut regularly. Their versatility lies in the fact that they can be cut to any angle.

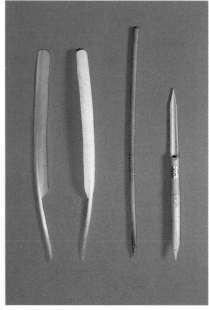

HANDMADE PENS. From left to right: two Quill Carvings Unlimited goosefeather quill pens with right and left curves (flight feathers from opposite wings). Yoshi reed pen. Cane pen (Chinese bamboo pen).

METALPOINT PENS

When you buy metalpoint pens, be generous with yourself. Different pens produce different effects. This is true of dip pens and fountain or technical pens. Buy a selection of each type. Metalpoint pens are available in a wide range of point widths and degrees of flexibility. William Mitchell/Joseph Gillott in England; Brause & Co. and Heinze and Blanckert in Germany; and Hunt in the United States manufacture quality metalpoint pens. I recommend that you experiment with many pens in order to find those that are best suited for your drawing style.

It is important to have a variety of nibs because of the differences in the lines they produce. It is equally important to have a reserve supply of duplicates for most of the points. Fine metalpoints such as crow-quill or mapping pens are easily damaged or bent. No one can avoid accidents entirely. With extras you won't lose time in the event of a problem.

Metalpoint pens (dip pens) are manufactured for use in all categories of pen work: sketching (general drawing), mapping, poster, calligraphy, and italic. All these pen types can be used for drawing, and most of these nibs will take any ink or watercolor.

Dip pens may require a little more patience and practice than reservoir pens such as fountain pens or technical pens, but they're worth the effort. It doesn't take long to gain confidence and ease with a dip pen.

Newly manufactured metalpoint pens are covered with a protective layer of lacquer or oil to prevent tarnishing or rusting. This coating must be removed before the pen is first used in order to ensure an even flow of ink. There are several methods used by artists to remove this coating completely. You can briefly immerse the full penpoint into boiling water for this initial cleaning, or hold the penpoint in the flame of a match to burn off all of the protective coating, then wash it with dishwashing detergent and water. If you use new metalpoints just as they come from the dealer, without taking the time to prepare them, the protective film prevents the ink from forming an even film on the underside of the nib and retards the free flow of ink from nib to paper. Sometimes the ink is held in the pen when it should be making lines, and occasionally too much ink is released, making an ink blot on the drawing.

CROW-QUILL PENS

Crow-quill pens are metal dip-pen nibs capable of producing a line of great delicacy and variable thickness. Crow-quill nibs are all pointed as opposed to lettering pens, which have angled tips that come in a variety of tip widths and shapes.

Crow-quill pens were invented as a means of retaining the flexibility and stroke character of quill pens while remedying their shortcomings. Not only does a well-made, properly used metal nib have a much longer life than a natural feather quill, but it is also far more responsive to the artist's control. This accounts for the continuing popularity that these pens have enjoyed, even with the advent of fountain pens.

Crow quills can make tonal variations in a drawing through changes of line thickness as well as through hatching. These nibs are flexible and responsive to pressure. Changing lines create tonal areas that have a much livelier textural quality than those made with the fixed line of a technical pen.

When you are selecting metal quill nibs, test them by pressing the point of the nib against your thumbnail. Some nibs are rigid and spread little or not at all. These points will give a line of only slight variation. If you force a rigid nib to perform like one that is much more flexible, you will be fighting the pen the whole time you are drawing with it. Also, a sharp nib that is used with too much pressure will score the surface of many papers, making them more absorbent. When this happens, the ink lines spread slightly before drying, giving the drawing a disturbing fuzziness. Traditional pen instruction advises careful preparation of the nib so that the ink is laid on the paper by capillary action rather than by spreading the tip under pressure.

Nibs that spread can easily make smooth transitions between fine and broad lines. This is the crow-quill pen's strength and its potential weakness. If the nib is too flexible, it will spread too easily, producing lines of poorly controlled thickness. Too much line variation unsupported by an expressive rationale makes a weak drawing.

Testing the tip of the point against your thumbnail reliably discloses the nib's flexibility. It is easy to test the nib this way every time you change a point. Remember, you can use more than one nib to do a drawing. Rembrandt's ink drawings are full of examples of multiple pen use.

The expressive line quality of crow-quill pens makes them more suitable than technical pens for drawings intended for illustration.

METALPOINT PENS

Crow-quill points can be maintained longer if you polish and sharpen their nib points, removing the irregularities caused by rust or wear. Wrap a piece of blue cloth (wet/dry) emery paper around the shaft of a pencil to make a fine abrasive cylinder that fits into the arc cut from the underside of a crow-quill point. Hold the nib against the emery cylinder at a right angle and rotate the pencil by rolling it between your fingers. Rust can be prevented by cleaning and drying the penpoint after each use.

HAWK-QUILL NIBS

Hawk-quill nibs are similar in shape to the crow-quills but have sturdier, less flexible points. This nib is good for long, even lines and cross-hatching.

Hunt hawk quill 9407 is an example. It has a superfine point that is stiffer than the crow-quill.

MAPPING PENS

Mapping pens are small nibs with specially hardened points. The best of them are manufactured in Germany (the Brandauer 518 is a fine example); in Birmingham, England; and in the United States by Esterbrook and by Hunt. Good mapping pens are resilient and, if properly cared for, long-lasting. These pens give a uniform line of extreme fineness and are unequalled for drawing very delicate detail or fine textures. The limited variation in the line that can be achieved with a change of pressure on the pen, and the slight increase in line weight that occurs when the pen is periodically recharged with ink, give drawings done with these points a subtle vitality that is missing in the lines of a technical pen.

Pens of this type actually improve with age and use. New mapping pens are sharper and do not flow across the paper as easily. They often feel slightly scratchy at first. The abrasion of the paper against the pen tip wears it, and like a fine fountain pen, it becomes modified to the characteristic holding angle and movements of your hand. Over a period of time, mapping pens soften and yield a more flexible line variation, and remain loaded long enough to permit comfortable working on larger-format drawings.

WITCH PENS

Witch pens have a square-cornered, rolled-over writing edge. They are made to glide more smoothly over rougher papers than would traditionally be used for pen drawing or writing. William Mitchell manufactures these and sells sets of five widths, each with its own wooden holder.

LETTERING PENS

Lettering pen nibs, Round Hand pens, and Italic pens are usually made from a heavier grade of metal. They lack the flexibility of quill (fine), lithographic (flexible superfine), and mapping pens (superfine).

Lettering nibs of professional quality are manufactured in the United States by Speedball, and in Germany by Brause & Co. and also by Heinze and Blanckertz. Speedball lettering and drawing nibs come in four basic tip shapes: square, round, flat, and oval. The square (style A) and flat (style C) can produce angled edges on a line drawn with a sharp change of direction. The round (style B) and oval (style D) nibs always give rounded "corners" to a line. The flat (style C) and the oval (style D) produce the maximum change of line thickness. This change is a function of the direction of the pen stroke in relation to the nib and not because of a change of pressure against the paper. These nibs are rigid, and the line width is set by the size of the tip. All of these penpoints are equipped with a reservoir for greater ink capacity and uniform ink flow. Lettering nibs are also available for fountain pens.

William Mitchell manufactures calligraphy pens called Round Hand, which have right-handed nibs called Square Cut in ten sizes from 0 (broad) to 6 (fine), and left-handed nibs called Italic in five sizes. Mitchell also manufactures separate lines of script nibs and poster nibs. The script nibs are available in ten sizes, while the poster nibs are available in eight sizes.

METALPOINT DRAWING PEN NIBS

Like the lettering pens, drawing pens have a larger base than the cylindrical shaft of a crow-quill or hawk-quill pen and require a different style holder. Steel penpoints are available for every kind of technique from bold to hairline drawing. Drawing pens of professional quality are manufactured by Hunt, Joseph Gillott, Esterbrook, and several other companies.

Metalpoint pens must be redipped regularly in ink as you draw, but a properly prepared pen can produce graceful long lines as well as shorter marks and dots. Dip pens require more practice and patience than internal reservoir pens such as fountain pens or technical pens, but they pay rich dividends in return. No fountain pen on the market can produce a line that equals the delicacy and fluidity of some drawing pen nibs.

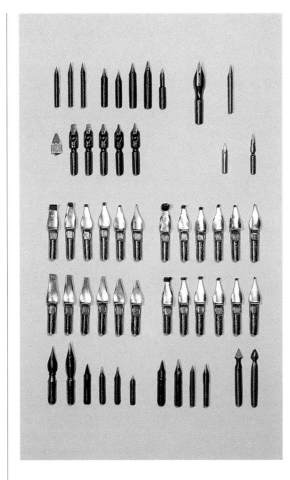

METALPOINT PEN NIBS. Top row: Mapping and drawing pens from William Mitchell/Joseph Gillott; then Inflexible 322 by R. Esterbrook & Company; then 515 by Brause & Company. Second row: Rexel Round Hand Left Oblique (reservoir and five widths of point); Finstone Midgit Stub by Marx; and Brause & Company 66EF Iserluhn. Third row: Hunt Speedball A set and B set. Fourth row: Hunt Speedball C set and D set. Bottom row: a series of Hunt nibs; on the far right, two scratch knives.

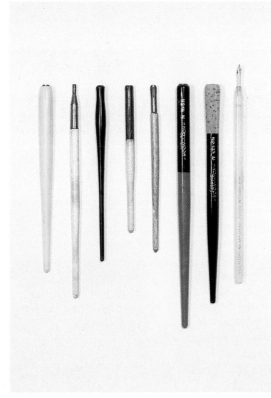

ASSORTED PEN HOLDERS. From left to right: yellow pen holder with triangular cross-section. Mitchell's lithographic or mapping pen holder. Unlabeled, comfortable pen holder. Mitchell's Pedigree Universal holder. Joseph Gillott 403A. Koh-I-Noor 14N. Koh-I-Noor 127N cork-collared holder. Braun quill holder.

INK RESERVOIRS

Most metal nibs are for dip pens. Some, such as the Graphos or Speedball, have a self-contained ink reservoir. William Mitchell's Round Hand and Italic pens have an optional Mitchell Slippon Reservoir (#35256) that holds an extra supply of ink. These are designed for calligraphy to reduce the need to dip as often and to allow a full, even flow of ink. Points with ink reservoirs are not for calligraphy only. Try them for other drawing uses.

PEN HOLDERS

The size of nibs and their holders varies as much as the metal alloy from which the nibs are made. Quill pen holders and drawing pen holders come in several designs. These variations are more than a matter of appearance. Not only is there a difference in feel, weight, surface texture, and balance between them, but more importantly, the shape and thickness of the holder in your fingers is a factor in drawing comfort. Each one of us has an individual hand movement style and muscular tension. A pen holder that is too narrow can cause muscle cramping in your hand or wrist. One that is too thick gives some artists the sensation that they have less control. Try several pen holders before you make your purchase. Move your hand as though you are drawing. You wouldn't buy shoes without trying them on. Why should choosing a pen holder be any different? There is no single holder that will work best for everyone. If a holder isn't comfortable, it will show soon enough in your drawing or end up never being used. The most user-friendly pen holders are not necessarily the highest-priced.

CORRECTING INK FLOW PROBLEMS IN DIP PENS

Even well-cleaned pens resist letting go of the ink occasionally. Shaking a pen to restore ink flow is a proper method when you are using a technical pen. It is not the way to deal with a balky dip pen. Even with proper cleaning before its initial use, a nib must be regularly cleaned during use to remove ink that is thickening on the point because of evaporation.

The solution for this is simple and will soon become part of your working rhythm. Dip the pen tip in a small puddle of the same ink you are using. The ink acts as its own solvent and restores the flow. All nibs periodically need this encouragement. Place a small piece of waxed paper, a bottle cap, or some other small container holding a few drops of ink near the drawing but

safely out of the way of your moving hand. Also, keep a piece of scrap paper by your ink supply. Whenever you dip a pen in ink to recharge it, make a few lines on the scrap before returning to your drawing. This helps to reestablish a smooth ink flow and removes excess ink that might otherwise blot the drawing.

If a pen snags or doesn't glide easily over the surface of a smooth paper, try making a few light strokes on the smooth side of an Arkansas whetstone to polish the pen tip. (This flat, cut stone is used for sharpening knives and can be purchased at any hardware store.) If that doesn't remedy the problem and the pen continues to catch on surface irregularities in the paper, the paper surface may be too soft for the nib you are using. Sharp metal nibs are best suited for working on a hard, smooth paper with limited absorbency.

As I mentioned above, even your favorite penpoint will work better if you occasionally clean it while you are drawing. Keep a jar of water mixed with a little alcohol or a container of commercial pen cleaner within reach on your taboret. (Higgins pen cleaner works well for this, or Koh-I-Noor Rapido-Eze liquid cleaner diluted in water, one part cleaner to four parts water.) Every few minutes as you are working, dip the entire point into the water or cleaner and agitate it to dissolve any ink that is building up on the nib. Rinse it in clean water. Then dry the nib on a scrap of soft cloth or paper towel by wiping downward, away from the handle, and off the point of the pen in order to remove any fibers that may be caught in the prongs of the tip.

If your penpoint has been gliding smoothly across a paper but suddenly begins to catch, your technique may be softening the paper. Going over the same section of the paper repeatedly in order to create a dense layer of hatching can soften and lift the fibers. Give the ink time to dry sufficiently. Wetting the paper surface temporarily weakens it. A sharp metalpoint will cut into the softened paper, lifting it. Work on more than one area at a time. It is better to return to a section of hatching several times, building the dark tones gradually. This lets you avoid working on a temporarily weakened section of your drawing.

The paper may also have been damaged slightly by erasing a preliminary pencil sketch. Paper that has been roughened in this way can sometimes be restored by *burnishing* (polishing) the area. This repacks the paper's surface fibers. Before you begin burnishing, allow any ink on that section to dry completely.

Burnish the paper with a plastic burnisher or a strip of illustration board bent double. Protect the surface of your drawing before rubbing it by placing a piece of thin hard paper (such as bond paper) over the area to be flattened. Use the burnisher with small circular movements to smooth the roughened section of the drawing.

If the fault is not in the paper when a pen snags, and you have tried smoothing the pen tip, throw the nib away and insert a new one. Some points have minute irregularities. It isn't worth fighting with a recalcitrant point. Not only is it frustrating to continue working with a defective nib, but you risk an ink blot on the drawing for the sake of saving a few cents.

PEN CLEANERS AND ERASERS

Water-based inks dry by evaporation. They begin to dry even on the nib while you are working and must be regularly redissolved or wiped off the pen as you draw. Water, to which a small amount of alcohol or ammonia can be added, is all you need to clean a pen while you are drawing. Simply dip the pen into the water now and then, blot it dry, and then dip it back into the ink. When you are finished drawing with a dip pen, or when you are refilling or changing the ink in a reservoir pen, the pen must be cleaned more thoroughly. Liquid pen cleaners make the job much easier. A bulb such as the Koh-I-Noor syringe cleaner can be used to force cleaning fluid through technical pens, airbrushes, and calligraphy pens. Rapido-Eze liquid cleaner is one example of a good fluid for cleaning pens.

There are also cleaners for removing ink from papers or drawing films. Some erasers, known as imbibed erasers, are impregnated with liquid ink dissolving fluids. They are effective for films and some papers. Solvents known as liquid erasers will soften and reliquefy dried and cured ink lines on drafting and drawing film.

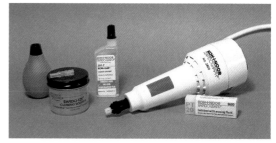

KOH-I-NOOR PEN CLEANERS AND INK ERASERS. From left to right: pressure syringe. Rapido-Eze cleaning solution. Resting on jar lid: pressure bulb attachment for technical pen points. 291-F Koh-I-Lar liquid eraser. All-purpose electric erasing system with yellow imbibed strip eraser. Yellow imbibed eraser.

TECHNICAL PENS

Technical pens are drafting and drawing pens that have a controlled ink flow from a self-contained ink reservoir. They are designed in three types: a refillable reservoir, a replaceable ink cartridge, and a disposable pen. Technical pens that are refillable offer the greatest advantage to the artist. This type of ink reservoir is not restricted to the prepackaged inks from the pen's manufacturer. These inks are extremely limited in color choice and permanence because they are designed primarily for technical drafting and are not prepared with the needs of an artist in mind. However, despite their intended purpose, technical pens are justifiably popular for drawing. They are unexcelled for techniques such as stippling or general drawing where a constant line quality is what you want.

Technical pens are characterized by a radical design departure from the basic dip pen nib or its adaptation in the fountain pen. The unvarying line made by a technical pen is produced by a point based on a hollow, cylindrical tube with a thin wire pin inside it; some technical pens use slight variations on this basic structure. The ink is fed through the tube onto the paper in an even flow. The points are made from one of three materials: steel (the most common), tungsten carbide (a harder tip that is more resistant to the abrasion of film and tracing papers), and jewel (a sapphire for polyester film).

The points are available in a series of metric widths commonly used in drawings for engineering, architectural, or scientific illustration. Technical pens are unequalled for ruling lines with straightedges or French curves. The ink does not flow on the surface of the nib as it does with all dip pens and fountain pens, but rather through the tube, emerging only at the very tip. This eliminates the problem of an ink coating being deposited along the guiding surface of the straightedge or curve, where capillary action can pull it underneath to form a blot.

The design of these pens permits use of waterproof ink, an advantage over fountain pens. Whatever brand you use, it is essential that you follow the maintenance and cleaning instructions that come with each pen. Waterproof inks are difficult to clean out of a pen once they have dried. If the pen is tightly capped when not in use, most technical pens can be loaded with waterproof ink and remain ready to use for several weeks. If the supply of ink in the pen has not been used up within that time, the pen should be emptied, flushed and cleaned, and filled with fresh ink. Because of the variations in ink binders used to make waterproof inks, never add ink of a different brand if you are "topping up" a low ink supply in a pen.

A pen that has become blocked with dried ink must be soaked in water to soften the ink seal. This can be hurried by adding a small amount of alcohol to the water, but should be mostly water because an alcohol mix that is too strong can dissolve some plastic pen holders. This mixture can be used with a cotton swab to clean ink that has thickened in the reservoir.

Technical pens work best on smooth, hard papers and drafting film such as Mylar or vellum. The hollow pen tips can become clogged by fibers from soft papers collecting in the tube.

The metric line widths of technical pens are compatible with standard American drawing sizes and microfilm practices. Points on nondisposable technical pens are interchangeable, and range from 7 (a wide 2.00 mm line) to the ultra-fine 6×0 (0.1 mm line). These pens are useful mostly to nontechnical artists for stippling and constant-weight hatching or pure contour techniques, usually in the 3×0 to 1. or 2. sizes. If your work is for reproduction, consult the line width chart that comes with each pen to select a larger size that will reduce to the proper printed size.

EXAMPLES OF TECHNICAL PENS

- *Koh-I-Noor Rapidograph* has a refillable ink reservoir, which permits a wide choice of inks and colors. The point sizes range from 6×0 through 7.0, and the points are replaceable and interchangeable.
- *Mecanorma* has a refillable ink tank that is exceptionally convenient to use, and the manufacturer claims that the airtight seal keeps the ink permanently workable. The chrome or tungsten carbide points are replaceable and range from 6×0 through 7. The shorter overall length of this pen makes it a particularly convenient technical pen to carry in your pocket for working on location or sketching.
- *Reform Refograph* has a refillable reservoir. It also has replaceable technical points in stainless steel for drawing on paper in sizes from 5×0 to 6, and in tungsten carbide for drawing on abrasive surfaces like drafting film in sizes from 5×0 to 4.

- *Rotring Rapidograph* has replaceable ink cartridges and replaceable points in sizes from 6×0 (.13 mm) through 7 (2. mm).
- *Staedtler Marsmatic 700* has a refillable reservoir. A spring seal design lets the ink flow start instantly. The replaceable points are available in 12 sizes, from 5×0 (.13 mm) through 6 (2. mm).
- *TG1-S technical pen (Faber-Castell)* is available in three replaceable point materials (steel, tungsten carbide, and sapphire) and 12 sizes, 4×0 (.13 mm) to 7 (2. mm). It has a refillable reservoir.
- *Tombow PGS* has a refillable reservoir. The point is designed to work at any angle. This pen does not have to be shaken to start the ink flow. Replaceable points are available in sizes 6×0 through 2.5.

TECHNICAL PEN PROBLEMS

Problems with technical pens tend to fall into one of two categories: ink flow (too much or too little) or a problem with the point. When the ink doesn't flow, you are either running out of ink and it is time to refill, or the point has become clogged. In the case of clogging, try wiping the tip of the point carefully with a soft paper tissue. Pinch the point gently between your fingers and pull the paper off the end of the tube point. In some technical pen models, this is all that is needed to remove paper fibers that have caught and accumulated against the wire that lets the ink down the tube. If this does not remedy the blockage, carefully remove the point and wash

the parts. Be very careful not to bend the fine wire within the point. The pen cannot operate properly if this wire is bent.

If the ink flows too quickly, it will either come out through the tip of the point and form a small drop on the end (watch for this while you work and blot it on a paper towel or tissue) or it will leak out around the seam between the point and the holder. If this is happening, hold the pen away from your drawing, open the back, and tighten the ink cartridge. If it is empty, refill it or replace the ink container. Ink will sometimes leak this way if the container is not seated properly or if it is almost empty. When reseating the container after refilling or while replacing it, first wrap the tip of the pen in a tissue. The pressure caused by pressing the ink container into place will force ink already in the point or ink-feeding mechanism out through or around the tip. This ink must be wiped off the outside of the pen before you begin drawing. Pens of this type must be regularly checked for ink leakage while you are working because this can happen at any time. Even a change of barometric pressure can change the rate of ink flow.

Technical pens should be used with inks that are formulated for them. This is especially true for the finer points. Inks that are too thick will not flow through the narrower point sizes. Diluting the ink is not the way to solve this problem. Thinned ink gives a line that is not true black. The line density might look fine on the original, but may not photograph successfully for line reproduction. Line continuity and detail can be lost. Also, an ink may have pigment particles that are too coarse in size for the point. This will not be remedied by diluting. Inks that are prepared for use in technical pens have very finely ground pigments and, in some cases, additives to enhance the flow of ink through the narrow tube points.

When using a technical pen, always check the supply of ink before you begin to work. If the drawing involves carefully ruled lines, it is extremely difficult to resume drawing an extended line at midpoint without some visible change in its continuity.

It is often necessary to shake a technical pen in order to restart the ink flow after refilling the ink supply or if some time has elapsed between uses. As with any pen, never shake the pen over your drawing. Then check the rate of ink flow by making a few trial lines on a scrap of paper.

TECHNICAL PENS. From left to right: Reform Refograph. Staedtler Mars 700. Rotring Rapidograph. Koh-I-Noor Rapidograph. Mecanorma.

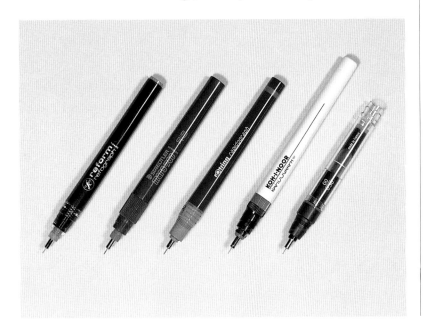

FOUNTAIN PENS

Fountain pens are reservoir pens that employ the same type of nibs as metal dip pens. The variety of fountain pen nibs, however, is more limited.

The movement pace of sketching is similar to that of writing. Writing pens, with their broad nibs and the high-quality design and construction of the feeder structure under the nib, make truly fine sketching pens. Some fountain pens are manufactured by the world's great pen crafters, and they encompass a wide range of prices. The best fountain pens are expensive for good reason: They have solid gold nibs that are individually crafted by hand. Gold does not rust. It glides across the paper more freely than other metals, and ink flows along it with less resistance. Solid gold is strong, yet soft enough that the tip adapts itself to the movement characteristics of the user. This explains the popularity of fine writing pens among artists. This is also the reason why a fine fountain pen should never be used by anyone other than the owner. A fine pen is well worth the investment.

Fountain pens are available in two forms: those manufactured as art materials and therefore designed for use with fountain india inks, and those designed for fountain pen inks only. (Fountain india ink contains finely ground particles of pigment, but fountain pen inks are based on liquid dyes, which will not clog the pen.) Fountain pens manufactured for drawing or calligraphy include Pelikan, Reform, Osmiroid, and Platignum. Before buying a fountain pen, be sure you know what kinds of inks you can use with it. None of these pens, however, are intended for use with waterproof drawing inks, which contain shellac or other binders that are virtually impossible to clean out of a fountain pen.

PENS USABLE WITH FOUNTAIN INDIA INKS

- *Faber-Castell*'s fountain pen has a steel nib plated with 14-karat gold. It has two nib sizes: fine and medium.
- *Faber-Castell 585* has a 14-karat gold nib and a plunger pump filling system. I have been using this pen for years with fountain india ink with no problems.
- *Osmiroid* is manufactured in England by E. S. Perry Ltd., and distributed in the United States by Hunt Manufacturing Co. This is an india ink fountain pen that offers a range of 38 "Easy-change" nib units made of stainless steel and plated with 22-karat gold. The nib unit is threaded and does not require a special tool for removal or replacement. Osmiroid makes nibs for fine writing, calligraphy, and drawing; the copperplate nib is the best choice for sketching. Both the regular nib units (rola and italic) and the specialist range (fine and medium hard, lettering, copperplate, sketch, and tipped) include a selection of oblique left-hand nibs.
- *Pelikan* pens are considered among the world's finest writing instruments, whether for writing, sketching, or calligraphy.
- *The Pelikan MC120* comes with a medium, writing/sketching, gilded gold nib. Seven interchangeable nibs fit this pen; they are easily changed with the nib key that is included. The MC120 has an automatic ink feed system that regulates the ink flow. It can be used with fountain india ink but should be washed (in water with a tiny bit of ammonia added) each time it is refilled. A plunger mechanism makes the pen easy to refill. This pen has long been the artist's workhorse.
- *Pelikan Souverän 250* has a 14-karat solid gold nib, a plunger pump filling system, and eight nib widths. The nibs become quite flexible with use. Like the Pelikan MC120, the Souverän can take fountain india ink if washed with water and a small amount of ammonia each time the pen is refilled.
- *Pelikan Souverän 600, M700, and 800* have 18-karat sold gold nibs available in eight widths, and a plunger pump filling system. These pens can take fountain india ink. Each time you refill the pen, flush it with a very weak solution of ammonia and water to clean it.
- *Rotring ArtPen* is available in three styles of selected stainless steel tips:

 Calligraphy: five widths, ranging from 1.1 to 2.7 mm.

 Lettering: medium (M), broad (B), and extra broad (BB).

 Sketching: extra fine flexible, and fine flexible.

These pens use replacement cartridges of ink but can be converted to a refillable cartridge by inserting the ArtPen Ink Converter, a permanent piston-fill ink reservoir. It can be used with waterproof drawing ink. The

calligraphy set comes with a sharpening stone for polishing the points. The long handle makes this a popular studio pen.

- *Senator* has gold-plated iridium nibs, available in interchangeable widths. It comes with a removable extension for the barrel, which means that it is pocket-size for travel and long for studio use. The Senator will take fountain india ink. With use, this pen's point becomes one of the most flexible points I have ever seen on a fountain pen.

PENS USABLE WITH FOUNTAIN PEN INK ONLY

- *MontBlanc* is a superb pen that has a solid 14-karat nib that comes in three tip widths. This pen takes fountain pen ink only.
- *Rotring 600* has solid brass construction. Its steel nib is available in eight sizes, including three obliques for left-handed artists. This pen takes cartridges, available in black and three colors, or has a piston converter. It does not take fount india ink.
- *Sheaffer Targa* comes in two barrel widths: classic and slim. The nibs are solid 14-karat gold in extra fine, fine, medium, and broad. (Although the manufacturer does not recommend it, some artists have found that the Sheaffer Triumph and Targa can take very finely ground fountain india inks. Clean the pen carefully each time you refill it.) Because of its touch, this model has become my personal favorite among all of my fountain pens.
- *Sheaffer Triumph 777-0* is another classic pen that comes in a variety of finishes trimmed with gold electroplate. It has solid 14-karat gold nibs, sizes extra fine, fine, medium, and broad.
- *Waterman* is considered the world's finest fountain pen by many, and it makes an exceptional drawing pen. The nibs are solid 18-karat gold. There are three tip widths: fine, medium, and broad. These pens use ink cartridges or a plunger-type converter with a refillable ink reservoir.

JAPANESE FOUNTAIN BRUSHES

Japanese fountain brushes hold a replaceable cartridge of ink within the handle and should not be used with other inks. The one shown in the illustration has a replaceable red sable tip. Ink cartridges for this fountain brush are available in black, nonlightfast blue, and a red-orange.

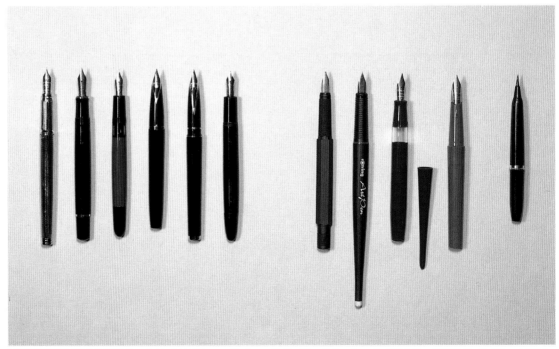

FOUNTAIN PENS AND BRUSHES. From left to right: Waterman Gentleman Sterling Silver. Pelikan Souverän 250. Pelikan MC120. Sheaffer Triumph 770-0 in black laque and gold electroplate. Sheaffer Targa in black laque. Faber-Castell 585. Rotring 600. Rotring ArtPen. Senator. Osmiroid calligraphy pen. Japanese fountain brush with a replaceable red sable tip

BALLPOINT PENS

The design of the pen tip is based on positioning a high-precision steel ball bearing at the end of a metal tube that contains the ink. The ink supply is in the form of a paste rather than a free-flowing liquid. This ink is constantly in contact with the inner portion of the spherical ball, which deposits the paste ink on the paper's surface as it rolls across it. Both the ballpoint and rolling-ball pens give artists a freedom of movement that no other type of pen can match. Quality ballpoints come the closest of any pen to capturing the complete freedom of directional change and range of tonal subtlety offered by a pencil.

Ballpoint pens are ideal for rapid drawing in sketchbooks where they are protected from ambient ultraviolet rays from sunlight or fluorescent lights, or for use in drawings that are done for printed reproduction. If the drawing will be framed and hung where it is exposed to light, then first determine the permanence of the ink. Ultraviolet-blocking Plexiglas should be used for glazing a framed work done in ballpoint pen.

Most ballpoint pens build up a surplus of ink at the tip as you use them. Finely made ballpoint pens give you less of a problem in this respect. Clean the tip occasionally on a piece of scrap paper as you draw. This will prevent the pen from depositing a small blot of paste ink on the drawing from time to time. Undried ballpoint ink will smudge under even the softest erasers.

The better-made ballpoint pens may require a stroke or two to get the ink flowing onto the paper. This is because the best pens have less tolerance between the ball bearing and the tube that holds it. This is not a fault. A pen that has more space around the ball bearing for ink flow or a more fluid ink paste builds up deposits of excess ink faster.

Ballpoint inks are highly viscous and are *not* water-based. Most ballpoint inks contain lubricants for the ball point, and they also contain dyes rather than carbon pigments or inorganic mineral pigments. (These latter ingredients would tend to clog the ball bearing and wouldn't dissolve in the solvents that are added to speed the drying of the ink.) This means that most ballpoint inks are light-sensitive. Black inks that use a combination of dye colors to produce a visual black undergo an unpredictable color change as the constituent colors deteriorate. The paste

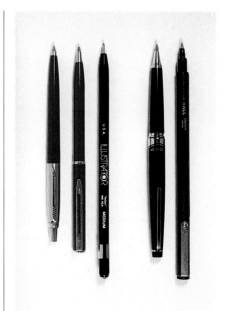

THREE BALLPOINT PENS AND TWO ROLLING-BALL PENS. From left to right: Parker. Waterman. Illustrator. Kenpen Rotarypen. Tough Ball (Marvy).

inks that use extremely fine carbon particles as their pigments are the only ballpoint inks that should be considered safe for use in drawing.

ROLLING-BALL PENS

Rolling-ball pens are a more recent development of the ballpoint pen principle. Each pen contains a precision steel ball or ceramic ball that is finely scored on its surface to enable it to carry a more conventional liquid ink. These pens carry permanent inks. Several kinds are now built to be rechargeable and use refill packs that are available in black and several colors.

Rolling-ball pens and ballpoint pens make a line that is relatively uniform in width. The rolling-ball line has an appearance similar to the line laid by a rigid metal dip pen or a technical pen. Its disadvantage is its unvarying line width. Its advantage lies in its self-contained ink supply, which permits continuous lines that are not bound by a need to redip.

Some of the newer rolling-ball pens use pigmented inks, and several manufacturers of such pens claim that their inks are lightfast. Sakura Co., the manufacturers of Pigma Ball, and Tombo Co., the makers of Roll Pen, claim that the inks in these pens are lightfast and waterproof when they are dry. Rolling-ball pens can use pigment-based inks, although most do not unless indicated by the manufacturer. Rolling-ball inks are de-ionized, water-based inks.

BRUSHES

Artist's brushes used for ink drawing are no different from watercolor brushes. Brushes come in a variety of shapes and sizes. They are made from natural hair, natural bristle, synthetic fiber, or a mixture. If you are using nonwaterproof inks, brushes made from any of these materials are suitable. The natural hair brushes, especially professional-quality brushes made from select sable hair, are the most versatile for watercolor techniques such as wash. Synthetic fibers are the brushes usually recommended for use with waterproof inks, whether the binder contains shellac or an acrylic, because these can damage natural hair. Hog-bristle brushes, which are used for oil painting, can be used with ink for a much more expressionist mark. Don't feel bound by a traditional approach to choosing a brush. Experiment. Only your personal handling of a brush can determine its suitability for you, the artist.

All brushes will last longer if they are cleaned immediately after you use them. Don't let waterproof inks dry on the brush. Never stand a brush on its hair, bristles, or fibers in a container of water or solvent. Clean the brush thoroughly and don't let pigment remain between the hairs, because these particles are abrasive and will weaken and break the hairs later. After washing your brushes with a mild detergent, rinse them and wipe them with a soft cloth to remove excess water. Straighten and reshape the hair. Let the brush dry hanging from its handle, if possible, to prevent water from remaining in the ferrule (the metal that surrounds the base of the fibers where they join the handle) any longer than necessary. Water trapped in the ferrule for long periods of time will gradually rot the wood and loosen the end of the brush.

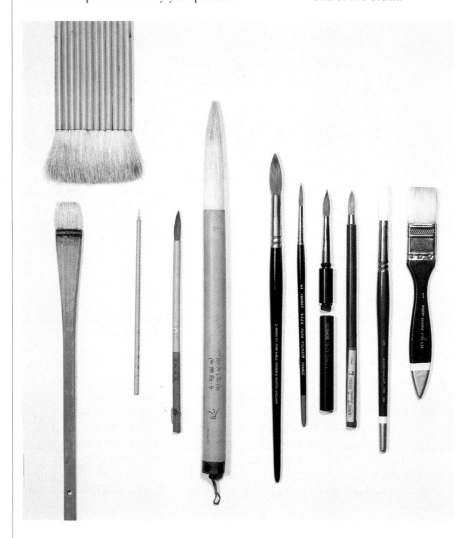

BRUSHES. From left to right, starting with top: Chinese hake brush (12 handles). Japanese hake brush. Three Japanese Boku-undo sumi brushes. Three kolinsky sable watercolor rounds: Winsor & Newton Series 7 no. 12; Isabey 6228 no. 5; Cosmos 15-03 no. 8, with unscrewable handle that stores brush. Three artificial-fiber brushes for working with waterproof inks: Saishiki G1210-L (Holbein); Robert Simmons 785 "White Sable" watercolor round no. 12; and Robert Simmons 1-inch 278W "White Sable" Skyflow wash brush.

INKS

The distinction between watercolor and ink is subtle if not arbitrary. Both are water-soluble, and both can be applied in washes with a brush or with a large variety of pens, including reed and natural quill, bamboo, steel, metal quill, and lettering pens. To further blur the distinction, not all inks are suitable for use with technical pens. The binders and the size of the pigment particles make the final distinction.

Watercolors (or water paints, as they are also known) use a brittle vegetable glue—gum acacia or gum arabic. This slightly acidic, water-soluble gum is the sap of the acacia tree. The gum arabic is usually blended with dextrin—a wheat starch glue—and plasticizers (such as glycerine) to increase the elasticity of the dried binder and make it more easily redissolved. Some inks use gum arabic as a binder. The inks that have been in use until very recent times used normal-strength hot hide glue as the vehicle and binder.

Every artist who works with inks should be familiar with three terms describing how well they last. *Lightfast* is an indication of the degree of resistance to fading when exposed to light. *Permanent* indicates the resistance to fading when washed. A permanent ink means only that the mark will still be legible after 12 launderings; a "permanent" ink may still fade or change color. *Archival* is the only term that means the color will last indefinitely. If you are looking for archival quality, don't be misled by the other two terms. They are not interchangeable.

INDIA INK

India ink was the original drawing and writing ink. It was invented by the Chinese using carbon black, lampblack, or bone black from India. This is the origin of the name that it carries to this day. These pigments are all permanent and nonfading. Lampblack is the finest-textured of the black pigments.

Modern india inks are made of carbon black pigment ground in a water-soluble binder. It is available in waterproof and nonwaterproof.

NONWATERPROOF INDIA INK

Nonwaterproof inks are bound with a water-soluble vegetable gum. This permits reworking the drawing by simply rewetting the ink, which reliquefies the glue binder. Using this technique, the artist can manipulate the grays by working back into the ink with a brush dipped in water. Nonwaterproof india inks cannot be used on film; they are meant for paper or illustration board. They are suitable for any brush, india ink fountain pen, technical pen, dip pen, or airbrush. Nonwaterproof india inks are opaque and archival because they are made with pigments that are unaffected by light.

EXAMPLES OF NONWATERPROOF INDIA INKS

- *FW nonclogging nonwaterproof india ink (Steig)* is for use on paper with dip pen, technical pen, brush, or airbrush.
- *Higgins nonwaterproof drawing ink 4425 (Faber-Castell)* is for use on paper with dip pen, technical pen, brush, or airbrush.
- *Higgins fountain pen india ink* is nonwaterproof and meant for use on paper with dip pen, fountain pen, or brush.
- *Pelikan fount india ink* is for use on paper. It is primarily for dip pens, but can also be used with india ink fountain pens and brush.
- *Pelikan drawing ink Z* is for all drawing ink fountain pens.
- *Speedball nonwaterproof drawing ink (Hunt)* is another archival-quality black ink.

HIGGINS BLACK INKS (FABER-CASTELL). From left to right: nonwaterproof black india ink. Black Magic waterproof ink. Waterproof calligraphy ink. Nonwaterproof fountain pen india ink.

WATERPROOF INDIA INK

India ink is made waterproof by the addition of varnish (water-dispersed resins) or shellac to the binder vehicle. Most waterproof drawing inks are resistant to bleeding into subsequent layers of water-based washes such as colored inks or watercolor as soon as the waterproof layer is dry. The overlays of wet paint, however, must be made carefully with a minimum of brushwork until the ink film has had time to cure. Inks that contain shellac require about thirty minutes before reaching maximum hardness and becoming waterproof. Before the shellac has fully hardened, repetitive overbrushing can lift some of the ink pigment and muddy the colors in the next layer.

Specialized waterproof inks with an acrylic binder, such as Higgins Black Magic waterproof ink, take 24 hours to be fully cured. Until the binder has cured, it is water-resistant but not truly waterproof. These inks are acid-free, which means that they are nonetching and noncorrosive. They are suitable for use on all polyester film, including Mylar, as well as tracing and vellum papers. If you are working on polyester film or tracing or vellum papers, these inks can be readily rubbed off and removed before they cure, but after that they cannot be rubbed off without using a solvent. Again, they *must* be allowed to cure for 24 hours after application.

All waterproof inks must be cleaned from brushes immediately. Unlike watercolors, waterproof inks cannot be redissolved during cleaning at a later time.

Many waterproof india inks are acid-free, pigment-based, permanent, lightfast inks of archival quality. They are safe to use on a variety of drawing surfaces.

EXAMPLES OF WATERPROOF INDIA INKS

- *Calli nonclogging waterproof india ink* is meant for calligraphic fountain pens. The manufacturer claims that the ink will stay fresh in the bottle for years.

THREE STEIG INKS. From left to right: Pro Black, FW nonclogging waterproof india ink, Calli nonclogging waterproof india ink.

- *Dr. Ph. Martin's Black Star Hicarb waterproof india ink (Salis International)* is formulated for uniform extreme opacity on clear, uncoated acetate and drafting film. It contains no varnish or shellac. It is formulated for dip pen, technical pen as small as 4×0 (0.134 mm), brush, or airbrush.
- *Dr. Ph. Martin's Black Star matte waterproof india ink* is for dip pen, technical pen, brush, or airbrush. It dries completely matte with no reflection and is meant for use as a flat black wash on paper or illustration board.

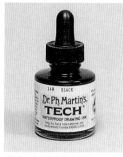

DR. PH. MARTIN'S BLACK STAR HICARB WATERPROOF INDIA INK.

DR. PH. MARTIN'S TECH WATERPROOF DRAWING INK.

- *Dr. Ph. Martin's Tech waterproof drawing ink* is extra brilliant and can be used on paper, illustration board, vellum, or cotton fabric. (Use with Tech Colorfix to make Tech inks colorfast on cotton.) It can be used with dip pen, technical pens as small as 3×0, brush, and airbrush.
- *FW nonclogging waterproof drawing ink (Steig)* works on all surfaces, including Mylar, acetate, glass, and paper.
- *Higgins black india waterproof drawing ink (Faber-Castell)* is for dip pens, technical pens, brush, and airbrush. The opaque matte finish reproduces without hot spots.
- *Higgins Black Magic waterproof drawing ink (Faber-Castell)* is for dip pens, technical pens, brush, or airbrush. It is intense and opaque with a semi-flat black finish.
- *Koh-I-Noor Rapidograph Universal waterproof drawing ink (Rotring)* can be used with dip pen, technical pen, brush, and airbrush on paper or drafting film.
- *Koh-I-Noor Rapidraw ink* has a latex binder and is also suitable for drafting film, paper, or cloth. This ink has superb opacity.
- *Koh-I-Noor Ultradraw ink* is for use on paper and is especially formulated to be nonclogging in technical pens.

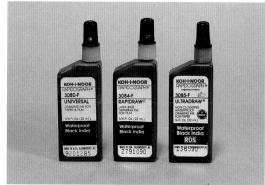

KOH-I-NOOR RAPIDOGRAPH WATERPROOF DRAWING INKS (ROTRING). From left to right: Universal drawing ink. Rapidraw ink. Ultradraw ink.

HOLBEIN DRAWING INK. KREMER-PIGMENTE
WATERPROOF BLACK INK.

- *Kremer-Pigmente waterproof ink* can be used with dip pen or brush on paper or illustration board.
- *Marsmatic 745R drawing ink (Staedtler)* is for use on paper with dip pen, technical pen, or brush.
- *Marsmatic 747T or 747TL drawing ink* is for use on film with dip pen, technical pen, or brush.
- *Marsmatic 745M2 drawing ink* is for use on paper or film with dip pen, technical pen, or brush.

MARSMATIC INKS (STAEDTLER). Left: 745R. Right: 747T.

- *Pelikan drawing ink A (waterproof)* is for use on paper with dip pen, technical pen, or brush.
- *Pelikan drawing ink FT (waterproof)* is for use on matte drafting film with dip pen, technical pen, or brush.
- *Pelikan drawing ink Z (waterproof)* is highly adhesive, for use on coated drafting film and hard-surfaced tracing paper with dip pen or technical pen.

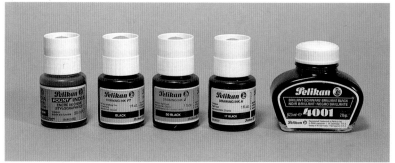

PELIKAN INKS. From left to right: fount india. Drawing ink FT. Drawing ink Z. Drawing ink A. 4001.

- *Rembrandt waterproof drawing ink (Talens)* can be used with dip pen, technical pen, reservoir pen, brush, or airbrush on paper, Mylar, or acetate. This ink dries to an eggshell finish.
- *Rotring ArtistColor (transparent and opaque) waterproof inks* are intended for use with dip pen, technical pen, brush, and airbrush on paper, illustration board, or cloth.

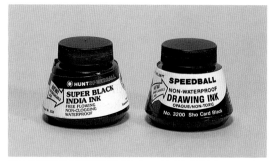

TWO SPEEDBALL INKS (HUNT). Left: Super Black india ink (waterproof). Right: Sho Card black drawing ink (nonwaterproof).

- *Speedball Super Black india ink (Hunt)* is archival and made with 100 percent carbon black pigment. It is suitable for paper, illustration board, vellum, or matte film. It can be used with dip pen, technical pen, or brush. (The manufacturer recommends cleaning pens every ten days with warm, soapy ammonia solution and then rinsing with warm water.)
- *Speedball Sho Card black drawing ink (Hunt)* is for use on paper and illustration board with dip pen or brush. Thicker than most inks, it is opaque and dries to a matte finish. The manufacturer rates it as having excellent lightfastness.

ROTRING ARTISTCOLOR WINSOR & NEWTON DESIGNERS
(TRANSPARENT). LIQUID ACRYLIC COLOUR.

- *Winsor & Newton Liquid Acrylic Colour, black (waterproof)* is for use on paper, illustration board, or cloth with dip pen, technical pen, brush, or airbrush. The pigment particles are, as the manufacturer puts it, "microised"— that is, ground to the microscopic size of less than 1/1,000,000th of an inch.

DYE-COMPOSITE INKS

While true india inks are archival, black inks made for technical pens and fountain pens may not be. The pigment in most pigment-based inks is too coarse for the finest technical pen tips. There are pigment-based inks that are especially ground for technical pens.

Also, pigmented inks must not be left in the pen for extended periods of time because the ink will coagulate and eventually harden. This can ruin a pen or, at the very least, make pen cleaning a more difficult task. For this reason, most inks manufactured for fountain and technical pens are made from dye composites. True india ink is made from carbon pigment only and contains no dye.

Carbon ink is lightfast. Most dyes are not.

Test any ink that you suspect may be a dye composite. Wet a section of paper with a water wash and then drop or brush some of the ink to be tested onto the wetted area. A true india ink (all carbon pigment) will spread and feather along its edge with no appearance of another color. The ink should feather from a black to lighter grays. A dye composite ink will separate into two colors, such as a blue and brown, or a blue and reddish-purple.

Another test to determine whether an ink is a dye composite is to brush a sample stripe of the ink on a piece of paper. Cut the paper in half so that the ink sample extends onto both pieces of paper. Place one side of it in the sun for several days (one or two days is often enough). The matching side should be placed in a drawer where it will be protected from ambient light. If the ink is carbon pigment, there will be no change. If it is a dye composite, the ink will soon show some fading. Nonlightfast dye-composite inks should not be used if the drawing is intended for exhibition and sale as original art. However, nonlightfast inks are perfectly suitable for illustration and design work that is meant for printed reproduction. Pelikan 4001 fountain pen ink is an example of a good dye-based black ink. Although not archival, it has a high lightfastness rating.

These demonstrations show how inks react to exposure to light.

Left: Fountain pen inks. The left half was exposed to sunlight for three months, while the right half was kept in a dark, acid-free box. Higgins fountain pen india ink is pigment-based; the others are dye-composite inks.

Right: Dye-composite inks. The far right-hand strip was wetted with clean water to show color separation of the dyes, then stored in an acid-free box away from light. The left-hand strip was exposed to sunlight for three months to show the color change in the nonarchival inks.

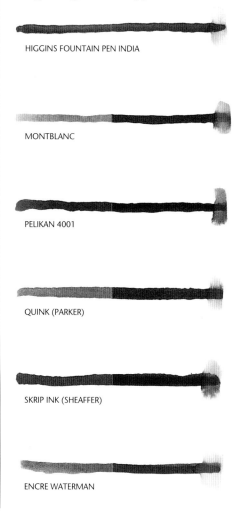

HIGGINS FOUNTAIN PEN INDIA

MONTBLANC

PELIKAN 4001

QUINK (PARKER)

SKRIP INK (SHEAFFER)

ENCRE WATERMAN

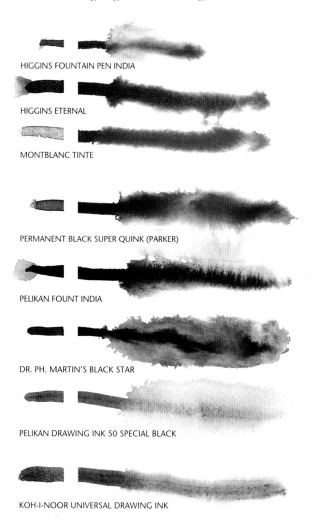

HIGGINS FOUNTAIN PEN INDIA

HIGGINS ETERNAL

MONTBLANC TINTE

PERMANENT BLACK SUPER QUINK (PARKER)

PELIKAN FOUNT INDIA

DR. PH. MARTIN'S BLACK STAR

PELIKAN DRAWING INK 50 SPECIAL BLACK

KOH-I-NOOR UNIVERSAL DRAWING INK

ORIENTAL INK STICKS

For centuries the ink manufactured by the Chinese and Japanese has been mixed 1 part pigment to 2 or 3 parts hide glue. This mixture is ground until it is free of lumps. It is then either poured into ceramic dishes to dry or stirred until enough water has evaporated so that the stiffened mixture can be molded into a stick. This is wrapped with a waxed paper to allow it to dry slowly so that it will not crack from rapid shrinkage.

Pine soot mixed with hide glue binder was used to make the ink sticks most widely used during the Sung period. It was jet black and matte or dull. Since the Ming period, lampblack has been the preferred pigment for ink sticks used to grind ink for brush painting. Lampblack has the finest texture of the black pigments. This pigment is made from burning vegetable oils such as sesame oil or rapeseed oil. The soot is collected by scraping the deposits laid by the smoke. Lampblack pigment yields a bluish black that has a faintly metallic sheen in the dried ink film. This is most readily observed in rich black marks made by applying the ink in a highly concentrated density rather than the more diluted mixtures used to achieve gray tones.

Today carbon black from Chinese and Japanese ink sticks, bone black, or lampblack (all of them permanent) are used to make india inks. There are many color undertones available in black ink sticks, from cool blue-blacks to purples to brownish-blacks. The particular color of the black is unrelated to its permanence. For our purposes, the choice of warm or cool black is a matter of subjective taste. The only important consideration is the quality of the materials and the care taken in the manufacture of the ink sticks. Good ink sticks are very light in weight, rather brittle, and when broken, have an almost crystalline structure. If they have been broken in shipping or through handling, they can usually be repaired by dipping them in warm water, rejoining the broken surfaces, and letting them dry pressed together. This reliquefies the binder to act as a glue once more.

In traditional ink painting, several different ink sticks are sometimes used to make inks for a single picture. The oil-based lampblacks are darker than the pine soot inks and were used by many Oriental artists for the more contrasting final detail drawing over the cooler washes produced with the pine soot pigments.

Good-quality handmade ink sticks improve with age. Ink sticks produced today should be

CHINESE INK STICK AND SLATE INK STONE GRINDING DISH.

aged for several years before using. Boku-undo ages its handmade ink sticks for five years before distributing them to the dealers.

One of my own favorite ink sticks was handmade in China over a century ago. The stick is large enough that it may well provide ink for several generations of my descendants! Top-quality ink sticks can sell for thousands of dollars and may be several hundred years old.

Modern Chinese ink sticks are made primarily from high-resin pine and tend to be bluish. They are graded numerically:

> 101: highest professional quality.
> 102: very good, professional.
> 103: good, professional.
> 104: amateur.
> 105, 106, and up: student grade.

Japanese ink sticks are made most often from vegetable oil soot and tend to be warmer in undertone. They also contain some camphor, which produces a metallic luster in the dried full-strength strokes.

The Japanese coding system uses dots to indicate the quality of ink in the stick. Five dots mean highest quality; fewer dots mean successively lower quality.

Many new ink sticks have a protective coating that should be removed before you use the stick to make ink for drawing. This is done by grinding it in water in an ink stone dish just as you would to prepare ink for drawing. Throw out this first-ground ink and rinse the inkstone before continuing.

INK STONES

The stick form of the ink (the Japanese name for this ink is sumi) is always prepared fresh before each painting session. The liquid ink is made by rubbing an ink stick in water against a stone dish made from slate or lava. Ink stones have a grain that acts as an abrasive to break up the pigment particles as the glue matrix is softened by the

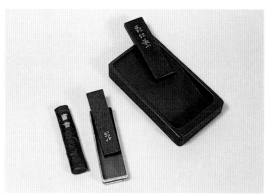

ORIENTAL INK SUPPLIES. From left to right: Chinese ink stick. Japanese ink sticks. Lava ink stone grinding dish.

water. The nature of the grain in the stone determines the consistency of the ink it will make. Finer-grained stones produce smoother inks but require longer grinding.

The best ink stones are slate, which can be found in a variety of grades. Slate improves with age, so the highest grade ink stones are taken from the oldest slate deposits. The highest grade are extremely valuable and are collected as art objects. A good grade of slate will grind a finer ink than a lower-grade one. An inferior ink stone can actually make a good-quality ink stick produce a lower-quality ink, and a better stone can improve the consistency of an ink made from a lower-quality ink stick. Less expensive than the slate ink stones but still good are the ones made in Japan from lava. The cheapest ink stones are not real stone at all but ceramic. The ceramic stones are best used for grinding colored inks. If you are interested in doing a lot of drawing with Oriental inks, take the time and care to acquire an ink stone that is at least equal to the quality of the ink sticks you will be using.

You can test the grain of the stone before you buy it. Simply scratch the smooth grinding surface of the stone with your fingernail. The teeth in the surface of the stone should all be angled in the same direction (toward the well). When you scratch the stone against the grain of the teeth, the filing action of the stone on your fingernail should leave behind a clear mark. This is the same filing action that grinds the pigment particles from the ink stick as you rub it against the ink stone. Select a stone that yields a clear and even mark.

The process of grinding the ink in preparation for drawing is not regarded as a necessary evil to be "gotten through," but a period of meditative concentration to put the artist in a more focused state before drawing.

Ink made from Oriental ink sticks is ready for use when it has an almost oily or creamy consistency that runs down the sloped ink stone grinding surface sluggishly. This mixture becomes even more concentrated through slow evaporation. The ink is then usually transferred to a porcelain dish, where it is easier to control the thickness and tone of the ink.

Use the ink full strength for dense blacks, or dilute it with more water to achieve a wide range of tones from dark grays to a very delicate off-white that in lampblack, the finest-textured black pigment, has the delicacy of a pearl.

LIQUID CHINESE OR SUMI INK

There are Oriental inks available in a commercially prepared liquid form. This is a concession to the Western "frozen dinner" approach to life and work. The inks are sold in cans (a completely liquefied ink) and in plastic squeeze bottles. The squeeze bottles contain a denser mixture of carbon ink that is almost honeylike in consistency. There is also a heavier ink in paste form that can be found in better art supply stores.

The better liquid Oriental inks have animal glue as the binder, just as is used for manufacturing the ink sticks. However, some Oriental inks are now being manufactured with an acrylic polymer as the binder. Any advantage in this is to the supplier, not to the artist. These inks have a longer shelf life.

The disadvantage to the artist is in the fact that the acrylic-based inks are waterproof. This prevents later reworking with a wet brush to manipulate the ink for subtle shading effects. It is an unfortunate innovation since this flexibility in handling is the reason for choosing Oriental inks over commercially made india inks in the first place. Another problem with the acrylic

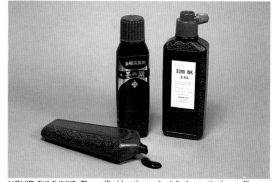

LIQUID SUMI INKS. The spilled bottle on the left shows the honeylike consistency. The center bottle contains ink with a purple undertone. The ink on the right, imported by Yasutomo & Co., has an animal glue binder that is water-resistant upon drying.

polymer binder is that it requires paying more attention to cleaning your brush while you are working. Acrylic ink that has dried in the brush can ruin the brush, whereas animal glues, like the gum arabic binder in watercolors, can be redissolved and cleaned later. (See page 22 for more about care of brushes.)

SEPIA AND BISTRE INKS

Genuine sepia ink uses pigment obtained from drying and grinding the ink from the ink bladders of cuttlefish and squid. This ink is a brownish-black fluid that these cephalopods eject to cloud the water as a defensive maneuver. Sepia is often mixed with other brown or reddish pigments in order to give it more warmth of undertone.

Bistre is a brown or yellowish-brown pigment derived from wood soot dissolved in water. I have had students make their own bistre inks. The ink itself is relatively simple to make. The soot is gathered by scraping it from the inside of a fireplace chimney, where it was deposited by the smoke from burning wood. First spread a piece of paper to catch the soot as you scrape it. The type of wood that has been burned in the fireplace determines the color of the ink solution that it will produce, which means that it is almost impossible to keep the color consistent from one batch to the next.

To make the ink, add slightly more water than soot, and boil it for about an hour. Then strain it through a paper coffee filter or four or five layers of cheesecloth to remove the fine grains of black carbon that were deposited in the smoke. (If these particles are not removed, the ink will be blackish and the real color will be hidden.) After filtering the soot/water mixture, boil it again for an hour or more. When it has cooled, the ink should again be filtered through filter paper until it is a clear, rich brown or golden-brown liquid.

Test the ink on paper. If the color is weak, it can be concentrated by boiling it longer or putting it in an open container with a wide top and letting it evaporate. Although the bistre at this stage has enough natural binder in it so that it is already an ink and not just wet pigment, the addition of a water-soluble glue such as gum arabic will enhance its working properties and brighten the color by slowing its absorption into the paper before it dries.

Prepared bistre can be purchased from Kremer Pigments Inc., 61 East Third Street, New York, N.Y. It comes in a paste form that can be thinned for working with a pen. This can be mixed with Kremer-Pigmente ink thinner or Rotring Universal medium to produce a waterproof bistre that can be used on any nongreasy surface.

OAK-APPLE GALL INK

For the artist in search of the less common drawing ink, Kremer-Pigmente also carries Eisengallustinte II, Gallapfelextraction, produced by Abraxis Laboratorium. This is also known as oak-apple gall or iron-gall ink. It is made from the galls or lumps on the branches and leaves of oak trees where gall wasps have laid their eggs. The tree forms an oak gall, or oak apple, where the tissues are irritated by the growing wasp larvae. These hard knots develop concentrations of tannic acid and gallic acid, which are extracted by grinding the galls and soaking them in water or wine for about a week. Ferrous sulphate is added, and the yellowish liquid turns pale violet or purple. After aeration, this will darken to a deep purplish black.

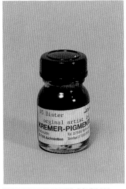

KREMER-PIGMENTE ORIGINAL ARTIST BISTER INK. OAK-APPLE GALL INK, PRODUCED BY ABRAXIS LABORATORIUM.

This is a black ink, but the artist should be aware that it is a very beautiful purple or violet when first applied to paper. Upon exposure to air (up to an hour or more, depending on how hard the paper surface is), the ink turns black. Over extended aging, the ink turns brown. This can be seen in old drawings done with iron-gall ink. Van Gogh used iron-gall or oak-apple gall ink, and the change can be observed in his drawings that now have mixtures of brown and black lines because the thinner lines are changing faster than the heavy concentrations of ink. The color finally becomes a bistrelike brown but is more opaque than bistre. Oak-apple gall ink is light-resistant, but exposure to sunlight may hasten the color transformation. It can be considered archival if your definition allows for a significant change of color with the passage of time.

WHITE DRAWING INKS

White drawing inks are pigment-based and may or may not be waterproof. Even the whites that are included in a line of transparent colors are made with pigment and are considered opaque inks. When added to a transparent drawing ink color, they will alter that color's transparency, making it opaque or semiopaque.

Because these inks are opaque, they can be used in black-and-white drawings. The densest whites can be used in black ink drawings to add fine white detail in areas that are solid black. It is faster and easier to make a fine flowing white line by drawing it than by inking the black up to both sides of the entire line and letting the thin strip of uncovered paper form it. To make every white in the drawing out of uncovered paper, you would have to know the exact placement and shape of every white detail that will be enclosed by black before you draw. The drawing would have to be sketched carefully in advance. A dense white ink frees the artist from this rigid preplanning.

Another use for white ink is to draw with white on a black or toned paper. This reverse method of working is actually closer to the way we perceive form. We see light. We see the brightly lit surfaces most clearly. The darker a shadow is, the more difficult it is to discriminate detail and color definition. Working with white ink on a dark ground lets us draw by concentrating on what we see most clearly. If this seems unnatural, it is only because we are conditioned by the convention of using dark writing and drawing materials on white paper.

Waterproof white ink can be covered with a layer of transparent colored inks to add color at a later stage of the drawing if the paper is a solid black. Paint the transparent inks over the dried white lines with a fine watercolor brush. This is similar to glazing. Black papers such as Aqaba, Arches cover black, Arches MBM Ingres, Velin D'Arches Noir, or Canson Mi-Teintes can be used. Also, you can blacken a favorite drawing paper in advance (completely or in sections) using a matte waterproof drawing ink such as Dr. Ph. Martin's Black Star matte.

All white inks must be shaken or mixed occasionally while you work except Winsor & Newton Designers Liquid Acrylic, which remains in suspension after shaking better than most other pigment-based inks.

The white inks have been applied with a pen (Hunt crowquill) and a brush to test (a) the working qualities of the ink with a fine pen line, (b) the type of wash that can be laid with a single brushstroke, (c) the opacity or hiding power of the ink, and (d) its resistance to bleed-through by dye-based inks. The black ink is a waterproof matte india ink, Dr. Ph. Martin's Hicarb. The colored inks are Marsmatic 745 colored inks (Staedtler).

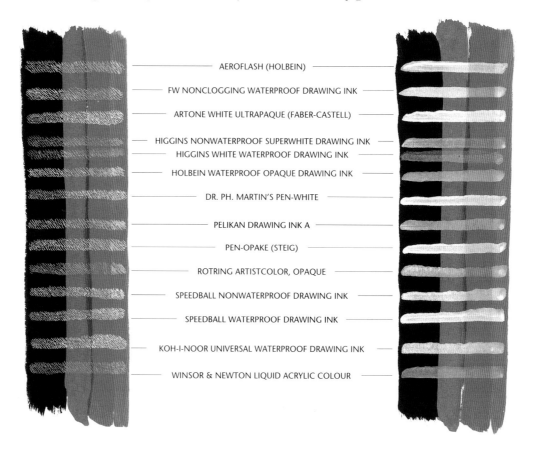

AEROFLASH (HOLBEIN)

FW NONCLOGGING WATERPROOF DRAWING INK

ARTONE WHITE ULTRAPAQUE (FABER-CASTELL)

HIGGINS NONWATERPROOF SUPERWHITE DRAWING INK

HIGGINS WHITE WATERPROOF DRAWING INK

HOLBEIN WATERPROOF OPAQUE DRAWING INK

DR. PH. MARTIN'S PEN-WHITE

PELIKAN DRAWING INK A

PEN-OPAKE (STEIG)

ROTRING ARTISTCOLOR, OPAQUE

SPEEDBALL NONWATERPROOF DRAWING INK

SPEEDBALL WATERPROOF DRAWING INK

KOH-I-NOOR UNIVERSAL WATERPROOF DRAWING INK

WINSOR & NEWTON LIQUID ACRYLIC COLOUR

EXAMPLES OF WHITE INKS

- *Aeroflash color (Holbein)* is a dense ink in a pure water-soluble acrylic. It can be used with dip pen, technical pen, brush, or airbrush and has archival permanence. It has high opacity and resists bleed-through when it is applied over a dye-based colored ink. This ink works very well with a fine dip pen.
- *Artone white Ultrapaque (Faber-Castell)* is the most brilliant white I have used. Intended for retouching and general use, this archival-quality ink works very well with a dip pen and gives an even wash with a brush. Dye-based colored ink does not bleed through it.

TWO HIGGINS INKS (FABER-CASTELL). Left: waterproof drawing ink #4265. Right: nonwaterproof Superwhite drawing ink #4015.

- *Higgins nonwaterproof Superwhite drawing ink (Faber-Castell)* works well with dip pen, technical pen, brush, or airbrush. Despite the name, this ink is only semiopaque, and dye-based colors bleed through it. The tinctorial strength is too low to be used for reproduceable whites when working over a dark ground. It does have archival permanence.
- *Higgins waterproof drawing ink (Faber-Castell)* is usable with all pens and brushes. This ink has even less covering power than the Superwhite. Dye-based inks overpower it. I cannot recommend it, despite its archival permanence.
- *Holbein waterproof drawing ink (Talens)* is suitable for dip pen, technical pen, brush, or airbrush. This ink has moderate covering power when applied with a brush and must be given more than one layer to be truly opaque. It works very well with a fine dip pen and gives a beautifully even wash with a brush. It has archival permanence.
- *Koh-I-Noor Universal drawing ink (Rotring)* is usable for dip pen, technical pen, brush, or airbrush. Dye-based colors do not bleed through this lightfast, high-opacity ink. It is one of my favorites for a fine dip pen.

AEROFLASH COLOR (HOLBEIN).

DR. PH. MARTIN'S PEN-WHITE (SALIS INTERNATIONAL, INC.).

FW NONCLOGGING WATERPROOF DRAWING WHITE (STEIG).

HOLBEIN DRAWING INK (WATERPROOF).

- *Dr. Ph. Martin's Pen-White (Salis International, Inc.)* is a wonderful ink suitable for dip pen, technical pen, brush, and airbrush. This is one of the most opaque whites. Dye-based inks and marker colors do not bleed through it. This ink writes on untreated acetate as well as on standard drawing supports. It works very well with a fine dip pen and has archival permanence.
- *FW nonclogging waterproof drawing white (Steig)* can be used with dip pen, technical pen, brush, or airbrush. This dense, lightfast white has high opacity but does not resist bleed-through when applied over a dye-based colored ink. It handles very well with a fine dip pen and gives an absolutely even wash with a brush.

KOH-I-NOOR UNIVERSAL DRAWING INK (ROTRING).

KREMER-PIGMENTE WATERPROOF WHITE INK.

- *Pelikan drawing ink A* is suitable for dip pen, ruling pen, technical pen, and brush. This lightfast ink has good working properties but not much covering power. It is semiopaque; dye colors will bleed through.
- *Pen-Opake (Steig)* is suitable for dip pen, technical pen, brush, or airbrush. This dense white may need to be thinned with a few drops of distilled water to make it flow more easily on a very fine dip pen nib. Don't overdilute the ink or you will lose opacity. It may be used in technical pens down to 3×0. This ink has excellent covering power; dye-based color does not bleed through. It also has archival permanence.

PELIKAN DRAWING INK A.

PEN-OPAKE (STEIG).

- *Rotring ArtistColor* is suitable for dip pen, technical pen, brush, and airbrush. This ink is lightfast but only moderately opaque; dye-based colors will bleed through.

SPEEDBALL DRAWING INKS, WATERPROOF AND NONWATERPROOF (HUNT).

- *Speedball drawing inks (Hunt)* come in waterproof and nonwaterproof versions. Both work with dip pen or brush and are excellent for use with a fine dip pen. Dye-based color will bleed through the nonwaterproof ink slightly but will not bleed through the waterproof ink at all. Both inks have archival permanence.

ROTRING ARTISTCOLOR.

WINSOR & NEWTON DESIGNERS LIQUID ACRYLIC COLOUR.

- *Winsor & Newton Designers Liquid Acrylic Colour* is suitable for dip pen, technical pen, brush, and airbrush. It is semitransparent; dye-based colors bleed through. The very fine size and even suspension of particles give washes done with this white an extremely smooth color distribution. This is a lightfast ink.

COLORED DRAWING INKS

Drawing ink is a generic term that includes india ink and colored inks. Until very recently, all colored inks were made from highly fugitive dyes. That is, the colors faded very quickly when exposed to light. During the writing of this book, a number of new colored inks have come onto the market. Some of these inks are pigmented and some are dye composites using new light-resistant dyes. Many pigment colors are lightfast, and the new inks, like artist's paints, have a high to very high degree of lightfastness.

These new inks include transparent, semiopaque, and opaque inks, and some are of archival quality. Manufacturers will continue to develop new products. If the literature on a new ink product is unclear on the issue of lightfastness, speak to the product manager of the manufacturer, or test the inks yourself. An ink must meet rigid standards if it is to be used for fine art. The label "lightfast" tells you only that an ink meets the minimum standards for resistance to fading. This does not mean that an ink or paint bearing that label is of archival permanence. A "lightfast" dye resists fading about as well as the *least* permanent category of pigments used in watercolors.

All colored inks, whether dye or pigment, can potentially be used with dip pen, technical pen, brush, or airbrush. Manufacturers can now grind pigment particles to a fine-grain size: 0.001 to 0.004 mm. This means they can be used with the finest technical penpoints and airbrush tips.

EXAMPLES OF COLORED INKS

• *Aeroflash colors (Holbein)* are made from high-density pigments in a pure water-soluble acryl, not an emulsion, which ensures no change of color tone from liquid to dried color. Aeroflash colors may be used with dip pen, technical pen, brush, or airbrush and may be mixed with any water-based colors. They are available in 48 colors plus black and white. These colors have archival permanence.

AEROFLASH COLORS (HOLBEIN).

• *Calli waterproof inks* are formulated for calligraphers and can be used in calligraphy fountain pens. The manufacturer claims that the ink will stay fresh in the bottle for years.

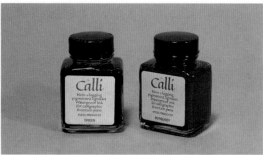

CALLI NONCLOGGING WATERPROOF INK (PIGMENTED, LIGHTFAST) FOR CALLIGRAPHIC PENS (STEIG).

• *Dr. Ph. Martin's Perma Draft opaque waterproof drawing ink (Salis International, Inc.)* is suitable for use on paper, illustration board, and transparent untreated acetate. It can be used with dip pen, technical pen, brush, or airbrush. There are seven colors, pigment-based, and they have archival permanence.

• *Dr. Ph. Martin's Spectralite (Salis International, Inc.)* is suitable for use on paper, illustration board, cloth, or film (or even fingernails). It can be used with dip pen, technical pen, brush, or airbrush. There are 48 pigment-based colors, and they have archival permanence.

The water-resistant medium is smooth and easy-flowing and leaves no brushmarks or overlap lines when the artist uses a brush or calligraphy pen.

• *Dr. Ph. Martin's Tech transparent waterproof drawing ink (Salis International, Inc.)* is suitable for use on paper, illustration board, cotton canvas, and cotton T-shirts. (It is colorfast on cotton if fixed with Tech Colorfix.) It can be used with dip pen, technical pen, or brush. There are 13 colors plus black, and they are nonclogging, extra brilliant, and waterproof. These inks are lightfast according to AATCC Test Method 16E—that is, when exposed to 20 hours of xenon-arc lamp. This means that they are about as permanent as the lowest-rated watercolors; they are resistant to fading from fluorescent light but not sunlight.

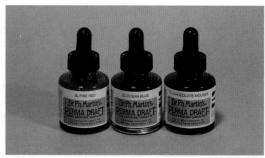

DR. PH. MARTIN'S PERMA DRAFT OPAQUE WATERPROOF DRAWING INK (SALIS INTERNATIONAL, INC.).

DR. PH. MARTIN'S SPECTRALITE (SALIS INTERNATIONAL, INC.).

DR. PH. MARTIN'S TECH TRANSPARENT WATERPROOF DRAWING INK (SALIS INTERNATIONAL, INC.).

ECOLINE TRANSPARENT WATERCOLORS (TALENS).

FW NONCLOGGING WATERPROOF DRAWING INKS (STEIG).

- *Ecoline transparent watercolors (Talens)* come in 45 transparent and 3 opaque colors (black, white, and gold) and are suitable for dip pen, technical pen, brush, and airbrush. They are selected for their brilliance, not for permanence, and therefore are recommended for illustrators and designers. The manufacturer recommends using lemon yellow, magenta, cyan, and their mixes for the best reproduction in offset printing. The lightfastness of Ecoline colors is reasonable to good. Finished work should be protected from light until it is reproduced.
- *FW nonclogging waterproof drawing inks (Steig)* are suitable for dip pen, technical pen, brush, or airbrush on paper, Mylar, or acetate film. There are 12 dye-based colors plus pigment-based black and white. These inks are as a group more lightfast than Luma watercolors or similar dye-based colors. They are designed for work to be reproduced.

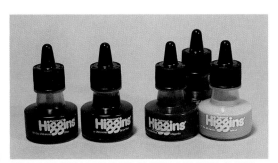

HIGGINS FADEPROOF PIGMENTED DRAWING INKS (FABER-CASTELL).

- *Higgins fadeproof pigmented drawing inks (Faber-Castell)* are waterproof and suitable for use on paper, illustration board, or film. They can be used with dip pens, technical pens, brush, or airbrush. There are nine colors, which are intermixable. They are opaque and permanent; they will not fade even in full sunlight. They have archival permanence.
- *Holbein drawing inks* are transparent and waterproof. They can be used on paper, illustration board, or film with dip pen, technical pen, brush, or airbrush. These are acid dyes and not lightfast.
- *Holbein special drawing inks* are opaque, waterproof, and pigment-based. They are suitable for paper, illustration board, or film, with dip pen, technical pen, brush, or airbrush. These inks are lightfast.

HOLBEIN DRAWING INK (WATERPROOF).

HOLBEIN SPECIAL DRAWING INK (OPAQUE, WATERPROOF).

- *Koh-I-Noor Universal waterproof transparent inks* are specially formulated for technical pens. They are suitable for paper, illustration board, film, or fabric and can be used with dip pen, brush, or airbrush.
- *Luma brilliant concentrated watercolors (Steig)* are suitable for dip pen, technical pen, brush, or airbrush on paper or illustration board. There are 85 colors plus black. These dye-based colors may be "erased" by applying laundry bleach with a cotton swab. Twenty colors from the list have very good lightfastness. The

KOH-I-NOOR UNIVERSAL DRAWING INKS (WATERPROOF).

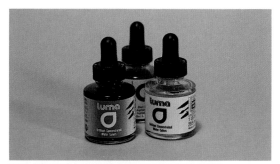

LUMA BRILLIANT CONCENTRATED WATERCOLORS (STEIG).

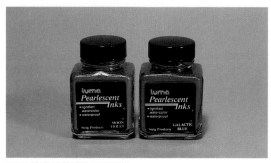

LUMA PEARLESCENT INKS (STEIG).

manufacturer recommends Luma watercolors solely for designing and artwork intended for reproduction.

- *Luma pearlescent inks (Steig)* are waterproof and suitable for use on all surfaces with a dip pen or brush. There are 16 colors: 14 have excellent lightfastness and two are rated less lightfast.
- *Marsmatic 745 colored inks (Staedtler)* are suitable for use on paper or film with dip pen, technical

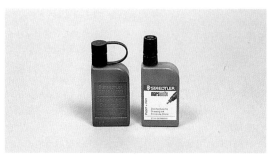

MARSMATIC 745 COLORED INK (STAEDTLER).

pen, or brush. There are six colors, and they are waterproof and smearproof when dry.

- *Pelikan waterproof drawing inks* are transparent and can be diluted with boiled or distilled water. They come in 15 colors plus black, white, and gray. They are suitable for paper, illustration board, or drawing film and can be used with dip pen, technical pen, brush, or airbrush.
- *Rembrandt waterproof drawing ink (Talens)* is suitable for use on paper, illustration board, or drawing film. It can be used with dip pen, technical pen, or brush. There are 18 transparent, high-brilliance colors plus opaque black and white. The transparent colors are dye-based and have a low degree of light permanence, so work should be stored in a folder to avoid exposure to light. These colors are recommended for work to be reproduced.

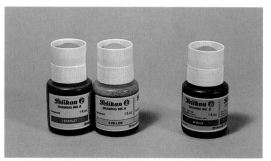

PELIKAN DRAWING INK A (TRANSPARENT, WATERPROOF); PELIKAN DRAWING INK Z (OPAQUE, WATERPROOF).

REMBRANDT WATERPROOF DRAWING INK (TALENS).

- *Rotring ArtistColor* is suitable for use on paper, illustration board, glass, or film (if used with Rotring universal medium). These colors can be used with dip pen, technical pen, Rotring ArtPen, brush, airbrush, or palette knife (in conjunction with acrylic binding agent). They are available in two lines: transparent and opaque; each line contains ten pigment-based colors plus black and white. Dried ArtistColor can be removed from most materials with Rapido-Eze cleaning fluid for technical pens. These colors have archival permanence.

ROTRING ARTISTCOLOR, TRANSPARENT.

- *Speedball nonwaterproof drawing inks (Hunt)* are suitable for use on paper and illustration board with dip pen, brush, or steel brush. There are seven colors plus black and white. These inks are thicker than most drawing inks and may be thinned with water. They are opaque and will cover dark or light surfaces. They are especially prepared for Speedball pens.
- *Speedball waterproof drawing inks (Hunt)* are suitable for use on paper or film with dip pen, brush, or steel brushes. There are 14 colors plus white. These inks are thicker than most drawing inks and may be thinned with water. They are opaque and will cover dark or light surfaces. They are especially prepared for Speedball pens.
- *Talens Graphic Art Colors* are based on a polyester resin in water which is waterproof after drying and gives the colors a silk matte finish. There are 24 concentrated colors, and they dry in a few seconds to several minutes depending upon the thickness of application and the absorbency of the support. They are

SPEEDBALL NONWATERPROOF DRAWING INKS (HUNT).

SPEEDBALL WATERPROOF DRAWING INKS (HUNT).

rated high to very high in lightfastness, depending on the color. These colors are suitable for dip pen, technical pen, brush, or airbrush on paper, illustration board, acetate, or polyester film. Greasy surfaces can be degreased in advance with Talens Ox Gall.

TALENS GRAPHIC ART COLOR.

WINSOR & NEWTON DESIGNERS LIQUID ACRYLIC COLOUR.

WINSOR & NEWTON COLORED INKS.

- *Winsor & Newton Designers Liquid Acrylic Colour* is suitable for use on paper, illustration board, or acetate. It can be used with dip pen, technical pen (if left in the pen no more than 24 hours), brush, or airbrush. There are 31 colors plus process black; white; and warm, neutral, and cool gray. The color range includes the four basic process colors. Applicators should be cleaned with water immediately after use. The airbrush cleaning fluid can be used to clean dried color from brushes, but repeated use of it could damage good-quality natural-hair brushes. These colors have archival permanence.

PAPERS AND SUPPORTS

You will be confronted with a bewildering variety of papers when you set out to select a drawing surface. The type of plant origin of the fibers (linen, cotton, kozo, mitsumata, gampi, papyrus, wood, and so on); the manner in which the fibers have been processed; their size, length, method of screening, and the presence and amount of additives; even whether or not the additive is in the slurry (or pulp) itself or on the surface of the formed sheet—all these factors contribute to determining the type of paper that is made.

In addition, many papers come in several thicknesses or weights. This is partly determined by the density or concentration of fibers in the slurry and how the slurry is screened. Some papers are made heavier in weight by combining layers. Each single layer is called a ply.

Papers come in a wide variety of sizes; weights (up to 400 lb. weight for some papers) or thicknesses; and in blocks, rolls, pads, and sheets. There are individual differences of surface and working characteristics among the drawing and watercolor papers made by each manufacturer as well as between different brands even though they are all in one of the three surface categories—hot-pressed, cold-pressed, and rough (HP, CP, and R) and have a wove or laid surface. For more about these paper surfaces, see the discussion of watercolor papers on pages 40–42.

When a paper's weight is given in pounds (lb.), it refers to the weight of 500 sheets (1 ream) of a standard size of that paper. If a paper's weight is given as 90 lbs., it is less than one-third the thickness of a 300 lb. sheet of the same type of paper. A weight of 140 lb. is considered the minimum for most general use. Anything less than this should be stretched before using techniques that require extensive wetting of the paper. Weights heavier than 140 lb. are progressively more resistant to buckling.

The weight of some papers is now given in gm/m^2, a more logical system for indicating thickness. No matter what size of paper you're buying, gm/m^2 tells you what a square meter of that paper would weigh. This is less confusing than lb. because it's not affected by the overall size of the sheet.

Many ink techniques are compatible with a wide range of papers whose sizings, coatings, and textures have been created for other applications. I consider most papers multipurpose for drawing.

The most important distinction you must make when choosing a paper is its permanence. Papers that will not age well should never be used for fine artwork that you intend to exhibit and sell in its original form.

Before listing papers available today that I recommend for some or all ink techniques, let's take a look at the types of paper on the market as distinguished by their fiber sources and methods of processing. This will also clarify many of the terms used to designate fiber type, surface, thickness, texture, and size. These are terms you will encounter when you shop for drawing papers.

GROUNDWOOD PAPER

This is a mechanically pulped wood paper. It is made by grinding debarked logs against a stone with water. Since water is the only processing material that is used and the logs are merely ground up, this paper is inexpensive. The problem for us as artists is that because entire debarked logs are used, the resulting pulp contains many extraneous materials, including lignin, which reacts to light or moisture. This makes the paper fibers break into shorter lengths, become less flexible, and weaken. The paper becomes brittle and darkens.

Newsprint, construction paper, oak tag, oatmeal paper, and chipboard are some of the papers made from groundwood. These papers may or may not be bleached. Because they are so inexpensive, groundwood papers are useful for throw-away exercises or experimentation before beginning work on a drawing or painting. They just cannot be considered usable for any work meant to last.

CHEMICAL WOOD PAPER

In this form of processing, wood chips are reduced to pulp using chemical solutions of sulfate or sulfite, high temperatures, and pressure. The chemicals and cooking remove the lignins and the wood resins.

This process is capable of making excellent papers, and some of them claim to meet archival standards. Since this process does not grind the logs, but chemically reduces them to pulp, the uncut fibers are full length. Although wood fibers are shorter than rag fibers, they do fall between groundwood and rag papers in strength and price. They are used to produce the better-quality artist's papers based on wood pulp. Kraft paper, a strong, rough-surfaced paper, is an example of a strong chemical wood paper.

Chemical wood papers do not deteriorate for ten years or more. If any residues of the processing chemicals and other impurities were not completely removed before the paper was made, they will finally begin to yellow and embrittle it.

These papers include many artist's drawing papers, tracing papers, bond, layout, some of the watercolor papers, illustration boards, and mounting and matting boards. Chemical wood papers are acceptable for commercial uses where the art will be reproduced and the original work is no longer necessary. However, unless the paper is manufactured with great care to assure that it is lignin-free, washed free of chemical residues, and buffered, it should not be considered of equal lasting quality to good rag papers.

The more expensive of the chemically treated, lignin-free buffered pulps are often mixed with cotton fibers. This pulp is also used to make museum board for archival storage and framing. The mixture should contain more than 50 percent cotton to be considered for fine art.

RAG PAPER

The term "rag paper" is a holdover from the time when the source of fibers for these papers was a pulp made from beating rags of cloth. The fibers for rag papers are cotton and linen rather than wood pulp. Today most rag papers are made from fibers picked from the cotton plant itself, or from cuttings off of newly woven textiles, rather than from pieces of scrap clothing.

Raw cotton and linen fibers are nearly pure cellulose. This means that they require relatively little treatment. Pulps made from clothing scraps must be bleached if the finished paper is to be a pure white rather than a grayish-tan color resulting from a homogenization of fibers blended from fabrics of varying patterns and hues.

The fibers of cotton and linen are much longer than even the unbroken wood fibers obtained through the chemical wood process. This means that rag paper is potentially superior to the other types of paper made in the West *if* it is processed with care. Unfortunately, "rag paper" does not denote artist's quality paper any more than the word "natural" on the label of a food product means high quality. If the rag paper is poorly processed, it will not last much longer than ordinary chemical wood paper. We have to depend on the integrity of those paper mills that have a long tradition of fine papermaking, or the care given by the smaller paper mills that are dedicated to producing superior papers for the artist.

DRAWING PAPERS

Some of the terms used for drawing papers are the same as those used to specify watercolor papers, but they actually have different meanings. For drawing papers and illustration boards, "hot-pressed" is interchangeable with "plate" or "smooth," but, rather than the fine-toothed vellumlike surface of hot-pressed watercolor paper, hot-pressed drawing paper has an extremely smooth, almost toothless, glasslike finish.

"Cold-pressed" is the same as "medium surface," "kid," "vellum," or "regular," and it covers a variety of surfaces from a smooth, fine tooth to a rather small-grained granular surface.

"Rough" may be a laid surface or a finish of irregular hills and valleys or a mechanically patterned, embossed surface texture.

Most printmaking papers can be used as drawing papers, but their soft surfaces are less resistant to the abrasion of an eraser because they are made with little or no size. This can detract from the working quality of the paper if your technique requires a very subtle control of the medium. Also, hard drawing materials such as a pencil point can emboss lines into the paper that remain a disfigurement or "ghost" of redrawn elements even after the graphite lines have been erased. Water-based inks also have a tendency to soften or spread slightly on an unsized paper surface.

Among the drawing papers, charcoal and pastel papers may present the least inviting surfaces for pen and ink work. Other drawing papers span the spectrum of quality and durability from newsprint (described above) to the finest handmade 100 percent rag papers and come in all forms: sheets, pads, and rolls. Rolls are made in a variety of widths and lengths from the standard 10-yard rolls to rolls of 100, 150, and even 250 yards.

EXAMPLES OF DRAWING PAPERS
* *A/N/W drawing and framing paper* is 100 percent rag, machine-made with no deckles. It has neutral pH and is buffered. Sheets are available in white; rolls are available in white and cream.
* *Arches cover black* is the most lightfast of black papers because Arches has included some carbon pigment with the dyes. This also makes the paper more absorbent than other cover papers, so it should be additionally sized before being used with pen and ink. Arches cover is also available in white and buff. This paper is hand-inspected.

- *Basingwerk heavyweight* is machine-made in England from sulphite and esparto pulp—a soft grass from Africa that produces a very smooth surface especially good for calligraphy and ink drawing. The paper has no deckles and is available in cream, in 155 gm/m².

BEMBOKA AUSTRALIAN HANDMADE PAPER, OATMEAL, 140 LB. (300 GM/M²).

- *Bemboka Australian Handmade* is an exotic cold-pressed paper made using only 100 percent Australian cotton fiber. It is an archival-quality cold-pressed paper with sufficient sizing for all water media, and thus it is popular for watercolor. Its surface is also suitable for pen and ink. It is available in white and oatmeal, 300 and 600 gm/m², in sheets and blocks.
- *Fabriano Ingres cover* is 125 gm/m². Often used for pastel, it is also good for book text and cover paper, or for charcoal drawing. This paper is available in 19 colors including gray and black.
- *Fabriano Classico* is a 50 percent rag, neutral pH, moldmade paper popular for drawing and watercolor. It is available in 72 lb. cold-pressed and hot-pressed, 90 lb. cold-pressed and hot-pressed, 140 lb. cold-pressed and hot-pressed, 270 lb. cold-pressed and hot-pressed, and 300 lb. rough and hot-pressed. It has two deckles.
- *Fabriano Perusia* comes in 100 gm/m² "not" and 100 gm/m² hot-pressed.

FABRIANO CLASSICO AND ROSAPINO PAPERS. From top to bottom: Classico 300 gm/m², cold-pressed. Classico 350 gm/m², hot-pressed. Fabriano black, 125 gm/m². Rosapina cream, 220 gm/m². Rosapina white, 220 gm/m².

- *Fabriano Tiepolo* is a moldmade, watermarked white drawing paper with a neutral pH. It is 100 percent rag and cold-pressed with four deckles.
- *Gallery 100* is a very smooth, heavily sized drawing paper well suited for pen and ink. It is 100 percent rag with a neutral pH and weighs 250 gm/m². This paper is available in vellum surface with slightly more tooth and in plate. It is a domestic paper and is particularly receptive to ink.
- *Magnani Corona R* is a 100 percent rag, moldmade paper with a vellum finish, similar to Arches cover. It is 300 gm/m² with four deckled edges. It is an excellent surface for drawing.
- *Ragston* is a 50 percent rag, cold-pressed, neutral pH paper weighing 125 gm/m². The sheets come in two sizes: 20 × 26" (51 × 66 cm), with two deckles, and 26 × 40" (66 × 102 cm), with 4 deckles.
- *Soho extra heavyweight drawing* is 100 percent rag, neutral pH, 255 gm/m². It is ideal for drawing.

STRATHMORE PAPERS. From top to bottom: Imperial 140 lb. hot-pressed. Gemini 140 lb. hot-pressed. Strathmore 400. Aquarius II. Excalibur.

T. H. SAUNDERS CREAM LAID PAPER (INVERESK).

- *Strathmore 400 drawing paper* is 100 lb., nonrag but acid-free. It is excellent for all drawing media.
- *Strathmore Gemini* has a neutral pH. It is 100 percent rag and is available in 140 lb. to 300 lb. weights, in hot-pressed, cold-pressed, and rough.
- *T. H. Saunders cream laid* has a smooth, hot-pressed surface. This 100 percent rag, neutral pH paper is moldmade in England by Inveresk. It has no watermark, no deckles, and is an excellent surface for pen drawing.

- *Turner Grey* is a 100 percent rag, neutral pH, 72 lb., wove sheet with a cold-pressed surface and four deckles. It is suitable for all techniques.
- *Twinrocker papers* are handmade, 100 percent rag, neutral pH, and tub-sized with animal gelatin. They come in white and a variety of colors. They have four deckles and are manufactured as fine art papers. Drawing on them is an experience all its own.

BRISTOL BOARD

Bristol board is a strong, multipurpose drawing paper made with a heavy sizing and then polished. Bristol finishes are plate and medium (also listed as kid and vellum).

Plate bristol board is ideal for pen drawing as the surface is so smooth that it offers no resistance to the free flow of a pen nib in any direction. It will take a wash well and is suitable for extremely fine detail work.

Vellum-finish bristol board (medium or kid finish) is still smooth enough to be a good choice for pen work while having enough tooth on its surface to accept charcoal, pencil, pastel, and colored pencil, as well as paints. This makes it a paper to consider when planning a drawing in mixed media.

Bristol boards are available in sheets or pads and in different weights or plies. A ply is a single layer of the paper. The heavier weights (two, three, four, or five plies) are made by bonding more sheets together. Single-ply bristol board is translucent enough to allow tracing, but it must be handled with care since it will buckle with only slight moisture. Two-ply bristol board can be used for tracing with a light table, and is the weight most often sold in pad form. The heavier plies are progressively stronger and approximate the feel of thin illustration board. Bristol board is available in 100 percent cotton rag paper. Strathmore 500, an archival-quality bristol board, is a superior pen and ink paper.

STRATHMORE 500 BRISTOL BOARDS. From top to bottom: 2-ply high surface. 3-ply medium surface (kid). 4-ply plate. 3-ply vellum.

Mirage vellum is a bristol-type paper, laminated in two or more plies. It is a 100 percent rag, neutral pH, buffered paper machine-made by Rising Paper Co. It is available in vellum and plate. Both are good for fine detail drawing and are popular with artists.

Strathmore 235 is another example of a good 100 percent cotton bristol board. It is available in high surface, medium surface (kid), plate, and vellum.

BOND AND GRAPHICS PAPERS

Bond and graphics papers are two grades of commercially made drawing paper. Bond papers come in two finishes: ledger and layout bond. They are both thin enough to be translucent, which makes them suitable for tracing, but they are much whiter than tracing paper, which makes them excellent drawing papers for reproduction.

Layout bond is about half the weight of ledger bond, which is more opaque. Both of these papers are strong and can be used with a variety of wet and dry materials. Ledger bond has a smoother, more platelike surface. Layout bond (or simply, layout paper) has a vellumlike tooth. Some bonds are specially sized for use with permanent markers, which will bleed through most papers, often ruining the adjoining sheets in a pad or storage bin and fading in chromatic intensity.

Bond papers made with pure rag are truly fine surfaces for drawing and are sold as graphics paper. These are made for graphic artists and illustrators and are also sold as marker paper. All these papers are sold as suitable for working with markers, but some are specially treated for this use. Although they are 100 percent rag paper, they are not produced with the care that is necessary to assure archival quality.

WATERCOLOR PAPERS

Arches, Arjomari, Canson and Montgolfier, Dieu Donne, Duchene, Fabriano, J. Barcham Green, H.M.P., Indian Village, Moulin du Verger, R.W.S., T. H. Saunders, Schoellerhammer, Strathmore, Twinrocker, and J. Whatman are among the makers of the finest papers available. Many of their papers are excellent choices for artists working in pen and ink. All watercolor papers are suitable for brush drawing, and many have a hard enough surface to be superb as a paper for pen drawing also.

The best watercolor papers are pure rag—usually cotton. A few papers are made from pure linen fibers or a mixture of cotton and linen,

while less expensive papers have chemically treated wood pulp added.

A screen of fine wire, cloth, or synthetic mesh that has the same number of closely woven strands per inch in each direction makes a paper sheet that has a smooth, even surface. This surface is designated "wove" or "irregular." After the matted felt of fibers has been removed from the screen, it is given a finish or surface texture by pressing the still wet sheet against a felt blotter that has one of several different textures. The textured blotter embosses its surface texture into the even formation of the wove surface.

By tradition, the three finishes used most often to make watercolor papers are "hot-pressed" (a smooth, vellumlike surface), "cold-pressed," also known as "not" (a medium surface of irregular hills and valleys), and "rough" (a highly irregular surface favored for traditional aquarelle technique). This last category of paper surface can, like hot- and cold-pressed papers, be used for ink washes as well as for regular watercolor painting, but the more pronounced surface texture demands an energetic, confident brush technique in order to be used to full advantage. Hot- and cold-pressed papers are far more receptive to a manner of working that may include carefully controlled washes or detailed line work with fine brush or even pen.

Hard-sized (alum-gelatin sizing) watercolor papers such as Arches Aquarelle absorb the water in the medium slowly, keeping the pigments on the surface. This not only means that the color retains a greater chromatic strength or brilliance, but it facilitates reworking the color by rewetting it.

Hard sizing also withstands erasing better and is superior to a softer-sized paper surface for most drawing techniques. Hard-sized hot-pressed watercolor papers are excellent for pen and ink drawing, mixed ink and paint drawing, or techniques that require careful graphite or colored pencil rendering with the pen work. Many cold-pressed or "not" papers also make interesting pen drawing surfaces, especially if hard-sized. Over the years I have found that I enjoy using good-quality hot- and cold-pressed watercolor blocks as much as I like using a sketchbook. They are as good for pen and ink drawing and sketching as for watercolor. I like having the option of working over or into a pen or pencil drawing with an ink or watercolor wash without having to contend with a paper that immediately begins to stretch and buckle.

EXAMPLES OF WATERCOLOR PAPERS

- *Arjomari*, manufacturer of Arches papers, is widely regarded as one of the world's finest paper manufacturers. The watercolor papers have a hard surface that is wonderful for ink as well as watercolor.

ARCHES PAPERS. From left to right: Archette. Arches text wove. Arches Aquarelle 90 lb. hot-pressed. Arches Aquarelle 140 lb. cold-pressed. Arches cover black. Arches cover white. Arches cover buff. Arches 140 lb. hot-pressed. Arches 88 silkscreen, 350 gm/m². Arches 400 lb. cold-pressed.

- *Arches Archette watercolor paper* is moldmade by Arjomari in France, the maker of Arches and Rives. This 126 lb. cold-pressed paper is 25 percent rag with internal sizing and a neutral pH.
- *Arches Aquarelle paper* comes in sheets, rolls, and watercolor blocks. This 100 percent rag, neutral pH paper is moldmade, tub-sized, watermarked, chop-marked, and hand-inspected by Arjomari in France. The hot-pressed is suitable for fine pen work and hard pencil drawing, and it is available in blocks or sheets. Hot-pressed sheets range from 90 lb. to 328 lb., while cold-pressed and rough sheets range from 90 lb. to 1114 lb. Rolls of cold-pressed paper range from 140 lb. to 260 lbs.
- *Fabriano Artistico* is a 100 percent rag, neutral pH, moldmade watercolor paper available in 90 lb., 140 lb., and 300 lb. weights in cold-pressed and hot-pressed textures. The cold-pressed is smoother and slightly softer than Arches.
- *T. H. Saunders Waterford* watercolor paper is 100 percent rag with neutral pH. It is watermarked, has four deckles, and is available in sheets from 72 lb. to 1090 lb., or in rolls. The 72 lb. comes only in hot-pressed, and the 1090 lb. comes only in cold-pressed, but most other weights are available in hot-pressed, cold-pressed, and rough.
- *Strathmore Aquarius II* is a machine-made paper that contains cotton with a blend of synthetic fibers. Resistant to buckling when wet, it does not require prestretching. It has a neutral pH and no deckles.

T. H. SAUNDERS 140 LB. HOT-PRESSED WATERCOLOR PAPER.

- *Strathmore Excalibur* 80 lb. rough is machine-made from sulfite and fiberglass. This paper has a neutral pH and remains flat when wet.
- *Strathmore Imperial 500 series watercolor paper* has a neutral pH. It is 100 percent cotton and internally sized. It weighs 140 lb. (300 gm/m²) and is available in hot-pressed, cold-pressed, and rough.
- *Twinrocker Feather Deckle handmade watercolor paper* is 400 gm/m², 100 percent rag, neutral pH, tub-sized in gelatin, and loft-dried to cure. This paper has the most exaggerated deckle of any handmade paper. It is available in cold-pressed and rough rectangular sheets, and also in a circle 18 inches (46 cm) in diameter with the feather deckle.

 Twinrocker makes a wide selection of handmade papers in both wove and laid surfaces, and many are available either with or without gelatin sizing. Most of these papers are made in a single weight, such as 200 gm/m², but in a variety of dimensions. Twinrocker's list of watercolor papers is not always available, and new ones are added from time to time. Contact a fine paper dealer such as New York Central Art Supply for information about Twinrocker papers that are currently in supply.

- *Westport smooth archival student watercolor paper* is a slightly textured, neutral pH paper that resists buckling. It weighs 320 gm/m² and is available from Daniel Smith.
- *J. Whatman watercolor paper* is a moldmade, 100 percent rag, neutral pH, white paper with four deckles. It is strong and comes in three weights: 90 lb. (185 gm/m²), available in HP, CP, and R; 140 lb. (290 gm/m²), available in HP, CP, and R; and 200 lb. (400 gm/m²), available in CP and R.

SIZING YOUR OWN PAPER

Any paper can be given a gelatin size on the surface to make it less absorbent and more receptive to an ink line or wash. Fine papers that have been gelatin-sized are much more expensive than the same paper with only internal sizing or waterleaf papers with no sizing. It is simple to size your own papers.

Animal gelatin can be bought at art supply stores in the form of imported leaf gelatin. It is packaged in thin sheets (or leaves) that are 3 × 9" (8 × 23 cm). Soak one and a half leaves in a pint of water for about 15 minutes or until the gelatin swells to about three times the thickness it was when dry. Then warm it in a double boiler until it dissolves. Add enough water to make one gallon, and mix thoroughly to disperse the gelatin evenly.

An alternative can be found in any grocery store. Knox unflavored gelatin is sold in boxes containing one ounce of powdered gelatin divided into four ¼-ounce envelopes. Ralph Mayer in *The Artist's Handbook of Materials and Techniques, 4th Ed.* (New York: Viking, 1981) recommends a weak gelatin solution of one-quarter ounce or less to a gallon of water for sizing waterleaf papers or resizing papers that have lost their sizing from being soaked in water too long. This is for traditional watercolor technique.

To make a slightly harder surface that is receptive to pen line, a more concentrated size seems to work better. Heat 5 or 6 cups of water in a pan. When the water comes to a boil, remove it from the heat. Add one packet (¼-ounce) of the powdered gelatin to the water and stir. When the powder has dissolved completely in the water, allow the mixture to cool. It can then be applied to the paper by immersion, by painting it on with a large brush, or by spraying it on with an airbrush.

If you are not sizing the paper by immersion, spray or paint both its surfaces. To prevent buckling, the paper can be stretched by gluing or tacking all four corners to a flat board such as plywood or compressed wood with a paper tape coated with a water-soluble glue such as brown butcher's tape until the paper has dried. Do not use a self-adhesive tape because it will not adhere to the damp paper.

To tub-size the paper, soak it in a tray large enough to hold the sheet flat. A darkroom tray or large butcher tray will do nicely. A waterleaf paper should be soaked for several hours, but a brief immersion will do for a paper that is already internally sized. After soaking, remove it very carefullly so that it does not pull apart, and blot the paper gently. It can then be hung on a clothesline or spread on a sheet of glass to dry.

WATERCOLOR BOARDS

Watercolor boards are illustration boards surfaced with rag watercolor paper. They are superior illustration boards, and many come in hot-pressed, cold-pressed, and rough. These boards are not archival quality unless the board backing is 100 percent rag or the manufacturer states that the material is neutral pH.

EXAMPLES OF WATERCOLOR BOARDS

- *Arches watercolor board*, made by Arjomari, has the same 100 percent rag, 140 lb. moldmade paper that is sold by the sheet. It is tub-sized with animal gelatin and is a very workable surface mounted on heavy illustration board. It is available in HP, CP, and R.
- *Crescent watercolor board* is made by laminating a high rag-content watercolor paper to a heavy acid-free backing board. It is available in HP, CP, and R.
- *Schoellerhammer board*, made in Germany, is a rag illustration board available in HP and CP, and in heavyweight and extra heavy.
- *Whatman watercolor board* has a 100 percent rag Whatman watercolor paper hand-mounted to buffered, neutral pH 3-ply boards that are cross-laminated for stability and permanence. This board is available in HP, CP, and R.

ILLUSTRATION BOARDS

Illustration boards are marketed in both nonarchival (groundwood) and archival quality (100 percent rag) and a potentially misleading combination form that is a combination of the two. Illustration boards are either drawing or watercolor papers supported by a rigid board backing that serve to keep the paper flat while you are working on it and afterward when the art is to be photographed for reproduction.

With the exception of the 100 percent cotton neutral pH boards such as the Strathmore 500 series, illustration boards should be limited to use by illustrators and designers and not considered for permanent art purposes.

Illustration boards are manufactured in forms that are suitable for all media, depending on the surface of the board. The surfaces may be smooth (called hot-pressed, which is a plate finish) or cold-pressed (a medium surface). Some boards are imprinted with a canvaslike texture for use with acrylic paints. Most illustration boards are faced with a very thin paper, the weight being made up by the thickness of the backing board. This means that many of them do not hold up under heavy reworking or erasing. The Strathmore 500 surface is more durable than most and takes the same type of abuse as a bristol board.

The primary advantage of all illustration boards over regular papers is that they do not have to be stretched before working with wet media in order to prevent buckling. The disadvantage for illustrators is the lack of flexibility for color reproduction processes that use curved laser scanner drums. A new generation of flatbed scanners and video digital cameras may eliminate this problem, but for now the illustrator must ascertain in advance the client's printing needs and choose a drawing support accordingly.

If you plan to combine an ink drawing with acrylic paints, a heavier-weight illustration board (three or four plies) with a matte finish (cold-pressed) will allow for better and more uniform paint adhesion. Also, erasures are less noticeable on a cold-pressed or medium surface than on a smooth (plate or hot-pressed) one.

ILLUSTRATION BOARDS. Left, top to bottom: Arches boards (hot-pressed, cold-pressed, and rough). Right, top to bottom: Crescent boards (hot-pressed, cold-pressed, and rough).

EXAMPLES OF ILLUSTRATION BOARDS

- *Bainbridge illustration board* has a high-quality surface excellent for illustration. It is available in white HP and CP in single and double thickness, in ebony black on white in single thick, premium black on black single thick, and white rough in single thick.
- *Crescent illustration board* is available in a range of styles and surfaces such as 28-ply; double-thick, CP; and Line Kote.
- *Letramax illustration board*, made by Letraset, is available in Studio and in Premium clay-coated. It is single-thick.
- *Strathmore 500 series illustration board* is a 100 percent rag, white-on-white illustration board available in regular (kid) and high (HP) surfaces. It comes in lightweight (regular surface) and heavyweight (regular surface and high surface).

MUSEUM, MAT, AND CONSERVATION BOARDS

Although originally produced for framing or mounting and matting purposes, museum and mat boards are now used by some artists as working surfaces. Museum boards and mat boards of 100 percent rag—as well as conservation boards, which are made from purified cellulose pulp with the lignin removed—can be substitutes for cold-pressed illustration board with many drawing techniques. Their best features are that they are available in larger sizes than illustration board and in more colors.

It is easy to find museum board measuring 40 × 60" (102 × 152 cm), and museum board measuring 48 × 84" (122 × 213 cm) can now be purchased through suppliers in many cities. Museum and mat boards are also produced in a variety of colors, including black. Crescent Cardboard Company is currently making a rag mat board in 28 colors and plans to expand this number. The surfaces are softer than the drawing or watercolor paper faces found on illustration boards, so they may be less resistant to erasure and more absorbent than the surface of illustration board. Some artists control this by spraying the surface with a size such as methylcellulose or Myston before beginning a drawing.

The Bainbridge Company produces a very high-quality conservation board called Alphamat. It comes in 60 colors, which are pigmented to protect them from fading. Andrews Nelson & Whitehead makes a conservation board called pHase 7. Other high-quality conservation boards are Process Materials Corp.'s Archivart conservation board and Rising Paper Co.'s Conservamat. These are all heavyweight boards, and most are widely available in a standard 32 × 40" (81 × 102 cm) size.

BINDER'S BOARD

Binder's board is a board made for hardcover bookbinding. Supreme rag binder's board is an extremely tough archival binder's board of partial denim and cotton rag content. It is resistant to cracking and has an excellent surface for painting and drawing.

CALLIGRAPHY PAPERS

While there is no such official category for paper, many papers are used for calligraphy. Papers used for calligraphy must have a hard, smooth surface receptive to pen and ink. Hot-pressed watercolor papers work well, as do genuine and imitation parchments. Specific examples include Arches

Aquarelle HP, text laid, and text wove; Basingwerk; Bodleian Repairing Vintage; Coventry rag smooth; Crane's Crest and parchment; Dieu Donne linen; Dresden Ingres; Gampi Torinoko; Guarro Satinado; Invicta, J. B. Green Bodleian and Canterbury HP; Lana Ingres, laid, Royal wove, and Superior laid; Parole by Schoellerhammer; Richard de Bas Canton laid, Rives lightweight and Opale; Strathmore bristol; Twinrocker papers; Whatman Vintage; and Wookey Hole Vintage.

BODLEIAN REPAIRING VINTAGE LAID PAPER (J. B. GREEN).

LANA INGRES COLORED LAID PAPERS.

PRINTMAKING PAPERS

Some papers, known as waterleaf papers, are made from pure unsized fibers. These sheets are highly absorbent. Many printmaking papers are waterleaf. For ink drawing, waterleaf papers are of somewhat limited use because of their blotterlike absorbency. Although they can be used for dry drawing media such as charcoal, pencil, or pastel, they must be considered too absorbent for traditional Western wet drawing techniques such as pen and ink or watercolor.

The surfaces of most waterleaf papers are especially unsuitable for pen drawing because the fibers are too loosely bound and will be easily lifted or snagged by a sharp metal nib. Capillary action, the tendency of a liquid in contact with a solid to flow along the surface of that solid, will cause the lines to bleed outward. The loose fibers will also clog or form a wider mass on the tip of the nib,

which will cause an increase in line width with a corresponding loss of sharpness in a drawing.

If you are thinking of using print papers for a drawing surface, bear in mind that these papers are less durable and softer-surfaced because they have little or no sizing. For this reason they will not hold up well with erasing, and most emboss too easily under hard drawing materials. The ink techniques most suitable would be line drawing with a small brush or reed or bamboo pen, none of which have a hard, fine point.

EXAMPLES OF PRINTMAKING PAPERS

- *American Etching* is a heavyweight, off-white, cold-pressed printmaking paper. It is 100 percent rag and machine-made with a neutral pH and a weight of 360 gm/m². Its durable surface makes it a good drawing sheet.
- *Arches 88 silkscreen paper* has a surface texture similar to Magnani Incisioni, and it comes in cream or pale blue. Arches 88 comes in 300 and 350 gm/m² and is available in sheets or rolls. It is 100 percent rag, hot-pressed, and unsized, with a neutral pH.
- *Fabriano Rosapino* is 220 gm/m², neutral pH, and 40 percent rag. It is a superb paper for pencil drawing. Because it is a waterleaf paper, it is best suited for brush drawing rather than pen drawing, unless sized with gelatin or sprayed with Myston.
- *Magnani Incisioni* is a 100 percent rag, neutral pH, moldmade paper available in cream, blue, and white. This paper is waterleaf and must be sized for any ink drawing other than with a brush.
- *Rives* 100 percent rag, neutral pH papers are moldmade by Arjomari in France. BFK White is 250 gm/m²; this is the standard BFK. It has a rather soft surface and is available in rolls of 42" × 10, 20, or 100 yards (107 cm × 9.1 m, 18.3 m, or 91.4 m). Other BFK papers include BFK Tan, BFK Newsprint Gray, and BFK Buff; BFK Tan and Gray are available in

RIVES PAPERS. From top to bottom: BFK Tan. BFK Newsprint Gray. Lightweight White. BFK Buff. Papier de Lin. Standard White.

STONEHENGE PAPERS. From left to right: Regular weight in fawn, natural, gray, warm white, white, cream. Heavy white.

280 gm/m² pigment-colored papers. There is also Lightweight White, which weighs 115 gm/m²; and BFK Heavyweight White and Buff, which are more heavily sized than the standard BFK papers. All these papers are available in sheets measuring 30 × 40" (76 × 102 cm) with four deckle edges, or 22 × 30" (56 × 76 cm) with three deckle edges.

Rives also manufactures Papier de Lin, a white, textured paper moldmade from 25 percent linen and 75 percent cotton rag. This paper is sometimes used for watercolor because of its natural sizing. It has a neutral pH and four deckles, and weighs 270 gm/m².

- *Stonehenge heavyweight* is a printmaking paper weighing 320 gm/m² and widely used for drawing. Its texture is a bit softer than regular Stonehenge. The regular weight (245 gm/m²) comes in cream, white, warm white, pearl gray, natural, and fawn. All these Stonehenge papers are made in the United States by Rising Paper Co. They are 100 percent rag, heavily sized, neutral pH papers. White and natural are also available in rolls of 50" × 20 yards (127 cm × 18.3 m) or 50" × 150 yards (127 cm × 137.2 m) in the 250 gm/m² weight, or 50" × 140 yards (127 cm × 128.0 m) in the 320 gm/m² weight.

COVER PAPERS

Cover papers are medium-weight papers. They come in a wide variety of whites, off-whites, buffs, and many colors. They are produced for use by the printing industry, to make covers for magazines, booklets, and so on. Only a limited few of these cover papers should be considered for fine art drawing. Choose papers produced by the best mills using 100 percent rag with a neutral pH, such as Arches cover, Canterbury handmade cover, or Lana cover (Velin de Lana).

Arches cover white and cover buff are cold-pressed, 100 percent rag papers with neutral pH.

They are moldmade and hand-inspected. Lana Speckletone is a decorative paper used for book covers and endpapers, but it is also suitable for drawing.

TEXT AND STATIONERY PAPERS

Text papers are also excellent pen and ink papers. They are often chain-laid or wove papers that are strong, hard-surfaced, and bleed-resistant. The best of them are made for fine book printing and are pure rag papers with good lightfastness and durability.

Laid papers are made with a screen woven with closely spaced parallel or laid strands running the long dimension of the paper sheet. The wires that are woven into these strands at right angles are spaced at even intervals ranging from approximately 3/4 inch to as much as 2 inches. These wide-spaced wires, called "chains," give the sheet a finish of parallel columns of stacked narrow lines. This can be seen most clearly when the paper is viewed against a light source.

Although this finish may be found in watercolor papers, it is more popular in drawing or calligraphy papers, and stationery (which makes an excellent paper for small pen drawings—if you select high-quality 100 percent rag writing paper).

Wove papers are made with a screen having the same number of wires in each direction, like a window screen. This gives a uniform surface texture.

EXAMPLES OF TEXT AND STATIONERY PAPERS

- *Arches text laid* is a 100 percent rag, moldmade paper with neutral pH, available in white or cream. It has four deckles.
- *Arches text wove* is also 100 percent rag, with a neutral pH and four deckles. It is available in white only.
- *Bodleian Repairing Vintage laid* is an interesting paper made by J. Barcham Green at Hayle Mill in England, originally for use of the Bodleian Library. It is meant for book binding and restoration, but its smooth laid surface is also excellent for calligraphy and for pen and ink drawing. It is moldmade from 100 percent rag and has a neutral pH.
- *British Handmade R* and *laid white* are two neutral pH, 100 percent rag text papers made before 1972 by Hodgkinson & Co. at Wookey Hole Mill, England. These papers are superb surfaces for pen drawing. Because of their age (some date back to 1910), some of these papers have slight blemishes that add interest in fine

HODGKINSON & CO. BRITISH HANDMADE LAID WHITE PAPER.

art uses, but an illustrator might want to use nonvintage papers, which have perfect sheets.

- *Crane's Crest laid* and *Crest wove* are high-quality text papers. They are 100 percent rag, machine-made, neutral pH papers weighing 48 gm/m², and their erasure qualities are unmatched.
- *Fabriano Roma* is a 100 percent rag, chain-laid handmade paper, lightly sized and weighing 130 gm/m². It can be used as a book or writing paper but is also excellent for drawing, and is available in eight tones: Veronese (medium green), Tiziano (light gray), Romanino (deep blue), Guido Reni (brown), Del Sarto (medium gray), Moretto (deep red), Raffaelo (cream), and Michelangelo (white).
- *Lana Antique laid* is a smooth, white bookbinding and drawing paper weighing 100 gm/m². *Lana Royal wove* has a cold-pressed surface and weighs 125 gm/m². *Lana Superior laid* is a bookbinding and drawing paper that comes in weights of 90 or 115 gm/m². All are 100 percent rag, neutral pH papers. These elegant papers are widely used for printing fine books as well as for writing, calligraphy, and drawing.
- *Richard de Bas Apta* is a heavy chain-laid paper made in France and available in eight colors. The intervals between the chains are approximately 2 inches.
- *Svecia Antiqua* is a chain-laid stationery with a hard surface. It is a wonderful lightweight paper for pen drawing. I use this often.

SVECIA ANTIQUA CHAIN-LAID STATIONERY.

- *Twinrocker handmade stationery* is 100 percent rag, neutral pH, and tub-sized with animal gelatin. These writing papers come in white and a variety of colors. They have four deckles and are manufactured as fine stationery. These papers are excellent for small pen drawings and watercolors. Because of the amount of sizing, these papers do not need to be stretched for watercolor work.

TWINROCKER HANDMADE STATIONERY PAPERS. From left to right: White cotton rag. Berkeley. Buff. Peach.

COATED PAPERS OR COATED STOCK

Coated papers or coated stock are used for printing and graphic arts. They come in a variety of surfaces that include plate finishes, clay coatings to increase their opacity, metallic coatings, colored papers such as Color-aide papers, and many more in a wide variety of colors and finishes. These are not archival.

TRACING PAPER

Tracing paper is a semitransparent paper. It is used in layers for correcting and refining a drawing from the rough through the detailed preliminary. It is also used to make precise transfers and to serve as a protective flap over drawings to keep them clean. The lighter-weight tracing papers are best for this last purpose. Some tracing papers are made from rag fiber, but they are not considered archival unless so guaranteed by the manufacturer.

The nonrag tracing papers are sulfite. Both the rag and nonrag tracing papers are impregnated with either oil or resin to make them transparent. This does adversely affect their aging. Sulfite tracing papers are available in two qualities. The better ones, such as Arches tracing vellum (Frosdite) or Canson Vidalon tracing paper, are much more expensive but are superior papers. Canson Vidalon is transparentized under great pressure and has an extremely durable, hard surface that will even permit ink to be scraped off for reworking a drawing. The rag papers are less transparent than the sulfites and are not as hard-surfaced but do resist moisture better.

The better-grade sulfite papers are used for final drawings. For pen and ink rendering, never use a tracing paper that does not have a slick, smooth surface, or the ink will feather out and the lines will be irregular. Many good-quality tracing papers are made to be receptive to pencil drawing and do not accept the ink well because they are treated to reduce the smudging of graphite. Medium-weight number 84 is a good, but not permanent, tracing paper for use with pencil or pen and ink.

ORIENTAL PAPERS

A few of the best Oriental papers still use traditional methods that have been used for centuries. They contain no sulfite pulp or additives and are acid-free.

Where Western papers use cotton, linen, or wood pulp fibers, most Japanese papers use bast fibers. These fibers are obtained from the inner white bark of young kozo, mitsumata, and gampi trees. The fibers are long and slender and have a thin wall that has let the papermakers create beautiful and durable papers. Bast is much more expensive than cotton or wood pulp. If a paper contains kozo, mitsumata, and gampi fibers mixed with wood fiber, that paper is as permanent as good cotton or linen papers.

Kozo has been used in Japanese papermaking since the eighth century A.D. It is made from the fibers of the mulberry tree. Because it has the longest and strongest fibers, it is used alone to make a strong paper or mixed with mitsumata—a soft, absorbent, shorter fiber. These fibers produce a shinier, crisper paper.

Gampi is the most permanent paper of all. Its long, thin fibers contain a natural insect repellent. They are nonabsorbent, translucent, and lustrous, as well as extremely strong and flexible—in short, permanent. Gampi trees grow slowly and are more difficult to harvest than kozo.

GAMPI TORINOKO PAPERS. Left: cream. Right: white.

Torinoko is a heavy handmade paper that is a mixture of kozo and sulfite. It is good for sumi painting. Gampi Torinoko, which is available in the United States in cream and white, is 100 percent gampi fiber and acid-free. It is extremely strong, naturally resistant to insects and mildew, and has neutral pH. The paper is a waterleaf but with a smooth, pearlescent surface that makes it receptive to calligraphy and ink drawing. It can also be used with oil paint without rotting and is good for mixed media work.

VEGETABLE PARCHMENT.

VELLUM AND PARCHMENT

Vellum was originally a parchment made from treated animal skin. Fetal lamb was generally considered among the best, although chicken skin was and still is used to make parchment for small panels. Real vellum parchment is still available, although it is rarely used. The term "vellum" is now used to designate the commercially made and readily available drawing surface. Both the genuine hide parchment vellum and its commercial replacement are superior surfaces for pen and ink work.

Today commercially made vellum is made by impregnating cellulose fibers with a synthetic resin to give the sheet translucency and embedding finely ground silica particles in the surface to give it a slight tooth, making a more receptive surface for drawing media. Properly made vellum seems to satisfy archival requirements. Cotton supplies the cellulose fibers, and the resins that are used are stable.

There is an additional translucent form of vellum, which is made using a different process. Here the pulp is beaten for a longer time with sulfuric acid to give the finished sheet translucency. Unfortunately, this shortens the fibers, and the presence of sulfuric acid weakens them, making the paper unstable.

Parchment (imitation) is available in Antique, Snowflake, Vegetable, and Vellum surfaces. It is machine-made and has a cloudlike effect to simulate real parchment. It is smooth and has no deckles; it is also translucent and seems almost like a tracing paper.

Crane's artificial parchment is a 100 percent rag, neutral pH, parchmentlike paper of archival quality, weighing 171 gm/m². It is ideally suited for fine pen work and is available in ivory, off-white, blue, gray, and fluorescent white.

SCRATCHBOARD

Scratchboard is one of a small group of coated boards and papers. It is produced by covering posterboard with a layer of white clay. When a layer of ink is applied to the clay coating, it can be scratched or scraped away using a razor blade or one of a series of specially designed scraping blades that are held in an ordinary pen holder. This leaves a crisp white line on the solid black that lets an artist capture the visual quality of a woodcut or engraving. This makes it a valuable tool for certain types of commercial or technical illustration. It is also used in combination with washes or powdered carbon for a highly controlled rendering technique commonly used in technical scientific illustration.

Commercially prepared scratchboards are less widely available in the United States than they once were because of a swing to other styles in popular illustration. Any artist interested in exploring the versatility of this medium should not be deterred. The British Essdee brand scraperboard (the British name for scratchboard) is distributed in the United States by United Process Boards. It comes in white or black surfaces. The white is the color of the clay

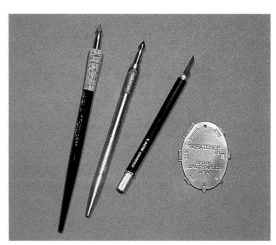

SCRATCHBOARD TOOLS. Left to right: Hunt scratch knife no. 112 in a Koh-I-Noor no. 127N pen holder. Hunt scratch knife no. 113 in an aluminum pen holder. X-Acto no. 16 blade in an X-Acto Gripster. Scratcher, manufactured by Scratch-Art.

A PARTIALLY INKED ESSDEE SCRAPERBOARD (WHITE).

coating. This smooth surface is extremely receptive to pen or brush and ink line. You brush in solid layers of ink only in areas that will have a deeper tonal level, such as heavily shadowed sections. The remaining white surface can be drawn on with pen to make the lighter sections of your image.

The black boards are also coated with white clay, and then covered with a final layer of solid black ink. For most pen and ink drawing purposes, the white scratchboard surface is preferable. The white surface allows you to transfer a detailed drawing from one done on paper if the drawing is to include details that must be worked out in advance. The board can then be worked onto directly with a fine pen such as a crow quill to produce areas of "line" tone. The larger areas of deep tones are covered with a wash of black ink, which is scratched into (only after drying completely) to produce fine white lines, hatches, stipples, and so on.

The smooth British Essdee brand scraperboard is too smooth for using a mixed-medium technique with graphite, charcoal dust, or black and colored pencils. For these more elaborate combinations, they manufacture textured clay coatings. The Essdee 15B medical board (clay coating) has a stipple texture that allows smooth brush shading and yet does show the stipple in the wash areas. Essdee 14B suede (thin clay coating) is smoother but has enough grain to allow the carbon particles to adhere. Both of these boards scratch with a clean, crisp line. The suede surface may be slightly better for most styles of working because the surface texture is not an issue in finely rendered drawings. The Essdee boards claim to be of archival quality.

There are several other scratchboards and coated boards and papers that you may wish to try. Dull-finish stipple boards (Medical Models) have a thick clay coating and give sharp scratched highlights. Line Kote #210 and #220 by Crescent are thinly coated illustration boards that will take carbon dust techniques and can be scratched. You must use care with the Line Kotes to prevent your scraping tool from gouging and lifting the thin surface. When you use any of these coated boards or papers for a technique that combines ink line with carbon dust modeled tones, you will get richer tones and darks if you spray the surface once or twice with alcohol or workable fixative before dusting.

Some of the scratchboards made by British Process Boards (Essdee brand) are imprinted with textures such as parallel lines, crosshatching, or stipple. These textures are not visible until a section that has been coated with ink (either line or area) is scraped lightly and the ink covering is removed from the raised texture, leaving the ink-filled "valleys" black.

The best boards made for technical illustration are intended to last and are considered permanent.

DRAFTING FILMS

There are many kinds of drafting films, most made of cellulose or polyester. Both of these types are made by extruding the material and rolling it into a flat sheet. The significant distinction between them if you are concerned with the longevity of the original work is this: Cellulose acetate requires plasticizers to make it flexible, but polyester films do not. The films are coated to make their slick surfaces receptive to drawing materials, and if used with the proper inks, they make excellent drawing surfaces. They are especially valuable for drawings that require great precision in the rendering technique such as technical, medical, or scientific illustration.

All types of cellulose acetate film become brittle with time and may even stain materials that are in contact with them. Other factors that must be weighed against them are that their surfaces scratch easily, they are permeable to moisture, and they tear easily. These films, like groundwood papers, are susceptible to the damaging effects of sunlight or fluorescent lights.

Polyester may look like cellulose acetate, but it is chemically inert and stable over a long period of time. It will lie flat even unstretched and is resistant to tearing. Mylar, one of the most widely used, is Du Pont's brand of polyester.

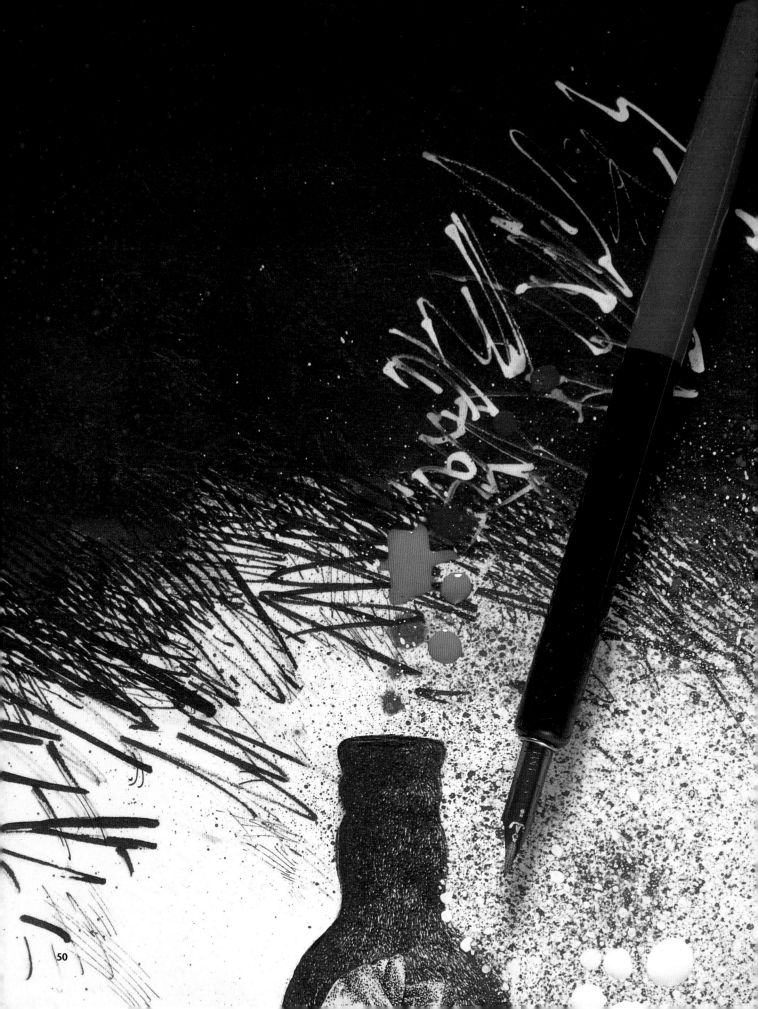

INK DRAWING TECHNIQUES

Anyone in art education has probably heard a teacher of studio classes insist that you never teach technical information about materials or the techniques for handling those materials because it will interfere with creativity. This seems to make sense on the surface. At least it makes sense if your definition of student artists is based on rigidly robotlike models who can only reproduce the information that has been poured into them. Yet no one in his right mind would argue that learning the proper use of a hammer will overly limit the kind of house you will build.

Damning the acquisition of mastery over your materials is based on logic that employs partial rather than wrong definitions. The widespread though naive confusion between art and a high degree of realism was probably an early contributor to the fear of a sound technical training for the artist when the art world began to move away from the academy.

Art is not the ability to reproduce what is in front of you (as though that were possible). Realism just happens to be one context among many in which art has been known to happen.

The chance of attaining something richer than imitation is infinitely greater if you can use your materials well enough to capture any aspect of visual phenomena necessary for the effect you want. In other words, technique isn't a limitation; it's a tool. Like any tool, it is a means to an end. It shouldn't be an end in itself, but neither should it be discarded altogether.

WHAT IS INK DRAWING?

In its purest form, ink drawing is an image on paper made entirely from pure black marks. Unless you introduce wash, almost everything you do when drawing with ink is based on how you use dots and lines. In this section we will review the mechanics of building images with ink.

There are three types of monochromatic drawing: pure line (outline); solid black shapes or patterns; and tonal, which includes the gray scale. Occasionally an artist will combine these, confining the different approaches to specific areas of the drawing for contrast.

Lines can be uniform in thickness, have variable width, or be broken. (A technical pen or a firm nib is best for uniform line work, while a flexible nib or a brush is preferable for lines of variable width.) Each of these types of line can be used in clusters to create visually gray or tonal areas. This is called hatching. The combinations of marks that can be used for hatched tone are unlimited, and the textures that you produce can imitate natural ones or be texture for its own sake.

Dip pens and watercolor brushes work best with pulled strokes. This is true of all metalpoint pens except fountain pens, technical pens, and ballpoint pens. Small marks such as stippling or hatching are done with the hand resting on the paper, but other linework is done best by pulling the pen with a movement of the wrist or the entire arm.

SEATED MODEL
Rotring extra fine ArtPen;
FW nonclogging waterproof india ink;
Sennelier sketchbook page,
9 1/4 × 12" (13 × 30 cm).

This is a pure contour drawing. The line width is relatively uniform because the ArtPen's steel nib has limited flexibility. I outlined the shapes receiving the most light, and relied upon the perceptual phenomenon of closure to form a readable figure. Closure is the viewer's ability to complete fragmentary information into a perceptual whole.

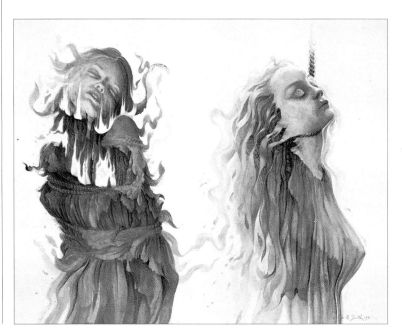

EXECUTED WITCHES
Illustration for *Witches* by Erica Jong, illus. by Jos. A. Smith, Harry N. Abrams, Inc., 1981. Hand-ground sumi ink; watercolor; Winsor & Newton series 7 watercolor rounds; Morilla 140 lb. CP watercolor block, 19 × 22" (48 × 56 cm).

This drawing is made entirely from modeled tonal change. It was done with a series of graded washes (progressively adding more water to the ink as a single layer of wash is put down) and layered washes to achieve a wide range of value levels with subtle intermediate steps.

BASIC PEN TECHNIQUES

Many of the following techniques are applicable to any drawing instrument. Only the visual character of the marks will vary, depending upon the width and flexibility of the pen or brush. These basic techniques are common to virtually all styles and should be mastered by everyone who has an interest in drawing.

You will find in practice that value areas must often be simplified or even changed when working with pen and ink. This is because any close grouping of solid black marks used to form grays also forms a texture that can overpower subtle value changes or fine detail. Pen drawings require a greater simplicity than continuous tone mediums like pencil. A hatched or stippled area has enough visual activity to appear full of detail without including literal, specific detail. This is both a limitation and a strength of pen and ink as a medium.

SOLID BLACK LINES

Solid black lines can be controlled or free and can express quite a variety of moods without using gray tones at all. The drawing should dictate your choice of line.

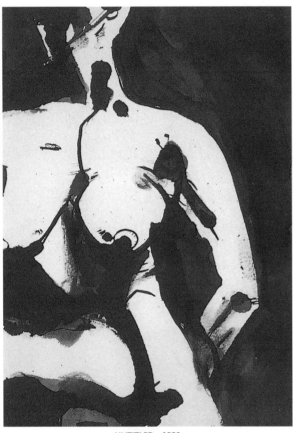

UNTITLED—1990
by Gregory Benton
Pen; brush; finger; Rotring
ArtistColor; Winsor & Newton
watercolor paper,
9 × 6 ½" (23 × 17 cm).

This monochromatic drawing depends primarily on solid areas of black with a minimal use of line. The bold, solid blacks inside and outside of the figure make the white of the paper function as a surface color, not simply as background.

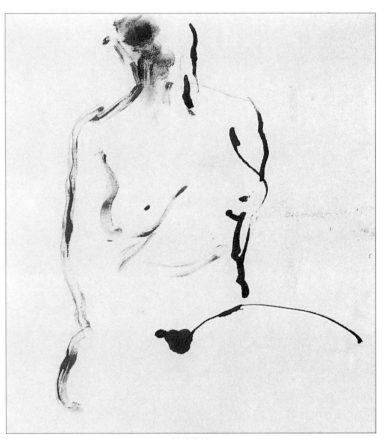

UNTITLED
Index finger; Higgins Black
Magic india ink;
Artistbook sketchbook,
8 × 7" (20 × 18 cm).

Variations in line thickness give a drawing more expressive impact than one using uniform line weight. Here I used my finger as a pen, dipping it directly into a bottle of ink. The density and width of the line changes rapidly: solid, black and heavy when first wetted, changing to a "drybrush" mark. This forces you to work quickly in a kind of shorthand that encourages spontaneity.

GRAY TONES

Grays are made by the visual mixing of grouped marks. The more closely the marks are grouped, the darker the gray will appear. When done with a pen, these grays function as both tones and textures. The nature of the textures is determined by the character of the lines you use and how they interact. For all but highly controlled technical illustration, freer and less rigidly controlled lines give a warmer, more interesting effect in a drawing.

Here are two examples of a flat tone made with a uniformly dense field of a random texture.

GOAT FAMILIAR
Illustration for *Witches* by Erica Jong, illus. by Jos. A. Smith, Harry N. Abrams, Inc., 1981. Staedtler Mars 700 technical pen 2×0, FW nonclogging waterproof india ink, acrylic gesso, HMP Vale handmade paper, 19" (48 cm) diameter.

When enough details fill an area, they create tonal areas without hatching. The goat's beard, neck, and horns are examples of this effect.

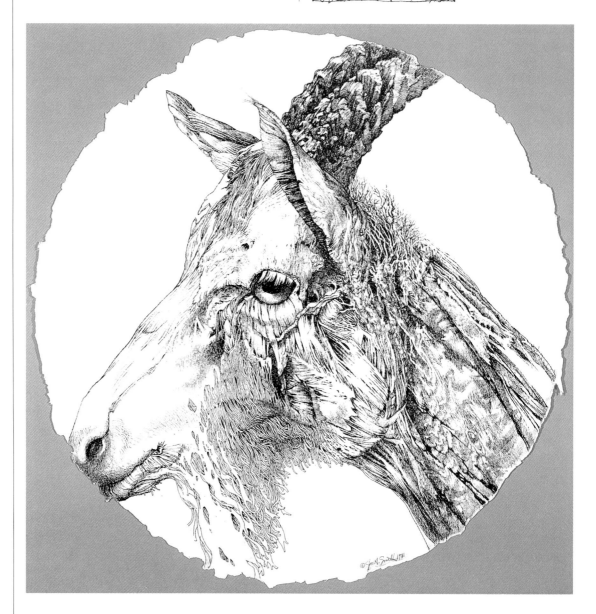

PARALLEL LINES

Parallel lines can be used to make a uniform area of tone that reads as a plane. The lines that form this plane have a directional flow that is independent of the compositional movement resulting from the area's total shape. The direction of the lines or marks that collectively make a shape either reinforces its shape's gestural movement or acts in counterpoint to it. This has the effect of modifying or strengthening the power of a shape to move the viewer's eye across a composition.

Freehand flat tone: parallel strokes drawn with uniform pressure.

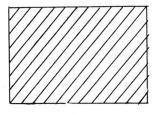

Controlled flat tone: parallel strokes drawn with a technical pen. These lines were drawn using a ruler.

When a shape is formed from an area of tone, the direction of the marks will influence our perception of the movement imparted by the long axis of that shape. Hatching that parallels the long axis reinforces our sense of the shape's movement. Hatching at right angles to it slows the movement of our eye as it follows the shape.

VALUE CHANGES

If the spacing between the lines is uniform, the area of gray created will be an even value. When this is done, changes of value are made by increasing or decreasing the line intervals from area to area. If two different uniform grays are adjacent to each other but must remain separate flat tones, the intervals that separate the lines in each tone must be clearly different. If the spacings are too similar, any change of value will be too slight. The drawing will lack structure and readability.

A graded tonal change can be made from sequentially decreasing or increasing the distance between lines of uniform thickness.

A graded tonal change can also be made by varying the thickness of the lines.

A drawing will lack structure if the separation of intervals between its value levels is not sufficient.

BASIC PEN TECHNIQUES

HATCHING

Hatching is a method of filling an area with parallel strokes. Hatched strokes can extend from one edge of the area being filled to the other, or the hatching can be made up of shorter broken lines. In practice, hatching is more often done with broken lines (shorter than the distance from one edge to the other of the area to be covered). A drawing that is hatched entirely with continuous lines has a very deliberate feeling. The artist must work more slowly, using greater care in order to make each line extend from border to border across the shape being hatched.

The top version contains more visual information because of the number of breaks in a given line. Even without recognizable subject reference, this drawing would have a smaller surface scale than the middle or bottom examples.

Hatching does not have to use simple lines. These flamelike shapes follow parallel linear diagonals, but beyond that they freely vary.

A hatched tone can suggest flat or curved surfaces. If the marks in an area are parallel straight lines, or a uniform, squiggly, wandering line that has no dominant collective directional movement, the surface appears to be a flat plane.

When the marks collectively follow a curve, the surface of the plane will appear to be curved. This effect is strengthened by deepening the gray value as the surface seems to curve. This is done by increasing the line thickness or by adding lines to reduce the white space between the marks.

Graded change can be used to suggest a change in the intensity of light falling on a surface, shadow, or local color change on an object.

Parallel straight lines suggest a flat plane.

A line that wanders randomly can also suggest a flat plane if it fills the area with an even tone.

Parallel curved lines create the appearance of a curved surface.

A value change will strengthen the sense of a curved surface by suggesting a change from light to shadow. This can be done by decreasing the space between the marks or by increasing the thickness of the lines as they follow the curve.

Graded changes between adjoining areas can suggest light and shadow on the surfaces of a volume.

If the values change dramatically within the area of a single plane or shape, it can suggest a change of color on that surface.

FREUD
Hawk-quill pen; Pelikan
drawing ink, Bainbridge
board no. 80,
18 × 13 ½" (46 × 34 cm).

The hatching in this drawing is composed of strokes with little variation in length. The flexibility of the nib has allowed for some variation in the thickness of the marks (the strokes are heavier in the darks around the eyes), but the lights and darks within the gray areas are primarily a result of increasing or decreasing the amount of white board that shows between the marks. The values in this drawing indicate color change; they also model the forms of his features.

BASIC PEN TECHNIQUES

CROSS-HATCHING

Cross-hatching is formed by superimposing one layer of hatching over another. These layers of hatching must have different directional orientations. If the top layer is too closely aligned with the underlying one, even minute variations in direction or spacing will cause irregular filling in of the white spaces that separate the marks. This makes a blotchy, mottled tone. If the overlaid hatching is at right angles to the one beneath, the result is a flat tone that tends to have a more transparent quality. Cross-hatching at right angles has a much more mechanical feel to it even when drawn freehand. The effect is like laying a piece of window screen on the paper.

Cross-hatching made from curved strokes that meet at an angle of less than 90 degrees will lie convincingly on the surface of a curved form.

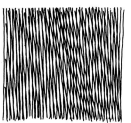

If the second layer of hatching changes direction from the layer underneath only slightly, it will form a moiré pattern. This can be decorative, like the surface of watered silk, but it will be visually disruptive if you want a uniform tone.

When the second layer of cross-hatching marks intersects the underlying marks at a greater acute angle, the surface will be uniform. This can be used to make planes that are seen as parallel to the picture plane or tilted at angles to it.

When the cross-hatched lines meet at a 90-degree angle, the plane will appear flat and transparent, like a piece of window screen.

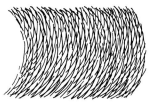

Cross-hatching done with curved lines can be used to describe a curved surface.

The flatness of a plane formed by hatching at right angles can strengthen the suggestion of a curved surface through contrast. Notice also how the background hatching appears more transparent, while the curved hatching appears to be solid.

TIME TO RE-TIRE?
Koh-I-Noor Rapidograph technical pen 1×0;
Higgins Black Magic drawing ink; medium-surface
Art-tec board, 28 × 22" (71 × 56 cm).

This takeoff on the old Fisk Tire ad was done during the Watergate trials. The tire inner tube, the Dr. Denton pajamas, and the rounded details in Nixon's face are all examples of cross-hatching that does not intersect at right angles. It progressively changes direction to describe the flow of the curved surfaces.

AND THERE WAS SMAUG
Staedtler Mars 700
3×0, 2×0, 1×0; FW
nonclogging waterproof
india ink; Morilla 140 lb. R
watercolor block,
14 × 20" (36 × 51 cm).

There are two forms of cross-hatching employed in this drawing. The flat surfaces of the hydrant are done with straight lines, while the curved surfaces are done with curved cross-hatches to strengthen the difference. The curved surfaces on the boy have been done with hatching rather than cross-hatching to keep them softer and simpler.

NIGHTBIRD
Koh-I-Noor Rapidograph
technical pen 1×0;
FW nonclogging waterproof
india ink; acrylic gesso;
HMP Vale handmade paper,
19" (48 cm) diameter.

Cross-hatching has been used to form a vertical rectangular structure within the curves and diagonals that make up the bird's head and neck. It gives an architectural underpinning to the mass of detail and movement in this drawing.

PATTERNS

Tonal areas in a drawing can also be made from shapes whose borders are filled by pattern. (Actually, any section of a drawing that has a dense concentration of details will introduce gray areas into what would otherwise be a pure contour drawing.) Uniform scale throughout a pattern reinforces its flatness.

Pattern does not have to be made of mechanically repeated motifs. Looser areas of a random texture with enough consistency of scale or similarity of detail can appear to be pattern.

There are also printed mechanical patterns that can be introduced as a collaged element into an ink drawing intended for printed reproduction. They are available in a wide selection, printed on a transparent film backed with a low-tack adhesive. These are placed over the drawing, cut to shape with an X-Acto knife, and attached to the board or paper by burnishing.

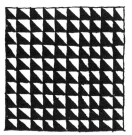

A pattern can be made from any repeated motif. This is a freehand pattern made by repeating the same black and white division of a small square.

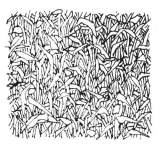

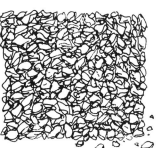

These examples of informal pattern are based on repetitions of elements that are similar in shape and scale but that are not identical. The flattening effect of pattern can apply even to clusters of representational elements such as grass and rocks.

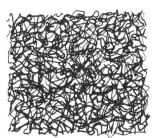

The same principle applies to any uniformly textured field, even totally nonrepresentational configurations.

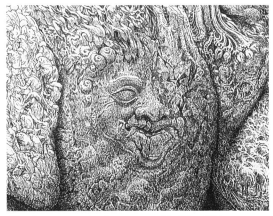

Here is an example of pattern used in The Rhinoceros. *For the entire drawing see page 171.*

IMPLIED LINES

There are many ways of creating lines without drawing them. These are implied lines. Some, such as the felt line of a directed gaze by a depicted subject (human or animal) or the expected resolution of a recognized gesture or action, exist only in the mind. Others are perceived lines that are not explicitly drawn. They exist as by-products.

The cumulative effect of a group of lines can create a larger movement or compositional line.

Similarities can be used to perceptually differentiate some elements from others in the field in order to imply a line.

Neighboring areas of tone or texture can end short of actual contact and bring a line into being that is independent of the direction of the actual marks.

A line can be felt along the edge of a change of directional strokes. As is evident in this example, this kind of line is very subtle. The greater the change of stroke direction between the two areas, the more readable the line.

Shorter marks placed between the long, hatched verticals create a line perpendicular to the marks themselves. It is not necessary to have the marks that form the line occur in every adjoining space to have continuity. It is essential, however, that the marks align themselves along the path of the line to be created.

STIPPLING

Stippling is creating tones with clusters of dots. The dots can be applied to the paper one at a time using a pen, which gives the artist maximum control. This type of stippling can be done with any type of pen: dip, fountain, or technical. A brush can also be used to stipple an area, but the dot size will not be uniform. A reservoir pen is convenient because there is a constant ink flow. This means that you can make a stippled tone with no variation in dot size. (Dipping a pen to re-ink the nib often gives heavier dots each time the pen is reloaded.)

The most careful stippling is used in scientific illustration. In order to assure a homogeneous tone, each new dot should be applied in a

triangular grouping with two previously laid dots. Place the dots at the points of tiny, imaginary, equal-sided triangles for a constant tone. The tone can be gradually lightened or darkened by increasing or decreasing the length of each side of the triangle you are forming. This helps to avoid the formation of "rivers": unintended linear continuities that are lighter or darker than their surrounding field. These are caused by opening or closing the intervals between the marks to a noticeable degree within a limited area.

This stippled tone was made by placing dots one at a time with a technical pen. If the dots are evenly spaced, the tone will be uniform.

A brush can be used for stippling. The marks will not be mechanically uniform, but the spacing can still be controlled.

Stippling done with a dip pen will show a slight variation in the size of individual dots. They are heavier each time the pen has been dipped in ink to recharge it.

This graded tone was made by decreasing the spaces between stippled dots of equal size.

SPATTERING

Another method of stippling is done by spattering dots onto the paper. This technique covers a relatively large area quickly with less control and great variation in the size of dots. The most common method of spattering is one most of us learned in grade school. Dip a toothbrush in a puddle of ink and spray the ink across the paper by dragging a knife blade or wooden matchstick slowly through the inked bristles in the opposite direction from the "target" area. The snap of the bristles toward the paper creates a spray of ink. This technique is obviously less controllable. You must mask the shape to be sprayed in order to protect the rest of the drawing or its border. Do not attempt to remove the mask before the ink is completely dry. A second color or third color can be sprayed onto the dried first spatter to add interest.

If the drawing is for reproduction only, a separate paper can be spattered and the desired shapes cut and collaged onto your illustration. The collage will not show in the printed piece. It is also possible to spatter the original board or paper and silhouette the shape by overpainting with opaque white tempera or opaque white ink. This might not be a desirable solution in a drawing intended for exhibition, but the opaquing white will not be apparent when used in a line reproduction.

A spattered tone is made up of droplets of ink sprayed from a stiff brush such as a toothbrush. There is no way to control the size of the spots.

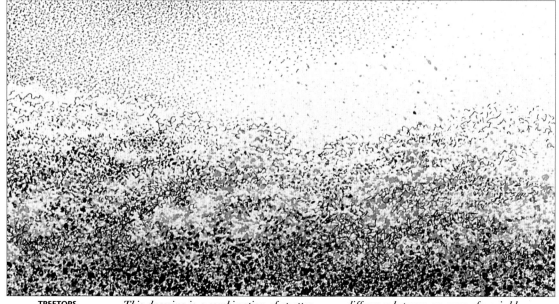

TREETOPS
Mecanorma technical pen 3×0; Oral B-20 toothbrush; sumi ink; Dr. Ph. Martin's Black Star waterproof india ink; Twinrocker handmade laid stationery, 6 × 8 ¼" (15 × 22 cm).

This drawing is a combination of spatter, stipple, and line. I first cut a paper mask the size of the total image area and positioned it over the drawing paper. Next I dipped a toothbrush into india ink and spattered ink onto the paper by pulling a knife blade through the bristles. This is a low-tech form of airbrushing that has the advantage of giving you far less control. I prefer to wait and see what the coarse spattering suggests.

The sky was carefully stippled with a technical pen to capitalize on the textural difference between an area of variable sized dots and the smooth homogeneity of a field of identical dots. I also used stippling to add shadows to masses of foliage within the spattered section.

I finished off with fine lines to enhance some of the shapes, careful to avoid creating a continuous line between the trees and the sky. Doing this would have flattened the foliage mass and reduced the sky to a toned background. Here the sky is more of a container for the trees.

DEMONSTRATION: SPATTERING

Spattering is probably the easiest and most entertaining ink technique for the artist. It lets you be messy in a controlled way.

I cut a mask that will act as a stencil for the shape to be spattered.

I pour some ink into a dish and wet a toothbrush with it.

Holding the brush over the area to be spattered, I force a palette knife blade through the bristles, moving it away from the target area. I spatter from all sides to cover the area uniformly.

When the first color is dry, I spatter a second color over it. After that too has dried, I remove the paper mask.

Finally I add a white line with an opaque white ink (FW nonclogging waterproof drawing ink) using a Speedball A-5 nib.

BRUSH TECHNIQUES

There are few materials in art that respond as sensuously as a well-made brush. If you draw with a good-quality sable round, the hairs will carry a surprising amount of ink, and the resilience of the hairs permits a tremendous variation in line width as you apply the brush with more or less pressure.

A brush can also be used for hatching, cross-hatching, and stippling. The principles are the same as with a pen, but the effect is different. A brush will not snag, so it can be used on a wider variety of papers than a pen. The irregular texture of a watercolor paper is as receptive to a linear brush drawing as it is to a traditional watercolor wash. The brush is equally suited to a smooth paper surface such as a bristol vellum. However, some surface texture is necessary to take advantage of the drybrush technique.

LAYING A WASH

One of the hardest things to adjust to when using a sable watercolor brush is how slowly you must move the brush across the paper when covering a large area with an even wash. The brush must be given sufficient time to release enough liquid to completely fill the depressions in the paper's surface texture. A brush that is dragged too quickly will trap pockets of air in the "valleys," leaving a wash speckled with white. When this effect is what you want, it is considered the mark of a lively technique. When you need an unbroken field of tone, the white dots are a flaw.

If you are using an opaque ink, you simply go over the area a second time for an even tone. If the ink is transparent, this can be a problem. A dried layer will remain visible through the new one. Each time you add another layer, even a single stroke for touch-up, the color or value of the wash will deepen.

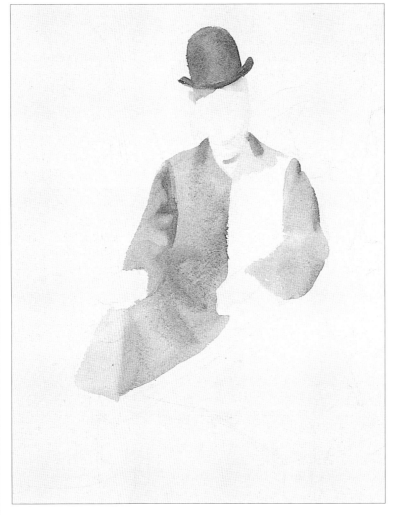

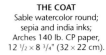

THE COAT
Sable watercolor round; sepia and india inks; Arches 140 lb. CP paper, 12 1/2 × 8 3/4" (32 × 22 cm).

This was a detail study for a larger work. The body of the coat was done first as a uniform pale wash. The hat was done with a mixture of india and sepia ink, but the darks in the coat were built by overlaying additional layers of the base color.

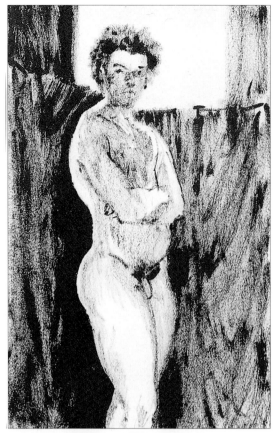

UNTITLED
Kenpro fountain brush with sable tip;
rag drawing paper in a handbound sketchbook
by Daren Callahan, 10 × 6 ½" (25 × 17 cm).

The grays in this drawing are the effect of a brush that has been partially blotted. Drybrush is most effective on paper that has a textured surface. The brush leaves ink on the raised parts of the paper and does not fill in the valleys because it is not carrying a full wet load of ink.

DRYBRUSH

Drybrush is the opposite of a careful wash. Dip the brush into the ink then shake the excess ink out of the brush, or blot it with an absorbent paper towel. Spread the brush hairs with your fingers or by pushing the brush against the towel. (A brush prepared in this way can be used to lay a multiple line.) Now draw quickly. This technique creates an extremely broken surface with little detail other than its own soft tones and textures. A paper with a surface texture heightens the effect. The drybrush technique gives a mark that is a visual hybrid between a brushstroke and a spatter or a hatch. It makes hatching unnecessary for adding toned areas to an ink drawing. However, the mark has such breadth that fine detail is eliminated by all but the very finest brushes.

DEMONSTRATION: USING BASIC PEN AND BRUSH TECHNIQUES

When drawing solid illusionistic volumes, try to use the directions of the marks in a tonal area to strengthen the forms you are drawing. The marks can follow perspective convergence or change direction with a change of plane or curved surface. Give some thought to the logic of the image before you begin drawing it in ink. In a similar vein, an overuse of curved lines can make it difficult to read surfaces that are meant to be flat.

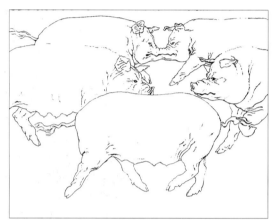

I first do the drawing lightly in pencil, to establish the major shapes and the diagonal lines formed by the legs. On a whim, while I am working on the pencil drawing, I place a mirror on edge across the nose of the top left pig. This suggests the finished image to me. Next I develop this image as a contour pen line drawing.

I then add limited modeling with short hatches to establish the volumes and the wrinkled hides. The hatching is done with an awareness of the flow of marks on the surface (similar to following hair patterns).

I put in a diluted ink wash around the pigs because I want a featureless, spatially ambiguous background. This is too close to the value of much of the hatching, however, and the uncovered section at the bottom seems too self-consciously designed.

MERGING PIGS
Koh-I-Noor Rapidograph
technical pen 2×0; sable
round watercolor brush;
FW nonclogging waterproof
india ink; Svecia Antiqua
handmade laid stationery,
8 ¹/₂ × 11" (22 × 28 cm).

I paint in the background with a solid black wash of full-strength india ink. This gives the contrast and the drama I want. I decide to rework the modeling on the pigs' bodies to include stronger darks; this lessens the flattening effect of a high-contrast border surrounding the image on all sides.

DEMONSTRATION: LAYING A WASH

Choose a paper that is well sized, to delay absorption of the ink, and fasten it to a board. Loose sheets of less than 140 lb. should also be stretched. Before starting, tilt the drawing board enough so that excess water will settle along the bottom of each stroke. Have more of the color you are using than you think will be needed to cover the area. You cannot stop in mid-wash to prepare more, and if the color is a blended one, it is almost impossible to match a tone exactly if you have to mix a new batch. Have a container of clean water and a sponge or paper tissues handy.

Frame the image area with masking tape to keep the border of the drawing clean. If any parts of the drawing are to be isolated from the color that you are using for the wash, protect them by brushing on a removable friskit such as Grumbacher's Miskit, Dr. Ph. Martin's friskit mask liquid, or Winsor & Newton's art masking fluid. In this case, I use masking fluid for the central figure.

After the friskit is dry, dampen the paper by misting it with water. This keeps the ink from drying too quickly and lets the edges of the brushstroke feather softly, making it easier to join the next stroke to the last one without forming a dark line where they meet. The paper must be damp, not wet, or the color will bleed out too quickly as it is brushed in.

Before you start a wash with a fresh brush, wet the brush hairs thoroughly to release all the air that is trapped in the hairs. Once it is well wetted, it will hold far more ink. A large watercolor brush can take up to 15 minutes in water to become thoroughly wetted.

Make sure your brush carries sufficient liquid to lay at least one complete line of wash across the width of the area to be painted. With a loaded brush, lay the color in horizontal lines, reversing the direction of your stroke with each new band. Pull the brush slowly across the paper, handle first, dragging the hairs. The object is to put down enough ink to form a continuous standing drop along the bottom edge of the entire line. Overlap the line above to let the two lines run together, wiggling the brush slightly as you drag it. This helps to mix the new row into the standing drop along the row above.

The dark blue on the first layer of this picture has been laid with less care because it will be blotted with paper towels to lift a pattern of light shapes before it dries.

As I move the wash down the paper, I begin adding more clean water to each stroke. This gives a progressively more diluted color for a graded wash. The water must be absolutely clean or the transparency will be lost.

When I have filled in the wash to the bottom of the shape, I squeeze the remaining liquid out of the brush and use the dried tip to pick up the surplus ink. If this is not done, the pigment floats back from the edge before it dries and forms blotchy lighter grays edged with a dark rim of concentrated pigment.

When the paper is dry, I turn it upside down and lay a yellow graded wash in the opposite direction. You can also see the texture in the blue layer that I created by blotting the ink with a paper towel before it dried.

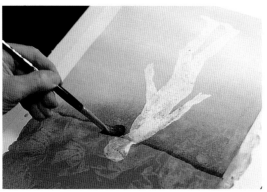

Next I begin adding increasing amounts of red to the yellow in order to blend one color into another. Notice the standing drop along the bottom edge of the new wash.

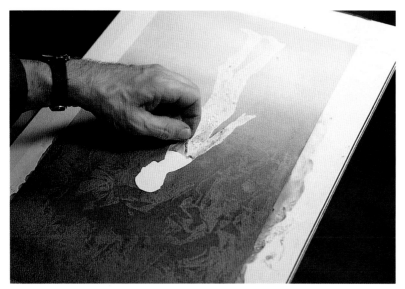

I remove the friskit from the paper after the washes have dried completely.

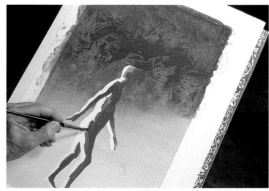

Now I paint in the figure with an opaque pigmented ink (Dr. Ph. Martin's Perma Draft).

Next I decide to soften the edges of the red figure by using the drybrush technique. I squeeze the excess ink out of the brush and spread the brush hairs in order to apply the ink.

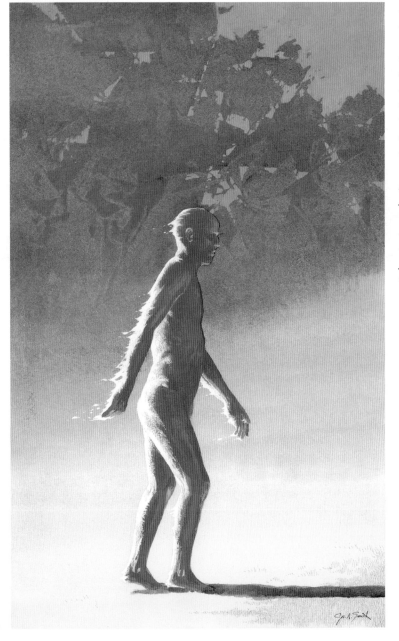

Next I paint the shadow with a transparent ink (Dr. Ph. Martin's Tech). I lay a strip of blue and then touch the still-wet color with a brush dipped in red. This second color spreads into the first and adds interesting color change within the shadow. I add reflected light along the shadowed front of the figure with opaque color.

Finally, in the finished painting I have added flamelike forms along the back of the figure with opaque white (Dr. Ph. Martin's FLO-2) and painted sky into the blotted foliage forms with a mixture of opaque white and blue.

WHITE INK ON TONED PAPER

The usual drawing procedure is to work on white paper and make forms by adding darks to the paper. If you reverse this and draw with white ink on black or dark-colored paper, the link between vision and image is much closer. (We see detail where light is strong enough and lose detail progressively as the intensity of light decreases.)

Drawing with white ink on dark paper requires the kind of seeing that is more often used in painting rather than drawing. In traditional painting techniques, the canvas is toned with an underpainting and the forms are developed by painting opaque lights into the darks. Representational drawing with white ink uses the same sequence of dark to light to create the appearance of volumes. This can be combined with transparent washes of thin white ink to create middle tones that can be worked over with a pen and opaque white ink.

BOILER ROOM II
Koh-I-Noor Rapidograph technical pen 1×0; Pen-Opaque white ink; white Berol Prismacolor pencil; gray Canson Mi-Teintes paper, 12 × 8 ½" (30 × 22 cm).

Drawing with white on a toned paper forces you to reverse the usual way you think through a drawing. A white line on a dark ground seems to emit light.

Here I wanted the untouched paper to read as a positive form, so the white marks had to appear deeper in space in order for the paper to read as an opaque object. I began by indicating the lightest lights in the drawing and working out from them.

DEMONSTRATION: WHITE INK ON TONED PAPER

The hatching and stippling techniques discussed earlier can be used with white ink also. Avoid putting unnecessary white marks in areas that are meant to remain in shadow. The white pigment acts like light and is impossible to remove completely once it is on the paper.

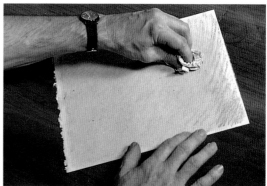

I tone this paper with a combination of colors by applying several layers of pastel. Then I smooth the pastel into the paper with a paper tissue.

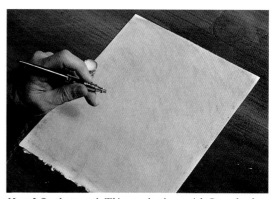

Next I fix the pastel. This can be done with Grumbacher Myston or by applying an even coat of skim milk with an airbrush. The skim milk is nontoxic and the dried casein from the milk gives a slightly grainy surface to the paper.

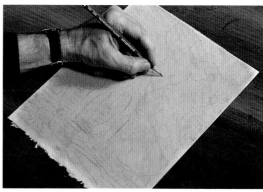

Now I lightly sketch in the image with a graphite pencil.

I use black ink to draw partial contours, omitting sections of the upper edges of the figures.

I then use a wash of white ink to indicate light and to relate the figures to the background. The white breaks the figures into smaller shapes that work with movements and shape groupings in the background.

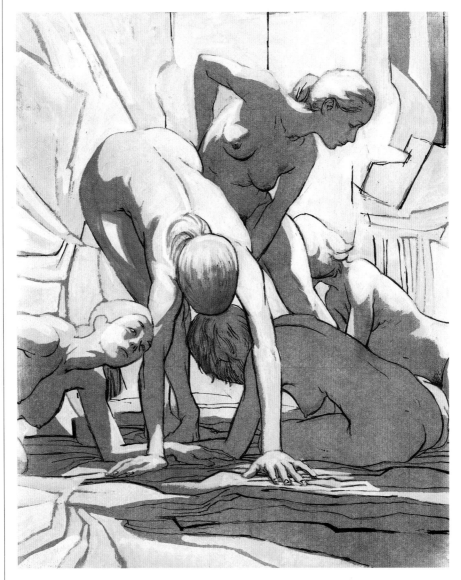

GROUP OF MODELS
Gillott #303 pen; brush; pastel; Myston fixative; FW nonclogging waterproof india ink; Speedball white waterproof drawing ink; Arches cover stock, 11 × 9" (28 × 23 cm).

Here is the finished image. I have reworked the drawing with a pen and india ink to add darks where necessary and to define some edges that seem to lack clarity.

COLORED INKS

Colored inks can be used for full-color drawings, to add an accent to a black line drawing, or individually to make monochromatic drawings. Sepia and bistre inks have been used as drawing colors of choice by many artists for centuries. Drawing with watercolor is basically the same as using colored inks.

Modern ink manufacturers have added a waterproofing element to the binder of some inks. Water-soluble shellac or varnish was commonly used. Many of the newer inks now have an acrylic base, and this has given artists new options in working with them. The addition of a full range of lightfast opaque pigments has greatly extended the range of color effects we have at our disposal.

Colored inks are almost identical to watercolor in handling. An important difference is that waterproof inks require more immediate care of your brushes while you work to prevent the ink from hardening in the brush.

Colored inks can be used straight from the bottle or preblended to achieve specific hues not included in the line. Colored inks are applied with brush or pen just as black ink would be. Another approach is to use the unblended pure colors and let the viewer's eye do the mixing. Here the colors are applied in layers of hatching. A yellow cross-hatch over a red will produce a visual mixture of orange. A light hatch of blue or green over parts of this can mute the color or introduce cool shadow effects. This works best with transparent inks where every layer will

GEORGE BUSH
William Mitchell/Joseph Gillott #303 drawing pen; transparent Rotring ArtistColor; Baryte paper,
11 1/2 × 16 1/2" (29 × 42 cm).

For this drawing I did not use any premixed colors. The hues were applied with the dip pen just as they came from the bottles. Transparent Rotring ArtistColor was used for this drawing because I wanted to create new colors where the ink lines overlap (like spots of glaze in oil painting). This is different from the visual blending that our eyes make from small adjoining spots of color (pointillistic color mixtures). I chose the Gillott #303 for its flexible handling. I clean the nib often as I work. This keeps the ink flowing smoothly and avoids contaminating colors in their bottles.

always be visible to some degree, but opaque inks can be used also.

The covering power of the opaque inks means that the colors do not blend by acting as transparent glazes. You must build the hatches more carefully, allowing enough space between marks in the upper layers to avoid covering too much of the underlying color. If not enough of a deeper layer of color shows through the top layer, it cannot contribute to the visual mixture.

Ink washes can be superimposed to create interesting color effects. Transparent inks will give cleaner, clearer mixtures when layered in washes than will dilute washes of opaque color.

UNTITLED
by Peter Wadsworth
Hunt 103 pen; Raphael 8404 watercolor rounds; FW colored inks; Strathmore drawing paper, 14 × 17" (36 × 43 cm).

This drawing shows the extreme transparency of dye-based inks. Wet-in-wet washes and colors applied over dried color as a glaze have been combined with pen lines and marks to give a rich variety of mixed color effects without loss of vibrancy.

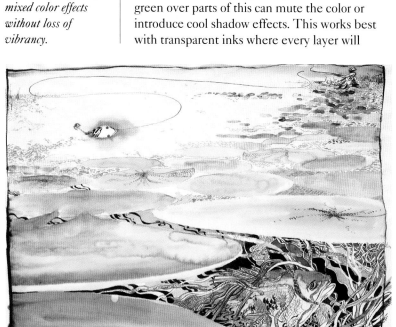

Opaque White Ink with Transparent Colors

After drying completely, waterproof white ink can be overpainted with transparent colored drawing inks for an intense color effect on colored or toned papers, or to add color over solid areas of waterproof black ink. There are a number of permanent opaque colored inks on the market that can be used over toned papers. Most colored inks will have a greater luminosity, however, if a solid white is used first. There are new inks being developed every year. When trying a new ink, make sample tests by drawing lines on several colors of paper to determine the opacity.

This technique will work with any black paper suitable for watercolor, in this case Arches Velin paper. The initial drawing was done with FW Pen-Opake white ink. Opacity is very important here because light reflected from the white is what gives luminosity to the color in the final drawing.

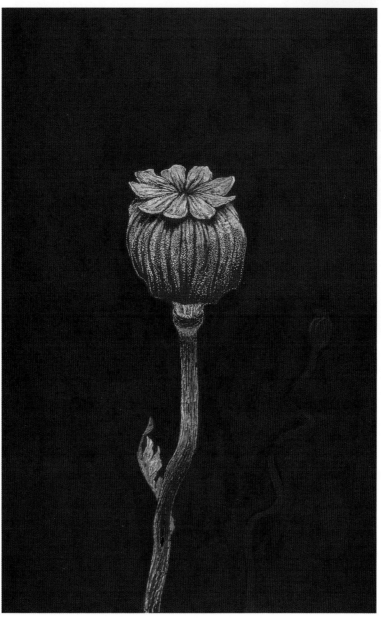

When the white ink is completely dry—which takes at least half an hour for most inks—transparent waterproof colored inks are washed over the drawing. (Here I used Rotring transparent ArtistColor inks.) Any colored ink that goes beyond the white drawing will not show because it is lost against the black paper. This means that the colored inks can be brushed on with some freedom; you don't have to be obsessive about keeping the color exactly over the white marks.

MIXED MEDIA

One of the beauties of ink is how naturally it can be used with other materials. The progression from line drawing to line with wash is only the tip of the iceberg: *All* drawing media can be freely combined. The order in which they are used will often have an impact on the final character of the drawing.

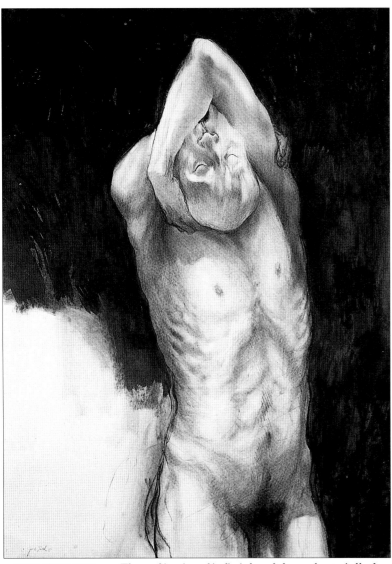

ASANA OF THE MIND
Hunt Speedball Super Black india ink; New York Central "Classic Hake" no. 5; Alphacolor Char-kole; Strathmore series 400 100 lb. drawing paper, regular surface, 55 × 42" (140 × 107 cm).

The combination of india ink and charcoal, especially the velvety rich black compressed charcoal made by Alphacolor, is a marriage made in heaven for the large, fast execution of an idea. After spraying the charcoal with skim milk to fix it, you have the option of further layers of charcoal, adding color with pastel or colored inks, or working into small detail with a pen.

For example, try using an ink wash to block in important forms, and then develop them with brush line, pen, charcoal, pencil, collage, acrylic paint, and so on. As long as you have a properly sized support (paper, board, or canvas), you can even add oil paint. Ink has no oil in it. This means that it is suitable as an underlayer for oils, which must be layered in a lean-to-fat sequence to avoid later problems as the paint ages.

The amount of oil in oil paint can be reduced by squeezing the paint out on blotter paper several hours before painting. This produces a much shorter (thicker, less flowing) paste, which can then be applied to heavy paper or canvas with a bristle brush. Do not add oil to the paint as you use it. This paint film dries with a matte finish. Paint reduced in this manner is called *essence*. Degas used it often for color sketches on paper as well as on several large canvases. Essence can be combined with ink line work for an interesting effect.

Oily and waxy materials such as oil pastels or wax crayons resist water. You can draw shapes or lines on the paper in crayon and then wash over them with black or dark-colored inks. (Inks with film-enhancing mediums for drawing on film do not work well for this technique.) The nonabsorbent lines will repel the water-based wash, and the drawing will appear. If a white crayon is used, the drawing stands out as a negative white line against the dark-colored ground of the wash.

Nonwaterproof inks combined with watercolor using wet-in-wet technique will bleed and give a softer line. A similar effect can be achieved by misting the paper to dampen it before drawing with a pen.

Pastels or charcoal work well over an ink underdrawing. Heavy washes of ink with a wetting agent (ox gall) can be scrubbed back into the dusty surface of the dry drawing material. If the paper is sprayed with a mist of skim milk, the skim milk not only acts as a binder for the charcoal or pastel but dries with a toothlike surface that is ideal for additional layers of pastel or ink.

With mixed media and ink, the only restraint is your imagination. As long as you do not allow unusual combinations to become a mask or a substitute for creative thought, virtually anything is possible.

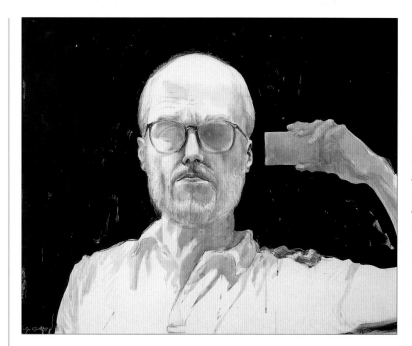

SELF-PORTRAIT WITH MIRROR
FW nonclogging india ink;
Winsor & Newton watercolor;
Conté a Paris 2B charcoal pencil;
white Berol Prismacolor pencil;
Speedball white waterproof drawing ink;
Derwent graphite pencil; T. H. Saunders
Waterford moldmade paper CP,
36 × 48" (91 × 122 cm).

This drawing shows the kind of direct, "lean and mean" drawing that both ink and watercolor are good for. The drawing was blocked in with indigo and Payne's gray watercolor. I used india ink to cut out the figure and make the shadows within it seem to be filled with reflected light by contrast. When the paper was dry, I added details with charcoal, white pencil, and white ink. The entire drawing was finished in less than an hour.

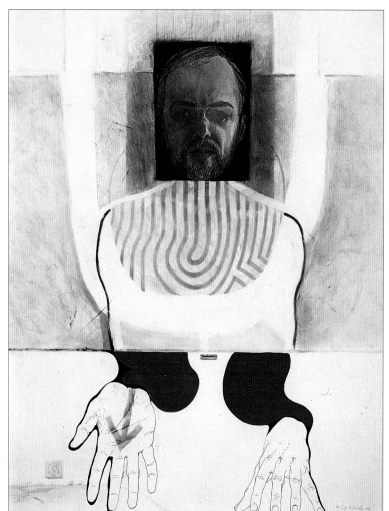

THE TOY ORACLE
Higgins Black Magic drawing ink;
gouache; vine charcoal; graphite pencil;
Rapidograph technical pen 3×0; brush;
Strathmore 2-ply bristol board, kid finish,
29 × 23" (74 × 58 cm).

When you use a variety of mediums by placing each one directly on the paper in its own area rather than layering them, your paper selection is more limited. Layered mediums in the proper sequence can prepare an otherwise unreceptive paper for the next medium. This drawing required a fine enough paper surface for delicate pencil and fine ink line rendering and enough tooth to use the vine charcoal properly. A medium-surface bristol in a sufficiently heavy weight (larger areas of watercolor would have required a 3- or 4-ply paper) is a versatile surface.

5 OF HEARTS
by Sandra Halat
India ink; charcoal; gouache; acrylic
gesso; acrylic paint; pastel;
BFK Rives paper, 40 × 48" (102 × 123 cm).
Collection of John and Jan Smith.

*This piece shows the compatibility
of inks with other mediums. The
drawing began as a collaborative
visual dialogue between artists
Sandra Halat and Patt Odom
using charcoal and india ink.
Sandra then used this as an
underpainting, working into it
with gouache and gesso, and
further developing it using pastel.*

NIGHTRADIO
by Susanna Dent
Watercolor round brush; india ink;
Sennelier oil pastels; Shiva oil sticks; pencil;
metallic tape; gouache; cream-colored,
moldmade, neutral pH paper;
frosted Mylar; 27 × 18" (69 × 46 cm).
Collection of Kim Jennings.

*This is a mixed media drawing
in every sense of the phrase. The
support is a combination of
paper and Mylar that retains the
texture and color of the paper
and plays it against the smooth
surface and clouded translucency
of the polyester. The image itself
combines wet and dry materials
and a visually exciting interplay
of depth tension and flat,
diagrammatic drawing.*

DEMONSTRATION: WAX CRAYON AND INK

Most of us learned this technique in grade school. Its simplicity when used by children should not blind the artist to its possible application to current work.

Choose a paper that is sized for watercolor. The initial drawing can be done entirely with white crayon if you want it to be monochromatic, or it can be done in full color.

Apply a wash of ink over the crayon underdrawing. The water-based ink does not bind to the areas that are covered with a film of wax, and the crayon drawing shows through as a negative image.

DEMONSTRATION: PASTEL AND INK

Pastel can always be applied over ink on paper. Sometimes the reversal of steps in any sequence can have the effect of opening new ways of approaching visual problems.

The first layer is a drawing done with soft pastel. When I brush ink over the pastel, the dry powder surface resists the liquid. For uniform coverage, the ink must be brushed into and blended with the pastel.

Next I work back over the ink wash layer with pastel to bring up more intense color accents.

After fixing the loose pastel pigment on the surface of the paper with a water-receptive binder (in this instance Grumbacher Myston), I add heavy detail using a waterproof india ink and a brush.

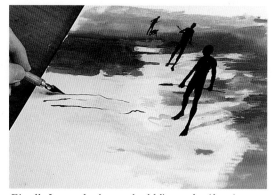

Finally I smooth edges and add linear details using a Speedball lettering pen with a relatively fine point. This pen has a reservoir that holds a large supply of ink.

DEMONSTRATION: ACRYLIC AND INK

Acrylic paint literally adds a new dimension to drawing with ink: physical surface texture. The transparency and consistency of the acrylic paints permits oil painting effects to be incorporated without the problems inherent in trying to combine a water-thinned medium (ink) with a water-resistant material (oil). Acrylics and inks share compatibility with the same range of supports, which gives this combination of materials even greater potential interest.

I begin by painting the positive forms of the head and torso as solid black ink silhouettes.

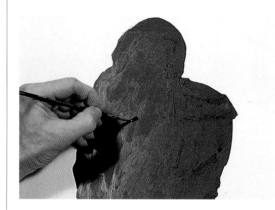

Next I paint the sky with Liquitex acrylic paint. I paint the entire background with warm colors first—yellows, oranges, and reds. I then scumble blue over this, allowing parts to remain uncovered.

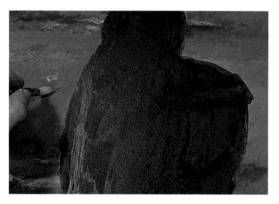

In this image I choose to model the volumes in the figure by painting an opaque layer of unbleached titanium white acrylic paint with matte medium over the ink silhouette to create the areas of the form defined by the light.

Now I glaze transparent layers of color (cadmium red, burnt sienna, and ultramarine blue) unevenly over the entire form. These layers of color darken the white areas while letting the white reflect through to give it luminosity. When the same colors are glazed over the flat black, there is enough pigment in the paint layer to give a suggestion of light and color reflected into the shadows.

I add linear details in a waterproof india ink that is suitable for film. For this drawing I am using a Koh-I-Noor Rapidograph no. 2 pen and Koh-I-Noor Universal drawing ink.

I finish the picture with a border of black Dr. Ph. Martin's Hicarb, adding the white and colored elements with a Speedball lettering pen with highly pigmented opaque inks. The white is Speedball waterproof drawing ink. I add the spots of color with Kremer-Pigmente waterproof colored inks over the white ink for greater color intensity.

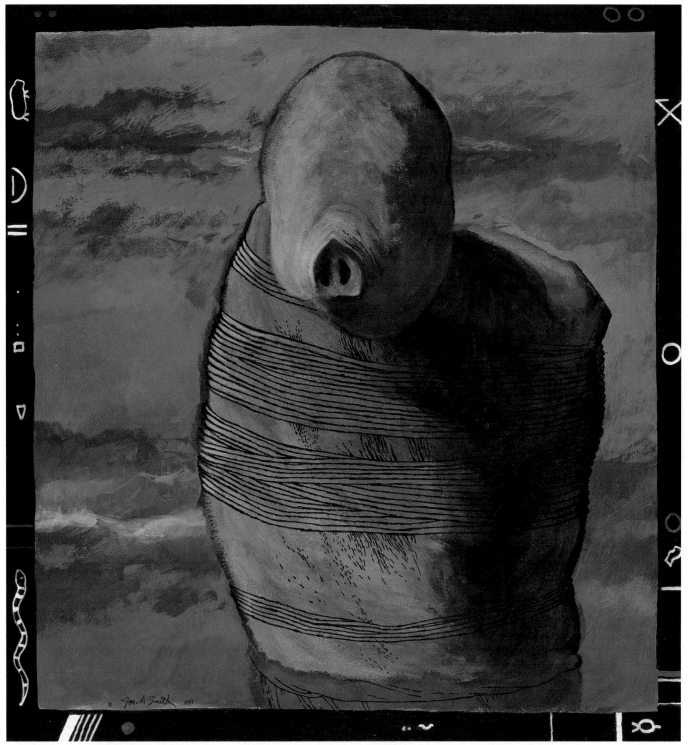

BOUND PIG
Liquitex acrylic paint; Koh-I-Noor Rapidograph
no. 2 pen; Speedball lettering pen; Koh-I-Noor
Universal drawing ink; Dr. Ph. Martin's
Hicarb waterproof india ink; Speedball
white waterproof drawing ink; Kremer-Pigmente
waterproof colored inks; medium-surface
Art-tec board, 14 × 15" (36 × 38 cm).

The finished painting shows the unique combination of textures that would have been impossible with ink alone.

SCRATCHBOARD

Scratchboard is a technique that is enjoying a second life after being largely ignored by all but the community of scientific illustrators for several decades. If you spend any time experimenting with scratchboard, you will find yourself wondering how the medium could ever have lost popularity, since it offers some notable advantages for the illustrator working in black and white for line reproduction.

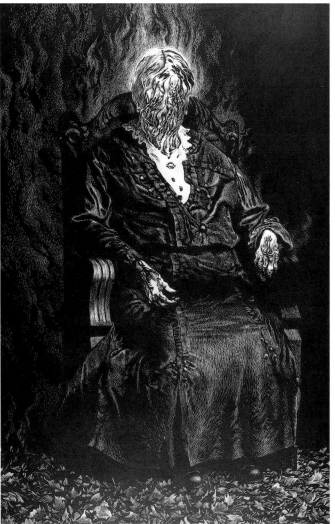

MATRIARCH
Dr. Ph. Martin's Hicarb waterproof india ink; Robert Simmons white sable watercolor round no. 12; graphite pencil; Pink Pearl eraser; X-Acto knife with no. 16 blade; sharpened stainless steel dental pick; Essdee scraperboard, 18 × 12" (46 × 30 cm).

The emphasis in this drawing is primarily on texture. The scratched marks were kept as fine as possible, so that they would be secondary to the textures of the materials being drawn, and the direction of each scraped mark would follow the surface contours of each form. Only the woman's blouse and two or three shaped spots on each hand were not covered in the original inking.

It is far more flexible than pen and ink on paper. Anything a pen can do is easily incorporated into a scratchboard drawing. The chalk surface of the board takes a pen line with more precision than most papers, and unlike a pen line on paper, an unsatisfactory line on scratchboard can be quickly and completely removed and redrawn. Color can be added with interesting results.

Before working on a commercially produced scratchboard, first mount it on a stiff backing to prevent accidental bending, which could crack the clay coating. A piece of illustration board or foam-core board that is larger than the scratchboard will protect the edges of the board from being damaged. It will also give you a safe means of lifting or turning the board while you work. The clay is absorbent and hygroscopic; it will absorb dirt and moisture from your hand.

Polish the clay surface by erasing the entire board with firm, parallel strokes of a Pink Pearl or a white plastic eraser in two directions. Then lightly wipe the surface with rubbing alcohol in a cotton wad or soft paper, using a circular movement of your hand. The alcohol will evaporate quickly, and then the board is ready to go. The polishing with an eraser removes surface clay dust (which might clog the pen), smooths any slight irregularities in the surface coating, and makes the board even more receptive to a pen line.

When you begin, draw the image lightly in pencil. If your drawing will have areas of white or mostly white, avoid those sections when you begin inking the board. Use a watercolor brush to cover the areas that are to be predominantly black or dark visual gray with a coat of india or sumi ink. Apply the ink with short strokes that do not overlap, keeping the ink layer thin and even. Give the inked areas time to dry thoroughly before applying the second coat. Avoid bubbles in the ink or thick spots, which crack when they dry and scratch with difficulty. Wipe up any spilled ink or drops immediately, because those spots will not scratch through properly.

Do not begin scratching into the ink film until it has had time to dry completely (at least half an hour). Damp ink does not scrape cleanly, and the wet chalk will stick to your scraper blade. Keep your hands clean as you work, and dust the surface of the board regularly with a drafting brush to prevent breathing the clay dust. The dust will also foul the pen nib when you begin adding pen lines to the drawing.

Just as with white ink on black paper, you do not fill in the shadows; you add light when you

scrape. The more lines or layers you add to a hatch, the lighter it becomes. Carry the scratched texture to the edge of the black shape and through it. The tone can be extended without a break onto the uninked white board by continuing the texture with pen marks. In this way you can start with a solid black and seamlessly lighten it until it dissolves into pure white. New black shapes can be reintroduced whenever and wherever you need them. Professional-grade boards can be re-inked and scratched again as many as four times.

You will have more control with most cuts if you work by pulling the blade toward you. The foam-core base makes it easy to turn the board for the most comfortable position to make scratches in any direction.

When you are done with the black, you might try adding washes of transparent colored ink to the board. If you used waterproof india ink, you can work directly over it. If not, avoid excessive brushing or you risk rewetting and loosening the black and muddying the incised lines.

Experiment with a variety of scrapers to get an idea of the line possibilities. You can even add hatching by scraping with broken sections of hacksaw blade for fine, parallel lines.

SCRATCHBOARD ON WATERCOLOR PAPER

Recently a number of artists have adapted the working method of scratchboard to heavy papers such as watercolor papers that have no clay coating. Rather than scraping the ink with incisors that give precise control when cutting into clay, these artists use sandpaper to remove the ink and expose the white of the paper. The effect is somewhat controllable. You can re-ink sections that were unintentionally exposed. However, without a new coat of sizing before re-inking, the abraded paper will absorb the ink, making it difficult to sandpaper down to clean white a second time. These drawings have a surface quality closer to painting, and if fine papers are used, the drawing is suitable for exhibition as a piece of original art.

RECLINING NUDE
D-weight 3M Open Coat production paper, dental pick, Dr. Ph. Martin's Black Star Hicarb waterproof india ink, Fabriano 100 percent cotton watercolor paper, 19 × 22" (48 × 56 cm), sized with Knox gelatin.

This is a variation on the scratchboard technique. I sized a heavy watercolor paper with gelatin and then painted the surface with ink, omitting the areas that were to be pure white in the finished drawing. After the ink dried, the drawing was done by sandpapering it off of the paper. The thin lines on the drapery were scratched with a dental pick. The abraded textures have a beautiful quality unlike any that can be attained by direct application of ink with a tool.

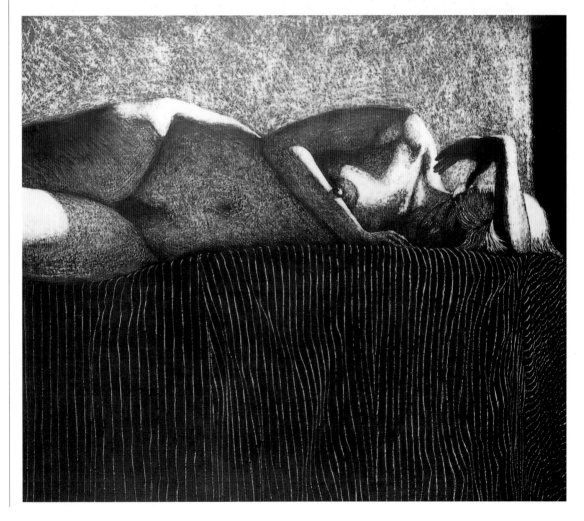

SCRATCHBOARD

DEMONSTRATION: SCRATCHBOARD

This demonstration shows many of the effects attainable with scratchboard and the step-by-step finished development of the image that is unique to this medium. Remember that all the line techniques used with pen on paper apply to scraped lines also. Scratch the lines lightly. If you cut too deeply into the clay coat, you will limit your ability to re-ink a section you want to change or redo.

After preparing the board by polishing the surface with a soft eraser (Pink Pearl), I draw one section at a time with a pale pencil line. I ink in the figure and an adjoining strip of the background first, brushing on two layers of india ink. The most brightly lit sections of the figure are left white.

After the ink is completely dry, I scratch white lines out of the solid black, making hatched halftones to model the forms and soften the transitions between the darks and lights. Fine, black lines added with a crow-quill pen extend tones and detail into the white areas.

When I am satisfied with the figure, dog, and owl, I ink in the background and begin the grass, working out from the figure in both directions to monitor the effect of light level in the grass on the shadow-to-light contrasts in the figure.

I complete the grass as an area before doing the trees and sky, so that I can see the actual value level of the entire yard before I decide how much light I will put in the top section.

THE YARD AT NIGHT
William Mitchell/Joseph Gillott #209 lithographic pen; Winsor & Newton series 7 watercolor round; Winsor & Newton series 239 watercolor round; X-Acto knife with a #16 point; Dr. Ph. Martin's Black Star Hicarb waterproof india ink; Rotring ArtistColor; Essdee professional-grade scraperboard, 13 × 9 ¼" (33 × 24 cm).

I decide I want a second, hidden light source within the picture in addition to the dramatic light on the figure and the foreground. To achieve this, I define the trees in the background with rimlight and a fine hatching of light lines between the silhouetted branches.

Finally I wash transparent color over the scraped sections of the image. On the larger white shapes, I keep the more intense color around the edges, letting the color fade to white toward the center of each shape. This gives a feeling that the light is washing out the color.

Unlike ink on paper, scratchboard permits alteration of details at any point as the picture progresses. The finished drawings have a more dramatic quality than drawings in most other drawing media.

EXERCISES

The following exercises should be done on a smooth paper such as plate bristol or vellum.

1. Outline a series of 1 × 2" (3 × 5 cm) rectangles in pencil. Within these boxes, draw parallel straight lines. Do a different direction in each box: vertical, horizontal, and diagonal. Do not move the paper when changing the directional orientation of the lines you are making. The purpose of this is to increase your control of the drawing instrument. Try this exercise using a variety of penpoints and brushes. First make the lines using a straightedge as a guide for your pen; then do the same exercise freehand. Try to maintain a consistent line weight when using a flexible tool such as a crow-quill pen or brush. Suggestion: Make some faint guidelines in pencil with a straightedge in the area to be done freehand. This makes it much easier to maintain relatively straight lines without the mechanical rigidity that characterizes lines drawn by keeping the drawing instrument against the side of a straightedge.

2. Within 1 × 2" (3 × 5 cm) rectangles, fill the area with parallel lines drawn with a flexible point. Change the thickness of the lines by varying the pressure of the point against the paper. Try to make the transition from light to dark or dark to light happen at the same rate of change from line to line so each line is a repeat of the preceding line.

3. Do exercises 1 and 2 with curved lines. When the change of line thickness is gradual and constant, the lines will work together to give the appearance of a curved plane. If the change happens abruptly at the same point along each line, it can be used to indicate a change from light to shadow.

4. Do the above exercises freehand using a variety of line qualities. The lines can be shaky, jagged, or even broken into chains of dots or dashes.

5. Do the above exercises, increasing or decreasing the spaces between the parallel lines to make a gradual change in the tone or value of the total area. (Closer lines make darker composite values.)

6. Using a variety of pens and brushes, explore the making of textures. Use even pressures and then uneven, mixed pressures. The textures can be drawn with any linear mark the tool is capable of making: stipple (dots), dashes, angles, zigzags, curlicues, undulations, and so on. Repeat each type of mark often enough to create a textured field within the area.

7. Make columns approximately 1 1/2 × 6" (4 × 15 cm), and divide these into eight 3/4" (2 cm) sections. Starting with white in the top box (untouched paper) and solid black in the bottom box, create a series of gray values in even steps from light gray to dark gray as you move down the column. Do this mechanically using a straightedge and a technical pen to make the hatching on one column and then draw the value steps with freehand textures on the other.

8. Do the value scale columns by careful stippling. Try to avoid making rows of dots within an area. This tends to create "rivers" of dots or white spaces that stand out within a tonal field. Practice maintaining even spacing between the dots in each section of the column. This can be done by placing each new dot in relation to two previously placed dots so that they are located at the points of an equilateral triangle. Increase the density of dots in each rectangle to make a darker gray.

9. Construct a still life of several objects that have been painted solid white. Light the still life from one side so that shadows from some of the objects fall on others. Be very conscious of value differences, and reproduce these with any of the line or texture techniques that you used in the exercises above.

10. Make a still life using objects of different colors. Draw them by using hatching or stippling to indicate local color differences and the changes of value within a color that are the effects of light and shadow.

11. As illustrated on the next page, cut strips from black and white magazine reproductions and attach them to a piece of drawing paper

with removable tape. Make sure there is ample separation between the strips (at least 1 1/2", or 4 cm). Use a light pencil to extend the dividing lines between different values on the photograph into the blank paper. The pencil lines should be treated as line contour; do not add any shading. Now, in any way your imagination suggests, complete the outline of the shape of each value area found on the photo, extending it onto the blank paper. You may choose to end it within the white space between the photo strips or to continue it across that space to link up with a patch of similar value in the neighboring strip of photograph.

Select a fine penpoint, either dip or technical pen, and use techniques such as stippling and hatching to extend the gray value level, the texture, and the type of surface pattern or detail you see on the photograph onto the white paper. Proceed in this way (the illustration shows the beginning of this process) until the spaces between the strips are filled.

Check the accuracy of your value matching by looking at the drawing through squinted eyes. If the value matches are exact, the strips of photograph will seem to disappear. When you are satisfied that you have successfully matched the photograph, remove the strips and complete the drawing.

This exercise can also be done using brush and sumi ink wash, or any combination of brush and pen techniques you choose.

Note: Each still-life drawing can be done twice. On one version, use descriptive textures that imitate the actual surface appearance of the object. The second time, use arbitrary or process-derived textures that arise simply from the act of drawing itself and the choice of medium.

This exercise in matching values can also be used to initiate a drawing in a style different from your habitual one.

THE ART OF INK DRAWING

Drawing is the basis for our perception of the visual arts. No other visual art has as many direct applications. It is fundamental to painting, sculpture, and printmaking as well as existing as an art form by itself. Nothing reveals the mind and eye of the artist as directly as drawing. In the private space of a sketchbook or on a single sheet of paper we encounter the artist's imagination in a form that is least affected by the mediating layers of materials that require more complex technical expertise in handling. Because of this, drawings often reveal a broader range of thought on the part of an artist. They can be meditative and deliberate, complete in their rendering, or impulsive, quick, and spontaneous. They permit an immediacy of expression that is not readily available in less spontaneous mediums.

The Uses of Drawing

Modern drawings fit into three divisions: exploratory, preparatory, and independent.

Exploratory drawing is a tool for investigation and experimentation in the early stages of developing an image. This image may ultimately be used for a painting, a sculpture, or an illustration. Such drawing frees the artist to create variations on a theme quickly. When you invest less time, you feel a correspondingly greater freedom to discard or play with images in ways that may not seem immediately constructive. Creative "play" of this type opens the artist to accident and intuition in a totally nonjudgmental manner, and increases the chance of developing something truly innovative. This is also a much more effective way of comparing alternative ideas in order to eliminate false starts and wasted effort after a finished piece has begun. The process can be halted at any point during the making of a painting or sculpture in order to try out new ideas as they arise.

Preparatory drawing is a common method of beginning to work on an idea to be finished in another medium. Painters often predraw the image on the canvas or panel as a guide for overpainting in oil or acrylic. Drawing is used to establish precise imagery as a preliminary step before working with controlled watercolor. These preparatory drawings are often left unfinished. Compositional studies can be used to explore the effects of differing placements and levels of value (tone). They are used to let the artist see the emotional impact of altering the strength, placement, or scale of dark and light areas. Compositional studies of this type not only function as a tool for getting beyond solutions that have become habit, but later they exist as a valuable record of the ideas that were weighed and rejected in a particular work. These sketches may become the basis of an additional painting or sculpture. In this way, ideas that would otherwise have been lost (because of the necessary degree of focus required in the execution of a finished work of art) are retained for later development.

Not only painters and sculptors but also architects use drawing to create an imaginary space. Drawing frees the artist of the necessity of finding or setting up a model from which to work. A knowledge of drawing form is all the artist needs to give free reign to flights of pure creation. Piranese's monumental prisons of the mind, or E. M. Escher's impossible architecture are examples of this use of drawing.

Other artists have used drawing as a means of making studies from art. That is, they have recorded the creations of other artists as a means of broadening their own repertoire of visual possibilities. There is a world of difference between looking at a work of art by another person and vicariously experiencing the act of creating it by drawing it. We understand something on a deeper level if we engage in recreating the act of doing a thing. There is a kind of "muscle understanding" that enhances our visual memory.

Studies from nature enlarge an artist's mental vocabulary of forms. In nature we can observe the effects of light and shadow upon a form, and we confront the effects of distance on scale and contour. The complexity and richness of the natural world challenges the artist to find or impose order and ultimately meaning on it. But first and most importantly, no matter what an artist's style, drawing from nature offers a source of inspiration and invention in its endless variety of shapes and patterns.

Independent drawings, drawings that are done as finished statements, make up the third division of drawing. These can come from any of the approaches to drawing that I have described above. It is historically a recent phenomenon that collectors have given drawing the status of an independent art, but Western artists have long regarded drawing as a complete form of expression and an end in itself. In the Orient, drawing and painting have been inseparable for centuries.

HONEYBEE
Staedtler Mars technical pen 2×0;
Higgins Black Magic waterproof
drawing ink; acrylic gesso;
HMP Vail handmade paper;
19" (48 cm) in diameter.

This careful, precisely rendered drawing mimics the accurate observation of a technical illustration. The forms in the insect's body do follow the bee's anatomy, but the machinelike articulations were used as an armature for invented detail. This drawing was used to explore imaginary, intricate surface forms.

PROFILE
Waterman fountain pen;
Pelikan fount india ink;
100 percent rag bond paper,
4 1/2 × 6" (11 × 15 cm).

This is drawing for the sheer excitement of it. The scale of the marks (imposed by the drawing gesture) is too large and too hurried to twist around small details. The motion of the pen becomes a blade that cuts away everything but those facts large enough to be compatible with its pace. The man was sitting quietly listening to a concert. The subject of this drawing is not the man himself, but the record of my hand racing to capture a moment.

THE USES OF DRAWING

SKETCHBOOK PAGE
Waterman ballpoint pen; graphite pencil; Prismacolor pencils; Winsor & Newton watercolors; Pentalic Paperback sketchbook, page size 8 ¹/₂ × 11" (22 × 30 cm).

This is a set of preliminary sketches for the jacket illustration of a young adults' book. (The entire set for this series covers several pages.) The sketches show drawing as a tool for recording visual information and experimenting with possible arrangements of that information. This page includes some efforts to visualize the main character, ideas about setting, and some comparisons between a focus on the character and a focus on atmospheric mood explorations. You can't really evaluate ideas until they are put down in visible form. An important part of creative work happens in this type of drawing.

JACKET ART
For *Bridger, The Story of a Mountain Man* by David Kherdian, illust. by Jos. A. Smith (New York: Greenwillow Books, 1987). Winsor & Newton series 7 watercolor round; Winsor & Newton Liquid Acrylic Colour; Hunt flexible quill pen 108; Berol Prismacolor pencils; Arches HP watercolor block; 24 × 18" (61 × 46 cm).

This final version of the jacket art grew out of one of the early sketches shown in the previous illustration. The details in the background wall of mountains have been suppressed by keeping the values of the colors as close as possible, to avoid a visual distraction under the printed title.

SCREAMING SHEEP
Pelikan drawing pen; nonwaterproof
india ink; sketchbook paper,
11 × 14" (28 × 36 cm).

This is the first version of an image that was used for several later pieces. After reading an article in The New York Times *about the death of 6,000 sheep that were accidentally killed when the U.S. Army was testing nerve gas and miscalculated the wind, I felt compelled to do something as a memorial for the victims of this horror. I used a single sheep because tragedy is ultimately individual. I was also considering making a sculpture to be cast in bronze; that is why the smaller figures depict two views.*

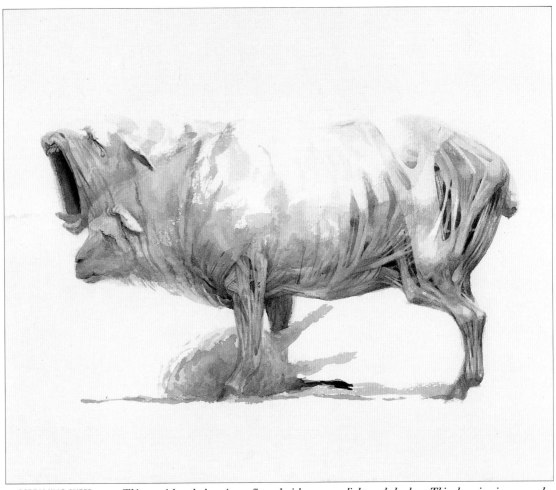

SCREAMING SHEEP
Hand-ground sumi ink
heightened with white
gouache; Winsor & Newton
series 7 watercolor round;
Arches R watercolor paper,
11 × 15" (28 × 38 cm).

This sumi brush drawing refines the idea. The sheep has become a ewe mourning the death of her senselessly stricken lamb which lies at her feet. Ink wash is an efficient means for capturing volume and the interplay of light and shadow. This drawing is a second-state study for a large pencil drawing I later did of the same subject. I will also use this image as a painting, and it may yet become a sculpture at some future time.

SKETCHBOOK PAGES WITH THUMBNAIL DRAWINGS
Waterman ballpoint pen; Sennelier sketchbook, each page 9 1/2 × 12" (24 × 30 cm).

This spread holds five very rapid compositional sketches of the same setup with a model. The larger drawing on the left concentrates on the vertical and horizontal relationships. The midsized sketch (2 1/2 × 3", or 6 × 8 cm) at the far right focuses on diagonal movements. The three thumbnail sketches (each 1 × 3/4", or 3 × 2 cm) compare the effects of different light and dark distributions in the composition. In all of them I have ignored superficial detail, which is irrelevant at this stage, in order to manipulate the larger structural aspects of the scene before me.

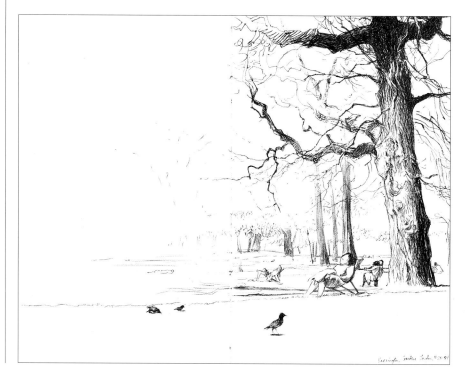

KENSINGTON GARDENS, LONDON
Parker ballpoint pen; sketchbook, each page 9 × 6" (23 × 15 cm).

I was struck by the scale of the trees in British parks. They are so much older and larger than most of the trees in the northeastern United States. This imposed such a distinctive quality of diminutive size on the people who were dotted here and there in the grassy spaces between them.

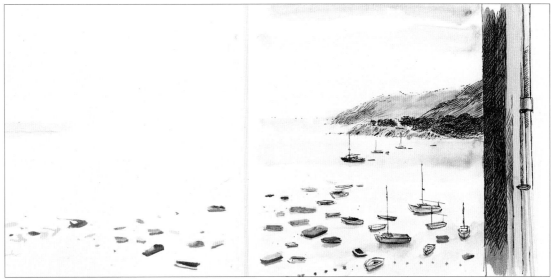

VIEW FROM SUZI'S WINDOW
Koh-I-Noor Rapidograph 2×0
technical pen; Koh-I-Noor
Ultradraw waterproof black india
ink; Winsor & Newton watercolors,
Cosmos kolinsky sable brush;
Artist's sketchbook, neutral pH
paper, each page 7 × 8"
(18 × 20 cm).

This was drawn from a window overlooking the harbor at Cadaques, Spain. The water was littered with small, brightly painted boats that suggested confetti floating. Often when something beckons to you to draw it, it is already clear to you how it will emerge in a later piece of work. But it would be a mistake to wait for such a clear idea before sitting down to record something in a sketchbook. The time you spend looking at something carefully enough to draw it will pay its own dividends over and over again in the future.

SKETCHBOOK
Rick A. Mallette
Speedball C-6 nib; india ink;
black and sanguine Conté crayon;
white Berol Prismacolor pencil;
Utrecht sketchbook 70 lb.
drawing paper, each page
5 ³/₄ × 3 ³/₄" (15 × 10 cm).

This artist has recorded plant forms in a manner that ignores details not relevant to his interests. The interplay of volumes is recorded, while the visual phenomena of specific color changes and surface textures are eliminated at this early stage and will not add extraneous information to future works that may refer to these sketches. In Rick A. Mallette's illustration on page 132, it is easy to see how sketchbook investigations such as these relate in a fundamental way to this artist's elaborate abstractions.

DRAWING STRATEGIES

Like courtship or warfare, drawing is based on strategy. If strategic planning is not a part of the process, the likelihood of a successful outcome can be a matter of chance. The less you consciously take control of your options, the less you are in control of your results. I am using the term strategy in its common meaning: overall planning for the most advantageous position prior to actual engagement. At that point in the drawing process, it is time to think about the techniques discussed in the preceding section.

Why strategy? Because drawing is a continual process of acting on choices. There are too many possibilities of material, technique, content, and concept open to the artist to be embodied in each new work. Every drawing, whether it

originates from an idea or from life, requires that certain decisions be made at the outset. Some of these decisions must be made before the drawing is actually begun. If this is not done, there are always serious problems, but they are most apparent when working from life—that is, from landscape, still life, or the model. Here the artist can easily be overwhelmed by the sheer visual richness of the subject at hand. The more imitative a drawing attempts to be, the more the artist risks the loss of clarity and coherence.

Confronted with random detail, the artist must find and distill from that chaotic overabundance, or create and impose a system of order upon it. A successful drawing is only apparent chaos. It is, in fact, complexity with an underlying simplicity. This is an imposed structuring form presented to the viewer very much in the way a wildly patterned, patched, and appliqued material can be given the coherent form of a tent through the use of a few properly placed tent poles. A drawing needs this ordering visual structure. It does not matter how personal and idiosyncratic the structuring principles may be. Their purpose is to harmonize the superficial detail in a manner that will impart visual meaning and readability.

Expression requires the intervention of the artist in the process. Without this, the drawing is reduced to an exercise in technically accurate rendering, a mindless cataloguing of what is seen. Accuracy of rendering is not without value. It is a tool that should be available whenever needed. The heightened control and increased facility to capture essential detail accurately is best regarded as a means to an end rather than an end in itself. In other words, use it only when it will add to a drawing.

Delacroix called nature the artist's dictionary. However, there is more to making poetry than simply copying words from a dictionary. Exercises to increase control of the medium and sharpen observation are a worthwhile practice for any serious artist. The misuse of this kind of rendering "accuracy" is in trying to equate it with "good art."

For years Picasso deleted accidental passages that "worked," then attempted to recapture the effect intentionally. His reasoning was that something belonged in a picture only if he could include it at will. What could not be repeated had no place in his work. This approach, in which you become a student of your own drawings, is one way of assuring growth in your work.

RECLINING NUDE
Illustrator ballpoint pen; Sennelier
sketchbook, 9 1/4 × 12" (24 × 30 cm).

This was an extremely busy visual subject. I posed the model on a platform covered with rumpled fabrics. Streamers of nylon ribbon were suspended from the ceiling of the studio. I added to the complexity by covering the backdrop with a sheet of mirror-finish Mylar and leaning a large mirror against that. The reflections were wildly fragmented. It was a wonderful challenge.

In order to make visual sense of the scene, I kept the contours broken and open so that I could concentrate on linear movement throughout the drawing. I found clusters of calligraphic shapes and bits of contours that seemed to flow among the forms. After establishing the longest undulating lines to divide the paper from side to side and top to bottom, I selected smaller movements for counterpoint to these major ones. This entailed no loss of realism, and I have plenty of information to work from later—information that already has a system of organization.

CAPE HUNTING DOG
Gillott 303 nib; FW nonclogging waterproof drawing ink; hand-ground Chinese stick ink; Grumbacher series 4116 1 ¹/₂" (4 cm) ox-hair brush; Fabriano Classico HP paper, 22 × 30" (56 × 76 cm).

This drawing was actually a study for another that would include the African Cape Hunting Dog, so I wanted an anatomically accurate portrait of the animal. I also wanted to emphasize its dramatic fierceness. I used the sumi wash to bring out the mottled patterns in the dog's pelt. The ink is drybrushed in the torso to indicate the hair texture.

The minimal background is concentrated around the head in a middle value, dark enough to contrast with the whites in the fur and teeth, yet light enough not to detract from the rich darks in the face and throat. I intentionally left the eye undefined, giving this dog the feeling of a feral natural force. We seem compelled to look at eyes. I wanted the viewer to look this creature in the teeth.

CICADA SHELL
Mecanorma technical pen 2×0; Isabey 6228 pure kolinsky sable watercolor round brush; Pelikan drawing ink A; Yasutomo & Co. liquid sumi ink; Kremer-Pigmente bister ink; graphite pencil; Arches 140 lb. HP watercolor paper, 12 ¹/₂ × 8 ³/₄" (32 × 22 cm).

It is important to set aside time occasionally to draw studies. These serve a double purpose: They sharpen observational skills, and they are opportunities to practice with materials before using them on more ambitious work. I drew the upper shell with sumi ink and brush before adding the hatching and contour lines in pen. The lower, side view was drawn first in light pencil. This was finished with layered washes of bistre—a warm brown, transparent ink. Bistre pigment particles are coarser than other ink pigments and have a low tinctorial strength. It requires more layers to build darks, but the resulting color has an interesting "painted" look to the surface.

DIVERGENT AND SPONTANEOUS DRAWING

Drawings derived directly from environmental sources are referred to as divergent or outer-directed drawings. Imaginary subjects or mind-generated drawings are known as spontaneous images. A sizeable majority of the world's figurative drawings were done from the artist's imagination. Ideas that exist only as a vague presence in the mind can be given form and examined through drawing.

The incomplete nature of mental phenomena makes the relatedness of parts in drawings derived from spontaneous images easier to achieve in many ways. Pictures in the mind have little or no superfluous detail. We rely upon a sense of their completeness rather than actually "seeing" exhaustive detail when seeing with our mind's eye. In order to fashion a complete drawing from a mental picture, the artist must flesh out the image, creating whatever is required to make the transition from an incomplete ephemeral interior vision to a concrete set of forms on paper. These forms are now subject to the laws and tensional dynamics of a retinal image. These dynamics have been brilliantly analyzed by Rudolf Arnheim in his book *Art and Visual Perception: A Psychology of the Creative Eye*, (Berkeley: University of California Press, 1988). The very fact that a complete image must be developed from a partial one is the reason that drawings in this category lend themselves to a more consistent handling.

On the other hand, in outer-directed drawing we are confronted with a seemingly endless array of details. Although much of this is random, accidental, or even unnecessary, and at odds with the clarity of a finished piece of art, there is a pressure to include it unselectively simply because it is there. That reasoning is a misguided use of being true to the subject.

There is too much in nature to let us include everything we see without devoting the remainder of our allotted time on this planet to one picture. All drawing then must automatically be an act of simplification. To use anything less than all means to select.

The process of selection is much easier if we define our intent and set criteria for evaluating the information before us in the light of that intent. Some details may be used directly, some must be ignored, and others will be altered to adapt them to the drawing. This is a purpose of strategic planning when we draw. It allows us to derive maximum advantage from the interplay of three factors: materials, gesture, and pictorial (artistic) intention.

When we are sensitive to the strengths and limitations of our drawing tools, we study the chosen subject using that knowledge as a filter to eliminate inappropriate visual phenomena. Edgar Degas advised us to look at the world as though we have a pencil in our hand because it forces us to see with a new set of eyes. To carry Degas's idea a step further, the world can present different constellations of usable information depending on whether we hold a brush, pencil, or even a rigid or flexible-nibbed pen. Which facts lend themselves to expression in each particular medium? Which ones are irrelevant or even unattainable in that medium?

New materials often pique our imagination to fresh invention and even stimulate perception. To make too much of craft can mislead the artist. A preoccupation with unusual materials can become a lazy substitute for original vision, but disregarding craft is a mistake. The materials are, after all, the physical frame for artistic ideas. Understand your craft. Be sensitive to the nature of your materials but try not to become preoccupied by them. The ideal is to know the elements of drawing so well, and to use your materials so instinctively, that your knowledge and skill are automatically intertwined with the process of seeing and forming images.

SARA SOSNOWY
Parker ballpoint pen;
sketchbook paper,
11 1/2 × 8 1/2" (29 × 22 cm).

This is an example of divergent drawing. The source is located in your environment and worked from directly rather than from memory. Divergent drawings include the figure, still life, or landscape.

BALLOON
Hunt crow-quill pen; Dr. Ph. Martin's
Radiant concentrated watercolor;
india ink; Tombow pencils; Arches
140 lb. HP watercolor paper,
20 × 16" (51 × 41 cm).

*This is a combination of spontaneous (or
mind-generated) image and divergent image.
Although a great majority of drawings are
from imagination or memory, the categories
of spontaneous and divergent drawings often
follow each other as steps in the creation
of an artwork. The artist first works out a
composition for a painting from imagination
and then uses models or landscape studies to
resolve specific details for the finished work.
In* Balloon, *the landscape and balloon were
from my imagination. The sky was a divergent
drawing: I drew the sky that I could see
through my studio window.*

CLOWN
Winsor & Newton series 7
watercolor round no. 10; Senator
fountain pen E; hand-ground
sumi ink; Pelikan fount india ink;
Arches 140 lb. HP watercolor block,
12 × 9" (30 × 23 cm).

*This drawing evolved from random marks.
I began by making small, amoebic shapes with
sumi wash. As the shapes overlapped and
formed darker collective shapes, they suggested
a ruffled collar. I let the image grow from there,
retaining areas of untouched paper for the lights.
I worked over this with the pen, repeating the
initial brushed shapes in contour line and
using the india ink to add definition to the
features. I washed clear water over some of the
nonwaterproof ink lines to lighten them, then
added the darkest grays with new layers of sumi
wash, and finished with some pen hatching.
The drawing is primarily based on arcs from
concentric circles centering on the only complete
circle: the nose.*

LOUIS
Hand-ground sumi ink; Chinese
sheep-hair pointed round brush no. 5;
Hunt crow-quill pen; Pelikan india ink;
A. Millbourn & Co. 200 lb. CP
handmade watercolor paper,
30 1/2 × 22 1/2" (77 × 57 cm).

*Some mediums and techniques
assist the process of selecting
details. This drawing was done
during a twenty-minute pose.
The time limitation, combined
with the size restriction on details
imposed by a no. 5 brush, acted
as a filter to eliminate most
superficial detail. I did sharpen
the definition of his fingers with a
crow-quill pen at the very end.*

MAN LEANING ON A WALL
Higgins Black Magic india ink;
left index finger;
neutral pH sketchbook page,
7 × 8" (18 × 20 cm).

*Drawing with a blunt instrument
on a small paper forces the artist
to search for a few elements that
can convey meaning on the level of
a gestalt. Fingers and noses and
laugh lines under the eyes don't
even exist as usable categories of
detail for this type of drawing.*

GREEN PEPPERS
Steven Assael
Sheaffer ballpoint pen;
BFK Rives paper,
22 × 30" (56 × 76 cm).

A high-quality ballpoint pen offers the artist a degree of control that most nearly approximates the range of a graphite pencil. Unlike broad penpoints, pens that discharge their ink supply quickly, or pens that lay ink of a uniform density, a ballpoint pen lends itself to the investigation of subtle form and surface modeling. It can produce almost painterly effects in the hands of an artist like Steven Assael, who has taught himself to see more than the obvious superficial surface phenomena and is willing to give a drawing whatever time it deserves.

ESTABLISHING CRITERIA

How do you approach setting criteria for the kind of selective seeing necessary for drawing? As an artist you must decide what approach you will employ with each new drawing. Think of this as a dialogue between you and your chosen subject. Try not to let an idea of style become a fetish. Most of those ideas are ideas that came from someone else. Your true artistic identity or style will be a by-product of your response to the world, the embodiment of your personality as it is revealed in your drawings. The things that excite you to do a drawing create a profile of you. Style should not be the result of compiling a rigid set of formulas for technique that you repeat over and over again. This is a creative straitjacket.

The rules you establish need not be the same each time you begin a drawing, but once you have decided upon the limitations for a particular drawing, apply them consistently. You can always devise a new schema or formula for the next drawing. Remember, a formula can guide or it can overchannel, inhibit, and actually block perceptual exploration and original vision.

As its creator, you determine what laws will apply within the universe of each drawing. No matter how illogical or arbitrary your laws may be, they attain validity through consistency of application. They must have sufficient internal logic to capture and hold a viewer's interest until those laws can be deciphered enough to make the drawing coherent. Without an internal logic, the drawing will not communicate.

An awareness of the strategies employed by artists who came before you and the many solutions they found can serve as a menu of ideas to free your own thought processes when you face the blank paper. In this way you can avoid the repetition of habitual drawing procedures that lead to stereotyped drawing solutions.

Fortunately the past does not provide all the answers. There is no single set of rules that any teacher or book can hand down to guarantee a great drawing. Any such formula would certainly kill the spontaneity and excitement of the drawing. There is a direct correspondence between the degree of rigidity with which some artists follow standardized rules and the level of predictability (and boredom) their pictures evoke. Predictability is an asset in science, but it is death in art.

Rather than providing answers, strategic thinking frames the questions upon which you will proceed in your drawing. Ask yourself the questions on the following pages as you confront your subject, whether it is to be found in the outer world or hidden in the world of your memories, fantasies, and imagination.

The nature of your answers determines what you look for, and what you look for determines what you see. Drawing is heightened seeing. A drawing is a diagram of your experience of looking. It is a transposition and an ordered solidification of your mind's perceptions. This is what your style is—a record of your unique vision. Each drawing, then, is a self-portrait. Slavishly borrow someone else's style and you can only do second-hand portraits of some other artist who has done the creative work for you.

The more acres of drawings you do, the more you have studied the work of other artists, the greater the variety of approaches and techniques you have mastered—the more interesting and personal your answers to these questions can be. Art feeds on art as well as on nature.

RABBIT FAMILIAR
Illustration for *Witches* by Erica Jong, illust. by Jos. A. Smith (New York: Harry N. Abrams, Inc., 1981). Koh-I-Noor Rapidograph 2×0; Koh-I-Noor Ultradraw waterproof black india ink; Liquitex acrylic gesso; HMP Vail handmade paper, 19" (48 cm) in diameter.

You decide what is reality in the universe of your drawing. Be consistent enough in the way you apply your visual ideas, and we will accept it. An object does not have to exist in our everyday, consensual reality to be convincing. If the idea is outside of our experience, it helps to clothe it with sensory aspects that are familiar.

STRATEGIC DECISIONS

Answer the following questions, either before you begin to draw (or paint) or at an early stage in the process:

1. What combination of support (such as paper, board, or canvas) and medium will give me the effects that I want?
2. Should the drawing be done in a vertical, horizontal, round, square, or free-form format?
3. What relationship do I want between the viewer and my drawing?
4. What kind of space do I want to create?
5. What scale do I want in the drawing?
6. Should the drawing be done entirely in line, tone, or a combination?
7. Will my line be descriptive, expressive, or process-related?
8. Will I use observational or process-derived textures?
9. What will value change mean in the drawing?

These are not arbitrary questions. Each answer has a unique impact on the progress of a drawing and on its final effect. The answers to some of the questions are mutually exclusive. To be unaware of the implications of these choices means that your intent in the drawing is nebulous. Many drawings suffer because of a lack of clear intent. This makes it all too easy to have a change of approach with no supporting rationale while the drawing is under way. This shift of visual thinking can also happen and remain unrecognized if the artist's attention is totally focused on other concerns.

A break in the continuity of conceptual approach can necessitate a major reworking of the drawing in order to integrate the new material. If this remains unrecognized and no attempt is made to establish relatedness between the new element and the total drawing, it can remain a disruptive and distracting passage in the composition. Breaks of this kind in the visual thought process are more easily identified and accommodated when strategic criteria have been set.

When an original idea changes or new ones intrude, there are three courses of action an artist can take:

1. Incorporate it. Make the necessary modifications in the drawing to reestablish a sufficient degree of relatedness to restore compositional harmony.
2. Do a second drawing. Set the original drawing aside temporarily and begin a new drawing that explores this change of priorities before returning to the first drawing.
3. Make notes. Do sketches to preserve the new idea for a later time and continue with the original piece as planned.

The first possible action results in a new drawing that is an amalgam of the ideas as they occur. The second and third alternatives permit a full development of both the original idea and the new ideas.

Answering the nine questions listed above is so basic a part of drawing that once you become aware of them, they become a natural step in the sequence of any finished drawing. As you become more used to this type of strategic thinking related to your art, some of your answers will be arrived at intuitively, with the questions unconsciously formulated, but there are always answers to these questions on some level in any successful drawing. Let's consider them one at a time.

1. What combination of support and medium will give me the effects that I want? The choice of support can make a contribution to a drawing only if you have taken time to acquaint yourself with as many different papers as possible. Use the section on paper in this book as a reference. I have listed supports that are receptive to inks and indicated what tools they take well. You will not know how a paper receives your handling of a medium until you take the time to experiment with it. Touch is extremely important in drawing. Papers that appear similar often give very different results when you work on them. The amount of sizing in the paper and the nature of its constituent fibers affect the way the ink is held on the surface or absorbed into the paper. A paper imparts a special feel to a drawing tool as it moves over the surface of the paper. The absorbency and the working feel of a paper are considerations in the selection. Their specific natures are interdependent and can be known only from working with a variety of materials. The ink and the paper become the substance of your visual expression.

Make your own paper tests. Be sure to label the paper name, type of pen, brush, and so on, and the ink used in each piece in order to preserve the information in a usable form for later use. The test sheets can be mounted or bound into a book to create a valuable studio reference when you are ordering new paper or starting a new drawing.

The intended use for the drawing is an important factor when you select a support. If the drawing is an illustration that will be reproduced in a book or magazine, you have more options. Not just drawing papers, but Mylar films, tracing papers, boards, and paper products that are not neutral pH can be employed because the final printed image, not the original artwork, is the prime concern.

Drawings that you are doing for exhibition and sale as original works of art have far more stringent requirements. Here, I believe, you have an ethical obligation to use materials that with proper handling can be considered permanent.

(B) Graphite pencil; Winsor & Newton series 7 watercolor round no. 10; Hunt crow-quill pen; Higgins waterproof india ink; Pelikan 4001 ink; Fabriano 100% cotton Classico 200 lb. paper, 11 × 9" (28 × 23 cm).

SEATED FIGURE

The seated figure is not the real subject of these drawings. They are really about light level, contrast, medium, and handling. Compare the differences in your responses to them.

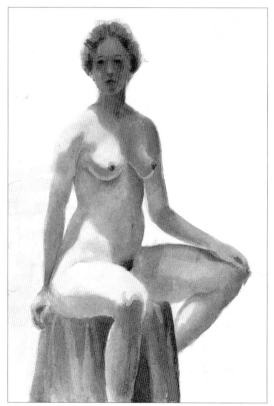

(A) Graphite pencil; Isabey kolinsky sable watercolor round no. 5; Twinrocker handmade wove stationery, 9 3/4 × 6 3/4" (25 × 16 cm).

I chose a gelatin-sized white watercolor paper for this version of the drawing. The sumi ink gives subtle value changes when it is first worked with and is endlessly reworkable, if the paper surface can stand up to it. This 100 percent rag paper is strong and resilient, and it does not absorb the ink because of the surface sizing. This permits a wide range of grays. I used this to break the silhouette with blocks of light.

This paper has a soft, absorbent surface and is heavy enough to have the rigid stability of a thin board. This made it possible to wet most of the paper without making it buckle. I diluted the india ink and started with the lightest gray wash, which covered everything but those shapes of lightest light. I layered several more dilute washes in smaller and smaller shapes. The waterproof ink did not lift with later rewetting. This permitted me to continue darkening large sections of background until I had the degree of contrast that I wanted to push the lit areas of the figure forward. The linework was added last. The dyes in the ink separated slightly , giving a warm sepia tone to the damp paper immediately behind the lines, especially around the eyes and hair. This adds a minute but visible color note.

(C) Gillott 303 pen; graphite pencil; FW nonclogging india ink; FW white ink; Twinrocker handmade wove stationery; 10 × 8" (25 × 20 cm).

The paper texture is smooth enough so that with the hard sizing a flexible fine-pointed metal nib can be used without cutting the surface. This let me take full advantage of the pen. The textured hatches include strokes that suggest a small brush in their range from very fine line to marks that are $^1/_{16}$" (0.16 cm) wide in places.

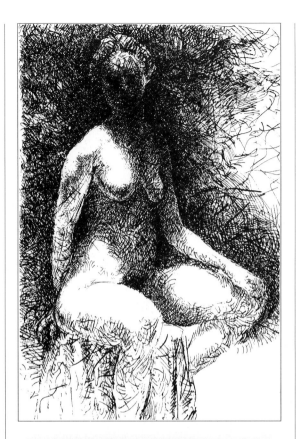

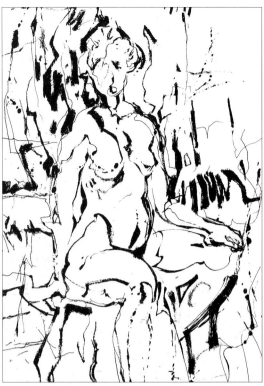

(E) Pelikan Souverän 400 fountain pen; Higgins fountain pen india ink; Tombow fountain brush; Hodgkinson & Co. British Handmade laid white paper, 10 $^1/_2$ × 7" (27 × 18 cm).

(D) Winsor & Newton series 7 watercolor round no. 10; Alphacolor Char-kole; Higgins Black Magic drawing ink; water; Indian Village handmade paper, 10 $^1/_2$ × 8 $^1/_2$" (27 × 22 cm).

I wanted a dramatic lighting contrast here. Notice that the value levels of the shadowed parts of the figure are almost identical to those in version A. The drawing was done lightly with Char-kole and washed into the paper by brushing a wash of plain water over it. I then worked into this with diluted ink and finally some washes and drybrush applications of the ink full strength in the background.

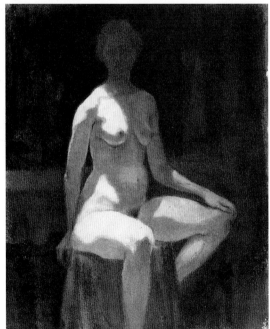

This drawing has a combination of pen line and brush line, each with its own distinct drawing function. The pen was used to begin the drawing. The brush was alternated with it from the start to avoid finishing the forms with a pen line and leaving the brush merely to decorate or restate what had already been done. There is a very active counterpoint established, and each contributes to the forms of the figure and its environment in its own way.

If you trace only the heaviest dark lines, it will be easier to see that they have a compositional grouping and movements that are very different from the movements of the figure. Although I have retained the outlines of the light and shadow on the model, there is no attempt to use light/dark shapes to organize or inject mood. Rather, the lines attack the figure and its surroundings equally, emphasizing lateral tensions.

2. Should the drawing be done in a vertical, horizontal, square, circular, or free-form format? Too often this decision is made out of habit or laziness. A drawn image is different from the object being drawn as it exists in nature. It is also different from something pictured in our imagination. Neither one of these is projected onto the retina boarded and enclosed in a containing field or format that fixes its orientation and size.

When we look at a drawing, the format determines the visual effect of any mark or shape placed on it. Images such as a tree, figure, vase, letter of the alphabet, or abstract shape—even when traced to assure identical copies—are no longer the same when placed within differently sized, shaped, or oriented formats. Each one will have a unique dynamic relationship to the space that it occupies. Even its placement within that space will alter its effect.

The long axis (longest dimension) of the paper will reinforce the dominant axis of a drawn shape if they are parallel. If the shape is aligned with the short axis of the paper, the long axis becomes a contrasting movement that will diminish it. An act of blind seeing is required to disregard that fact and its effect on a composition.

Rudolph Arnheim made the following statement in his book *The Power of the Center: A Study of Composition in the Visual Arts* (Berkeley: University of California Press, 1982): "The upright format strengthens the verticality within the picture. It makes the portrayed figure taller and the waterfall narrower and longer." A group of vertical elements placed on a horizontal format will be reduced in terms of the apparent strength of their vertical thrust by the horizon-like pull of the border.

The format not only influences the picture within it but is influenced by it. When a rectangle is filled with elements that exhibit certain vectoral tendencies, such as dominantly vertical, horizontal, or diagonal marks or shapes, its proportions will look different, depending on whether those marks complement or contrast with the enclosing rectangle. In this way the format is also influenced by the picture.

HOW LONG WILL NIXON HAUNT THE GOP?
Reproduced in *Newsweek*, September 23, 1974. Hunt hawk-quill pen, Higgins Black Magic drawing ink, 100 percent rag bond paper, 16 × 12 ¹/₂" (41 × 32 cm).

The gesture of this image with its pull upward is not only parallel to the long dimension of the paper, but centered on the central vertical axis. This stabilizes the column of the figure and mask. The diagonals that zigzag back and forth across that axis add asymmetrical movements for excitement within the simple silhouette.

**EMILY AND SMAUG WITH
THE IRRITATED ROCKS**
Koh-I-Noor Rapidograph
2×0; FW nonclogging
waterproof drawing ink;
Morilla R watercolor paper,
14 1/4 × 20" (36 × 51 cm).

*This drawing is
made up of a row of
vertical thrusts that
act collectively to
form a horizontal
progression. Cover
the picture on either
side of the little girl
so that your hands
frame a vertical
slice of the drawing.
Notice how much
stronger the upward
movement of her
gesture becomes. In
this case, rather than
overemphasizing
the vertical, the
horizontal paper
pulls your eye back
and forth from dog
to girl and from
side to side.*

FALLING MAN
Gillott 303 pen, FW nonclogging
waterproof india ink,
handmade laid stationery,
8 3/4 × 5 1/2" (22 × 14 cm).

*The orientation of the paper can be
used not only to strengthen or weaken
dominant movements among parts of
an image, but to become part of the
image itself. In* Falling Man, *the long
axis of the paper not only echoes the
movement of the streamers, it offers a
shaped space that pulls the figure into
it. Turn the drawing upside down, and
the large empty space above the figure
seems to have weight. It presses down on
the figure and flows around it through
the rippling ribbons.*

3. *What relationship do I want between the viewer and the drawing?* The answer to this question is determined by the artist's philosophical attitude about drawing in general. Georges Braque tilted the space in his still lifes to create a discontinuity with the viewer's space. This created a barrier between the viewer and the art so that the picture would remain an isolated object to be contemplated. (Braque went so far as to add sand to his paint in order to accentuate the physical surface of his painting. This further reinforced the awareness of the painting as a concrete object on the wall, separate from our reality.)

At the other extreme, the space in a drawing can be constructed as an extension of the viewer's space. This creates a psychological sense of identification with the drawing. The viewer's world is continuous with the world within the drawing, and the viewer can "enter" the drawing's space. In the one extreme the picture remains a picture. In the second we are invited into its reality.

**THE MYSTERY OF
THE FLOWER**
Liquid sumi ink; 1" and 4"
(3 and 10 cm) white
sheep-hair hake brushes;
charcoal; Arches cover
paper, 52 × 52"
(132 × 132 cm).

The space in this drawing is flat and ambiguous. The fragments are spread across the surface of the paper or just within it. In some places the floating pieces cluster or separate in a fashion that implies movement, while in others they drift or hang motionless. The viewer is presented with an ornament-strewn flat wall that does not invite entry. The drawing presents the fragments for examination as objects on a bed of black.

HORSEMASKMAN
Mecanorma technical pen 2×0; FW nonclogging waterproof india ink; Twinrocker handmade stationery, 8 1/2 × 5" (22 × 13 cm).

The space in this drawing is made up of individual units drawn with the appearance of three-dimensional form, but layered to make it impossible to read a consistent depth. The result is an ambiguous flat space whose forms exist in shallow relief. This excludes the viewer, denying a point of entry. The intent is to evoke the irrational juxtapositions of free association.

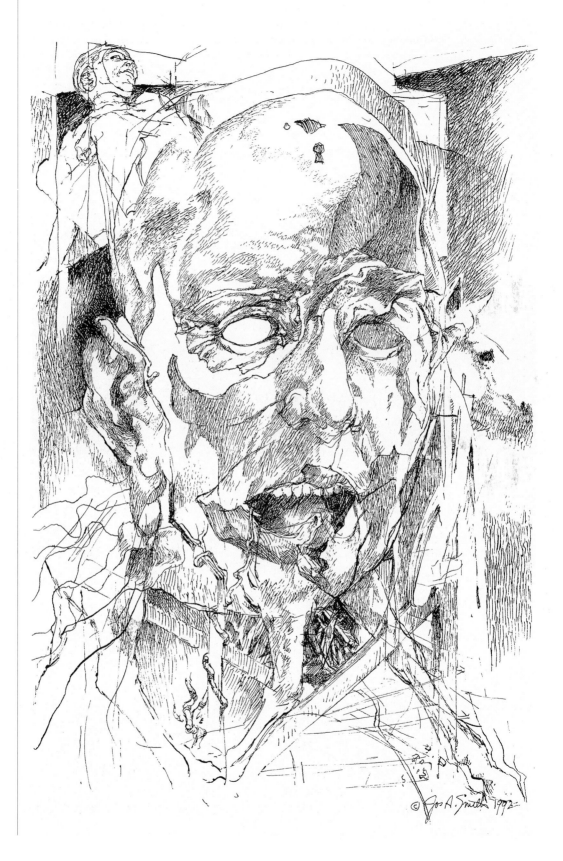

STATEN ISLAND FERRY
Rotring Rapidograph 4×0;
Koh-I-Noor Universal waterproof
black india ink; Arches R watercolor
block, 9 × 12" (23 × 30 cm).

*This freehand drawing uses a
single vanishing point perspective.
The horizon line is on the eye level
of the seated commuters. The result
makes the viewer look into the
drawn space from the vantage
point of a passenger occupying one
of the benches. This creates a direct
personal relationship with the
image. You view the scene from a
position in space within the
drawing. Although this is a small
drawing, the horizontal format
mimics our wider field of vision.*

HALLWAY
Parker ballpoint pen F;
Sennelier sketchbook,
12 × 9 ½" (30 × 24 cm).

*Here the viewer's eye level is
standing height. The horizon line
is high to keep the line of vision
parallel to the floor. We look into
the space, not down at the floor
or up into the ceiling. The lines
between the boards on the floor,
walls, and ceiling define the
angled planes of the twisting
hallway. Bands of light and
shadow are cast by sunlight that
fills the hidden rooms to the right
of the corridor. The light and
dark contrasts are intensified as
we move deeper into the drawing's
space, which pulls us into it. The
floor is drawn as though it is
continuous with the floor we
stand on, making the drawing an
extension of our space.*

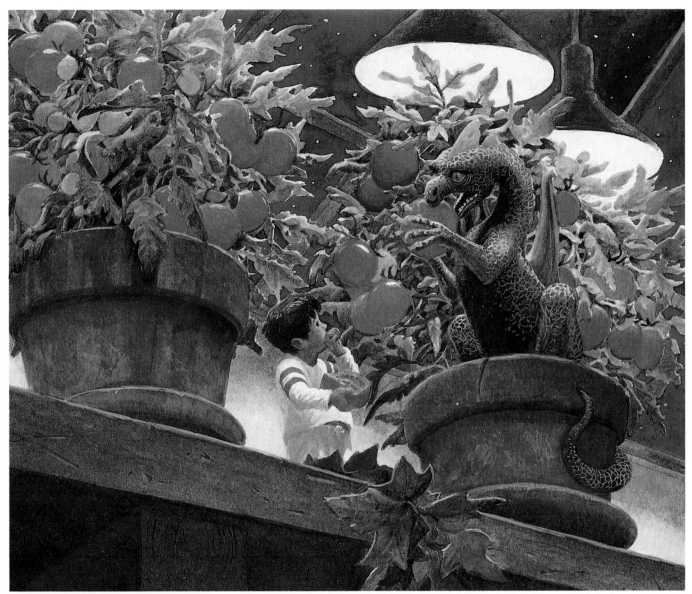

EATING THE PRIZE-WINNING CHERRY TOMATOES
Illustration from *Matthew's Dragon* by Susan Cooper,
illust. by Jos. A. Smith (New York: Macmillan,
Margaret McElderry Books, 1991). Gillott 303 pen;
watercolor rounds; Rotring ArtistColor inks;
Koh-I-Noor Universal waterproof black india ink;
Morilla R watercolor block, 9 1/2 × 11" (24 × 28 cm).

*The viewing angle for this drawing is through the eyes of someone very small, looking up
from the floor. Everything in the illustration is above the viewer's eye level. This is a device
for manipulating the viewer's position and sense of scale in relation to the subject—just as
filmmakers determine a camera angle.*

4. What kind of space do I want in the picture? This is clearly related to question 3. In general, there are two kinds of space possible in a drawing: flat or deep. The drawing either emphasizes lateral tension or depth tension. This means that the graphic elements are employed in a set of formal relationships that create a sense of movement either in two dimensions only, across the flat surface of the paper (lateral tension), or at right angles to the surface plane of the paper (depth tension). The best use of depth tension must retain an awareness of surface relationships and structure. In other words, the best realism must work on an abstract level.

Traditional Western spatial constructions since the time of Giotto have created some form of depth tension. The earliest form is still used today by many artists, especially sculptors when they draw. This use of depth tension treats the plane of the paper surface as though it were a solid supporting ground. Forms drawn using this plan are conceived as projecting forward from the paper. They seem to rest on its surface or shallowly in it like a bas-relief. This "sculptural space" develops the weakest pictorial space. The drawn forms are often conceived as being separate from and unrelated to the borders of the paper. The image is treated as a total unit—vignetted— an island of forms floating on a surrounding field of uninflected paper. In terms of its relevance to the image, it is a neutral value field that could extend indefinitely in every direction.

Artistic inquiry in drawings of this type does not extend beyond the drawn edge of the

MEA CULPA
Gillott 291 Superfine pen; Cosmos kolinsky
watercolor round no. 6; Pelikan fount india ink;
water; Indian Village handmade paper,
8 ¹/₄ × 6 ¹/₄" (21 × 16 cm).

STUDY OF MODEL LEANING AGAINST A WALL
Parker ballpoint pen; handbound sketchbook
by Daren Callahan, The Scriptorium, Athens,
Ohio, 10 × 6 ¹/₂" (25 × 17 cm).

A weak sculptural pictorial space is created when a modeled form in a drawing is treated as separate and unrelated to the borders of the paper. When there is more than one object, their pictorial environment is the surface of the paper around them, not a single deep space that contains everything within it.

Cast shadows establish a spatial relationship between an object and a neighboring plane. If that plane is the paper surface, the object will seem to sit on it. If the plane is not parallel to the paper surface, depth tension opens a pictorial space that appears to exist behind the paper.

object's image. The artist in this case is not concerned with the relation between the image and its environment. A common technique for indicating background in this form of drawing, if it is indicated at all, is to use diagonal parallel strokes that maintain a flat surface between the positive forms—flat tones replacing flat paper. Bracelet shading or curved hatching create a sense of volume in the drawn forms themselves.

A far more complex variation of depth tension treats the paper as a window—a transparent plane. Here the pictorial elements are manipulated to create the illusion of a limited or deep space, which appears to open behind the paper. This illusionistic space may be limited in depth by a wall, tabletop, or screen of foliage that serves as a backdrop for the focal objects of the drawing.

In an interesting complication, this limiting enclosure is sometimes broken by including a window, open door, mirror, or a framed picture within the picture. This allows the artist to create an additional circumscribed movement into a deeper space in a restricted area of the composition.

This sharply defined opening into a deeper level of depth works in a purely structural sense. A strong movement into depth has enough perceptual weight to counterbalance a graphically heavy compositional element that has a positive volume. This subtle but dynamic use of asymmetrical balance can be employed when you choose depth tension as a drawing strategy. Edgar Degas used this device brilliantly in many drawings and paintings.

NOCTURNE
Joseph Gillott 303 nib; Higgins waterproof black drawing india ink; Svecia Antiqua laid paper, 11 × 8 ½" (28 × 22 cm).

A focal stress is given to a limited area within the composition where a window, open doorway, mirror, or picture within the picture is included. The deeper space contained in that small area exerts a pull that can be used to counterbalance large volumes that are asymmetrically placed in a composition. It is as though we equate a deeper pocket of space with a solid volume that appears to have mass and weight.

Notice how much stronger is the tensional pull in the fragment of architectural space at the upper right than in any of the other structures in the drawing.

I used close values to link shapes that are not part of the same object, softening boundaries and giving the eye transitional passages. Our eye moves easily from the man's elbow at the lower left edge, across his shoulder and head, and into the drapery above his neck.

Repetition of linear elements creating a feeling of relationship between two parts is another means of leading the eye. Although the forms are different, the arched ribs that become the tortoise's shell are echoed in scale and direction by the boards on the walkway that leads back between the man's knees toward the wall at the rear. In a similar way, the scale of detail in the entwined shapes contained in the windowlike area at the upper right echoes the scale and pattern of the scales on the tortoise's head and leg. There is also a faint echo of similarly scaled details in the intervals along the twisting ribbon that emerges from the sleeper's mouth. This helps keep the viewer's eye moving from part to part through the drawing.

DRAWING STRATEGIES

Depth tension is commonly associated with one or more of the following techniques for establishing an illusion of receding space: linear perspective, atmospheric perspective, overlap, change of scale between objects of known size, graded tonal areas, modeled surfaces, directional light sources that create shadow and cast shadows, and the use of gradient—a sequentially diminishing change in the length, thickness of, and/or spaces between marks. Van Gogh often used gradient in his ink landscape drawings.

Lateral tension is emphasized and depth tension weakened by the use of strong compositional pattern, abrupt medium breaks and changes, and repetitions of shapes that are close in size. The use of parallel echoing across the picture plane between lines, sections of contours such as folds, and internal axes of shapes is another method of reinforcing lateral relationships in a drawing.

PETROGLYPH/MIMBRE II WALL SERIES
Sandra Halat
India ink; acrylic paint; collaged straw-like material; BFK Rives, 24 × 32" (61 × 81 cm). Private collection.

The artist has used the shapes in this densely occupied painting to underscore the flatness of the picture plane. Surface and image are synonymous. The total lack of depth tension in this drawing makes the intervals between the animated figures more important as shapes and not merely background. This interchange between the shapes that we can identify and label and the pure shapes that surround them gives the entire flat composition a decorative quality and a high level of energy at the same time. This lateral tension strengthens the pattern character of this picture.

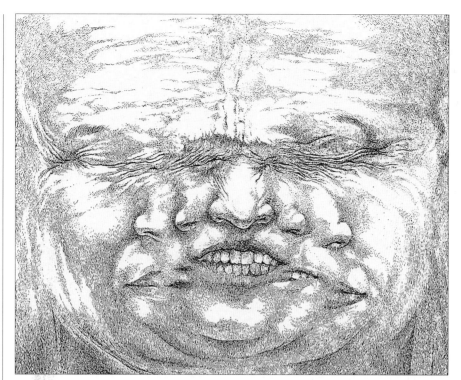

ANXIETY
Hunt Speedball Super
Black waterproof india ink;
Hunt crow-quill pen;
handmade paper
containing silk fibers
(no longer produced) with
gelatin surface sizing added,
21 ¼ × 21 ¼" (54 × 54 cm).

The repetitive use of an element without changing its size weakens depth tension and reinforces our awareness of the flat picture plane. This is an example of lateral tension. This drawing uses a minimal number of contour lines. Much of the image depends upon white shapes created by the absence of hatching.

SEATED MODEL
Waterman ballpoint
pen; Kenpro fountain
brush (sable hair) and
cartridge ink; Sennelier
sketchbook, 12 × 9 ¼"
(30 × 24 cm).

Open contour, little or no internal detail within shapes, and abrupt breaks from one medium to another all serve to flatten the pictorial space of a drawing.

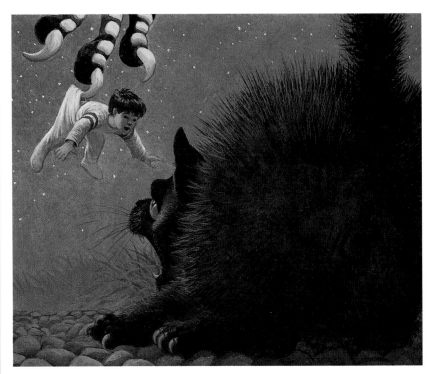

**A GREAT GOLDEN CLAW . . .
LIFTED HIM UPWARD**
Illustration from *Matthew's
Dragon* by Susan Cooper,
illust. by Jos. A. Smith
(New York: Macmillan,
Margaret K. McElderry Books,
1991). Hand-ground sumi ink;
Winsor & Newton watercolors;
Rotring ArtistColor inks; sable
watercolor brushes; Arches
watercolor paper, 9 1/2 × 11"
(24 × 28 cm).

*Depth tension can treat
the paper as a transparent
window. The pictorial
space is deep. The drawing
forms exist "behind"
the paper. This type of
pictorial space may be
boxlike, limited by a wall
or foliage, or it may be a
landscape space that
extends to the horizon.*

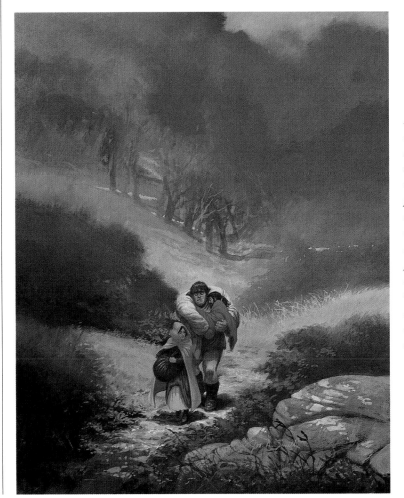

COVER ART
For *On Fortune's Wheel* by
Cynthia Voigt (Atheneum Children's
Books, Macmillan Pub. Co., 1990).
Sable watercolor rounds; Gillott 170
pen; liquid sumi ink; Sennelier
pastels; Rotring ArtistColor inks;
Arches 140 lb. HP watercolor block,
17 × 14" (43 × 36 cm).

*Atmospheric perspective creates
the appearance of depth by
reducing value contrasts and
color intensities in the distance.
Objects close to the viewer have a
potentially full range of white to
black values and full saturation
of hues. As distance is increased,
the darkest and lightest values are
progressively eliminated until
only a very close range of middle
value is perceived. Color also
loses intensity until at extreme
distance the colors tend toward
cool, neutral tints.*

COVER ART
For *Dragon's Milk* by
Susan Fletcher,
illust. by Jos. A. Smith
(New York: Macmillan,
Atheneum Children's
Books, 1989). Sable
watercolor rounds;
Gillott 404 flexible sketch
pen; Dr. Ph. Martin's
Black Star waterproof
matte india ink; Rotring
ArtistColor inks; Berol
Prismacolor pencils;
Arches HP watercolor
block, 20 1/2 × 13"
(52 × 33 cm).

*A sequential change
that gradually reduces
the size of an element
in a drawing creates
depth tension. This
use of gradient can
be used to structure
an entire drawing or
can be confined to
sections of it. The
rocks on the floor of
the cave show a use
of gradient to push
the central image
deeper into space.*

DRAWING STRATEGIES

5. *What scale do I want in the drawing?* Scale is a complex factor in the expression of any drawing. Its strength depends upon its power to evoke sensory associations in the viewer's memory, associations that are independent of the literal meaning of the image (if there is a meaning). Even in figurative drawings there are different ways of giving a specific sense of scale in the drawing. Each quality of scale carries its own nonverbal message hidden in the resulting image.

UNTITLED
Ballpoint pen, Winsor & Newton
Black + White sketchbook,
bond paper, 16 ¹/₂ × 11 ¹/₂"
(42 × 30 cm).

Although the figure is drawn in a more developed manner than the rest of this double-page sketchbook study, its scale and placement at the base of the composition make the space around the figure take a more assertive part in setting the expressive content of the drawing. The drapery soars while the figure sits posed at its base.

The size of the object or objects being drawn in relation to the total area of the paper has a profound impact on what the drawing conveys. Volumes can expand and assert themselves in the space around them, or they can shrink away from it. The message of the scale in this sense can reinforce the intended literal meaning of a drawing, or it can ironically contradict it.

Scale not only applies to the sense of expansiveness or fragility of the volumes in relation to the total space that contains them, but also to the amount of detail or lack of it in a drawing.

Scale of detail is an indisputable expressive factor. Large, simple forms (such as those of Léger, Botero, Matisse, Tintoretto, Modigliani, Titian, Rodin, Salvator Rosa, or the landscape wash drawings of Claude Lorrain) add up to a quieter surface than one that is built from a densely crowded or clustered tapestry of details (Jan Gossaert [also known as Mabuse], Dürer, James Spanfeller, Hymen Bloom, Ivan Albright, Sarah Landry, Jan van Eyck).

Where the forms are drawn with a concentration on the larger, simpler volumetric relationships, the visual impact is more dependent upon the quality of movement animating the drawn marks. Does the artist's hand seem constantly in motion, resisting any urge to slow down enough to explore the character of small details? In drawings made with this broader, faster attack, the viewer's eye movements are sweeping, scanning movements that reenact the movement quality of the artist's hand.

Where the pen lines do slow down, responding to smaller, more particular details, this diversion of attention elicits a very different eye movement in the viewer. Here the scanning slows, the arc of focus in the eye narrows from 12 degrees to as little as 1 degree. This finer field of focus means that the eye must crisscross an area many more times in order to see it thoroughly. This forces a viewer to spend more real time in order to read those areas that are perceived as carrying more information. It is fascinating that this occurs even when there is no identifiable "information"—only a sense of more graphic activity to be seen. In this way the artist can manipulate the viewer's experience of time. Clusters of lines drawn with a fine point can slow the eye, while bold, sweeping strokes from a broad pen can superimpose a framework of more quickly scanned lines. Rembrandt used this type of counterpoint with breathtaking effectiveness.

NESTLING
Dr. Ph. Martin's Hicarb waterproof india ink; watercolor brush; Dremel Moto-Tool Model 395-3 with a Flex-Shaft and a #952 aluminum oxide grinding stone bit; Fabriano Classico 300 lb. HP paper, 22 × 21" (56 × 53 cm).

The size of the object interacts powerfully with the size of the paper. The hawk is uncomfortably contained within the format. It seems about to press against the edges of the paper. Large forms assert themselves and can express a power and aggressiveness that are independent of the literal meaning of the subject. If I had drawn this hawk on its nest at the top of a tree, as we might see it from a distance, the subject would be the same hawk, but the evoked meaning or primary subject of the drawing might be that the bird is only a fragile fragment of life when viewed against the scale and complexity of the forest.

I covered the dark areas with a solid black ink layer and then sanded the whites of the feathers, eyes, and twigs of the nest with a power tool to uncover the details.

SKETCH FOR RECLINING NUDE
Manuel Hughes
Colored pencil;
ruled legal paper,
6 × 8 ¹/₂" (15 × 22 cm).

RECLINING NUDE
Manuel Hughes
Ruling pen; india ink;
French curve;
Strathmore 1-ply
bristol, 7 × 8 ¹/₄"
(18 × 21 cm).

These two drawings show a process that gradually refines away details. The scale thus created is limited to large forms even though the drawing itself is done on a very small format.

The sketch is done directly from life. It is already focused on the full curves in the figure and omits small-scale information such as toes and hair. The second version

has been drawn with a ruling pen (a nontraditional drawing instrument if ever there was one) and French curve to eliminate any wavering that is often a factor in curved freehand lines. The figure is drawn entirely with unconnected curves. The segments may be individually severe, but their collective interaction evokes a figure of surprising sensuousness.

**RAT IN TOP HAT
AND TAILS**
Karen Beckhardt
Reproduced in an ad by
Arista Records in *Billboard*,
February 11, 1978.
Bic ballpoint pen;
bristol board, 11 × 14"
(28 × 36 cm).

*Compare this
drawing with the
nude by Manuel
Hughes.* Rat in Top
Hat and Tails *has
no quiet areas. The
surface swarms with
detail that is treated
in two size divisions:
the clothing and
tail, and the fur and
facial features. Both
groupings are full
of movement. The
contour is active,
the fur seems to flow
like small flames,
and the tail not only
loops its way up the
right side but seems
to twist like rope
as it does. This
illustration, although
physically larger
than the Hughes
nude, employs
surface detail in a
manner that gives it
a much smaller scale
as a drawing.*

DRAWING STRATEGIES

UNTITLED
Gillott 404 flexible sketch pen;
Speedball nonwaterproof
drawing ink; Twinrocker handmade
white stationery; 8 1/4 × 6"
(21 × 15 cm).

Even a drawing that has little real information can slow the viewer's scanning and make an image that takes longer to read. The sense of internal movement or flow has been reduced by the intensive activity of the marks. There is much more happening on this paper for the eye to take in.

BABY
Takara brush-tipped fountain
pen (sable) and ink cartridge; Indian
Village handmade wove paper,
5 1/4 × 7 1/4" (12 × 18 cm).

In this quick sketch, I knew what I wanted my line to convey before I drew it, and then did it as decisively as possible.

I did not connect most of the lines to form completed enclosures. In this way the paper flows into the image, and we complete the drawing with our eyes. Notice the difference in your eye movements when you look at this simple drawing and then at Orant *on the following page.*

ORANT
Koh-I-Noor Rapidograph
2×0; Koh-I-Noor
Ultradraw waterproof
black india ink; Twinrocker
handmade white
stationery, 8 ³/₄ × 5 ¹/₂"
(22 × 13 cm).

*This drawing suggests
volume while limiting
depth tension. The
effect is more that of
a shallow relief than
of a fully rounded
sculptural form.*

*The drapery folds
are fully modeled.
They are not taken
from observing folds
in cloth, but rather
derived from shape
conventions used by
Dutch woodcarvers
to suggest overlap
(depth) in relief
panels. The right side
of the figure is
darkened to add
shadow, but the
figure retains its
flatness. The reason
for this is that the
change of value from
the lit side to the
shadowed side
(which would have
imposed a unifying
cylindrical volume
on the figure as a
whole) is not strong
enough to overcome
the dense clustering
of details throughout.
Neither are there
large, tilted planes
that carry the folds
on their surface.*

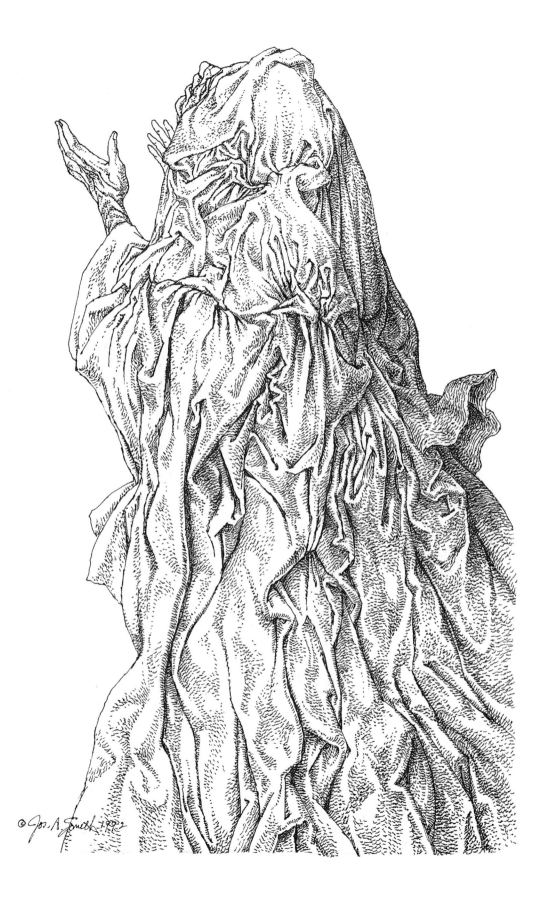

6. *Should the drawing be done entirely in line, or should it incorporate tone?* A pure contour drawing—a composition done entirely by defining the edges of shapes with line using no tone—may look simpler, but it makes more demands on the artist. Less in a drawing is not the same as less of a drawing. Properly handled, less can be more. A line by itself has only itself to offer. Either it is where it should be with the necessary movement and weight, or it isn't. In a contour drawing there is nothing to distract us from any shortcoming.

Tone or value similarities can increase the visual rapport between unlike shapes, forms, textures, and spatial areas. Tonal differences can also reduce the visual bond between like shapes. In other words, tone can cover a multitude of sins.

It would be a mistake to regard pure contour drawings as restricted solutions. The possible variations are limited only by your imagination. Some artists choose an uninflected line, one that retains a fixed thickness throughout its entire length. Technical pens would be a natural choice for a drawing of this type. Here, the

**NUDE WITH ARM
EXTENDED**
Parker ballpoint pen;
Winsor & Newton
Black + White sketchbook,
bond paper, 11 × 8 1/4"
(28 × 21 cm).

Pure contour drawing, defining shapes with line and no tone, is a more demanding method of drawing than techniques that allow the artist to include modeling or tonal areas. If the line is not in the "right" place or does not have the desired sensitivity, there are no darks to soften the effect or distract the viewer's eye to another section of the paper.

weight of invention must be carried by the shapes created with those lines.

This kind of drawing can be opened by using two or more sizes of penpoint, such as a #000 in combination with a #0 or #1, or a combination of pen and brush line. If you prefer marks of changing weight, a flexible point such as a quill pen or a brush will impart an almost fluid transition between line thicknesses. A second level of compositional relationships can be introduced by taking advantage of the variation in stress or emphasis between the most delicate lines and broader strokes by restricting the areas on the drawing where the darkest lines will occur.

Spatial relationships can be created counterpointing the dark elements to the shapes and movements made from lighter lines. The placement of darks and lights may be justified by design needs or they can be used to add meaning. Darker edges when used only on contours that face the same direction can indicate the shadowed side of forms without resorting to modeled shading. This gives a stronger sense of volume.

The introduction of tone in a drawing brings in an additional equivalent to our everyday visual experience. An area of tone in a drawing is a potent graphic force. It has several pictorial functions. Like line, it enters into such visual issues as direction, balance, emphasis, variety, and creating relationships or unity. Like line, it can make a lively abstract contribution. Since tone always has a shape as long as it covers less than the entire paper, these shaped islands of graphic activity and emphasis can contribute a new layer of compositional structure beyond those created by linear relationships.

Tone or value can be used with variation to ensure interest throughout a drawing. Used this way, it becomes the single most vigorous means of evoking mood. Low value can make a drawing dark and brooding. A wider range can enliven it with pattern and contrast of darks and lights. With a limited range of high values, forms can merge like a landscape shrouded in fog. This atmospheric emotional quality can reinforce the anecdotal meaning of a drawing or, adding paradox, contradict it. This flexibility is possible because the emotional content of value is independent of the identity and connotative meaning of the objects included in the drawing.

PENN STATION WAITING ROOM
Rotring Rapidograph 4×0 and 2;
Staedtler Marsmatic 745R drawing ink;
Crane's Crest wove paper,
6 1/4 × 8" (16 × 20 cm).

Even a combination of two weights of uninflected lines can have a surprising impact in a contour drawing. Overlap is one of the most widely used graphic devices for showing differences in spatial depth. The suggestion of different levels implied by overlap in this drawing is not perceptually as convincing as the spatial separation created by the increase of line thickness in the figure at the right.

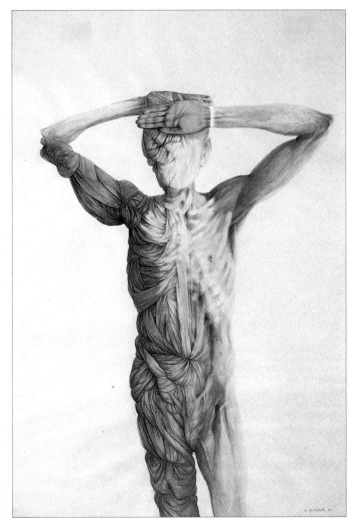

I AM WAITING
Sable watercolor rounds; hand-ground
sumi ink; watercolor; J. Whatman 90 lb. CP
watercolor paper, 38 × 26" (97 × 66 cm).

I did this drawing upon returning home after dissecting a human cadaver for the first time. The wrapped forms were my memory response to the plastic sheets that enfolded the body. This drawing served the function of integrating material that contained a disturbing element even though it was part of an exciting learning experience. The drawing gave me a means of endowing the person with a feeling of dignity.

BOY HOLDING
HIS SHOULDER

This set of drawings demonstrates the difference a single variable can make in establishing feeling content in a drawing. I used the same paper for each panel. The format size, scale, and placement of the figure are uniform. Any differences in expression are a result of variations in the application of the ink and use of line, tone, and contrast. Each of these should be a conscious, strategic decision by the artist.

(A) Mecanorma technical pen 3×0;
Koh-I-Noor Universal ink;
Twinrocker white gelatin-sized
laid paper, 8 ¹/₄ × 6 ⁷/₈" (21 × 16 cm).

This version is drawn with a uniform contour line and nothing else. The drawing offers interlocked shapes and nothing more. The tone is high-key, and the image has a delicate, precise feeling.

(B) Gillott 303 pen; FW nonclogging
india ink; Twinrocker white
gelatin-sized laid paper;
8 ¹/₄ × 6 ⁷/₈" (21 × 16 cm).

This drawing employs an angular line of varying thickness. The surface has a more aggressive, nervous feeling. The forms seem to fill the paper more fully. The eyes, containing more massed blacks, tend to involve you more directly. There is a bare suggestion of color change in the eyebrows and upper lip.

(C) Winsor & Newton series 7 watercolor rounds nos. 3 and 5; Higgins nonwaterproof india ink; Twinrocker white gelatin-sized laid paper, 8 ¼ × 6 ⅞" (21 × 16 cm).

The brushstrokes expand the darks and considerably lower the overall value of the drawing in relation to versions A and B. This treatment begins to make the figure feel crowded into the space of the paper. The brush stippling on the sweater adds an intermediate value to a drawing that is still done with solid blacks.

(D) Graphite pencil; sumi ink; Winsor & Newton series 7 watercolor round no. 8; Twinrocker white gelatin-sized laid paper, 8 ¼ × 6 ⅞" (21 × 16 cm).

This drawing relies on slight variations in value to define the forms. A suggestion of light and shadow introduces modeling into the head, neck, and arm. Except for two small areas in the hair, the drawing has a limited middle-value range that is much more subdued in feeling. Notice the way the value of the background enters the mass of hair on the left and left top, and how the values in the right side of the hair reverse contrast with the background to push it deeper.

(E) Mecanorma technical pen 2×0; Winsor & Newton series 7 watercolor round no. 8; Twinrocker white gelatin-sized laid paper, 8 ¼ × 6 ⅞" (21 × 16 cm).

This last version incorporates line, massed blacks, and modeled middle tones done with hatching and stippling with solid black marks. This drawing is almost equally divided between black and white. It has a graphic strength from the stark blocks of white and black that is much more assertive although less agitated than the others. There is more surface activity here to pull you into the areas between the individual features, so that the drawing does not rely on the eyes or mouth as the only interest within the contours of the face. There is more attention to transitional areas like the cheek, chin, or neck, and the hair takes on a more active role to offset the black shapes of the lower half.

DRAWING STRATEGIES

A WOMAN ON HORSEBACK

Drawings done in series have always interested me. Retain certain structural aspects, subject placement, or scale, and the effect of any change becomes more pronounced. This kind of exercise can be very informative if you analyze the results and ask yourself what aspects you respond most to, and why.

(A) Mecanorma technical pen 2×0; Twinrocker handmade white stationery; 5 1/2 × 8 1/2" (14 × 22 cm).

In a stippled drawing, line is not a factor. No directional hatching or contour lines add movement. Tonal contrasts are reduced. The drawing seems hazy, quiet, and flooded with light.

(B) Mecanorma technical pen 2×0; sable watercolor round; Indian Village handmade paper, 8 3/4 × 10 1/2" (22 × 27 cm).

The black sky adds drama. The lights on the ground plane appear spotlit. Contrasting bands on the foreground flatten it. Variations in the hatched tones of the background are overpowered by the dark/light contrasts, flattening the rear space and bringing it forward. The black sky works identically to the bands of black across the bottom of the picture. They have the same spatial function: They lie flat on the surface of the paper. There is nothing to pull you into an atmospheric deep space. This gives the drawing the theatrical aspect of a stage set. Any suggestion of volume in the folds of the woman's dress are overpowered by the extreme jumps in value from the uninflected black areas. The flat black shapes refer to each other rather than the hatched areas that they adjoin.

(C) Mecanorma technical pen 2×0; Amalfi handmade stationery, 8 1/2 × 11" (22 × 28 cm).

Here the value level is lower, and the darks on the horse are massed. This emphasizes the silhouette and adds to the sense of weight and volume. The rider's head is lost in shadow, and there is a more aggressive feeling to the shapes. This image is more ominous. The field around and behind the horse has an ambiguous vertical flatness, having been rendered like hanging ribbons. The horse and its rider take on stronger, more sculptural volumes from the spaghetti-like folds that are wrapped around and over the shapes. This is reinforced by the suggestion of light and shadow that models them.

7. Will my line be descriptive, expressive, or process-related? A concern about line is really inseparable from the discussion of scale in question 6. There is, however, an additional consideration. Line can be used in three approaches that embody such fundamentally different attitudes and yield such different results that we can regard this as a separate strategy. The approaches are descriptive, expressive, and process-related.

- *Descriptive line* is developed at a relatively slower pace. It is a probing, exploring line that conveys far more information than direction alone. It continues or ends not because of rhythmic phrasing but to record visual incident. Its primary concern is to record contour change, orientation, and points of overlap. Its movement has a high correlation to the movements of the eye as it traces the edge of a form. This line is often associated with the use of observational textures. It is also found more often with a controlled use of modeled tones when it is not being used in a pure contour drawing.

- *Expressive line,* or cursive line, embodies a very different type of drawing. The line is laid rapidly with a drawing tool charged with energy. Rather than the hand transcribing or altering details sought out by the eye, the gesture of the hand seems to capture form simultaneously with the mind's comprehension. It may even lead it, helping to create the perception. Invention and gesture occur together, with little consideration given to subtle, complex relationships being formed on either side of the line. Titian's and Rodin's drawings are good examples.

 Paul Klee employed more carefully worked expressive lines that were made to interact with other lines to form richly varied relationships out of the spaces between them. This is a means of inventing form through line exploring partial enclosures, repeats, and variations of curved angles.

 Both uses of expressive line described above strike a balance between capturing the artist's inner feeling and holding onto enough retinal information to preserve a convincing visual appearance. The identity of the object is not lost even when much specific detail has been stripped away.

 Under close inspection, the kinetic forms created do not "look like" anything we can identify. They are graphic descriptions of gesture, energy, and levels of excitement. They are given unity by the total representational image that they help to create.

- *Process-related line,* while also expressive, represents a different attitude in determining the nature of the line. Process-related line relies upon the difference between straight lines and curves. Obviously a drawing made entirely from straight lines will be rigid, angular, and hard. Curved lines will give softer, more rounded, fuller, spreading forms. In actual usage, the two do not have to be exclusive of each other, but are often intermixed. The feelings suggested by the drawings will depend upon which type of line predominates and the degree to which it does. This type of line, being more considered than a purely cursive style, permits a more thoughtful development of rhythms and structural relationships in a drawing.

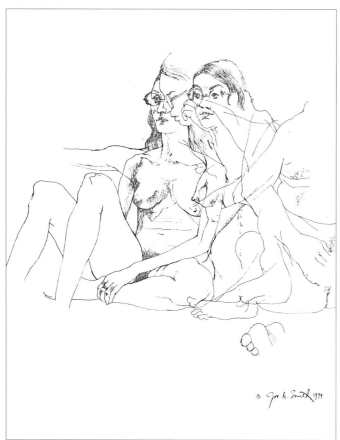

NUDE WITH GLASSES
Koh-I-Noor Rapidograph 3×0; Ultradraw waterproof black india ink; Arches 140 lb. CP watercolor paper, 10 × 8" (25 × 20 cm).

The descriptive line is characterized by an absence of expressive phrasing. It moves at a pace dictated by the number and scale of the details that it must include in its journey along a contour. It tends to be deliberate and precise in feeling. Whether it is a graceful, flowing line or a jagged, angular one is determined more by the nature of the subject than the expressive intent of the artist.

HOODED FIGURE
Reed pen; sepia ink on
T. R. Berkeley tan
handmade stationery,
wove surface, 5 × 7 ¹/₂"
(13 × 19 cm).

The expressive line
often seems to have
a life of its own.
Because reed pens
discharge their supply
of ink too quickly to
sustain a consistent
line weight, a bold,
dark line quickly
changes to a pale,
dry-brush type of
mark. This
encourages a lively
style in which the
artist must look for
the large gesture of
the subject and move
the hand rapidly
enough to get the
mark or shape down
before the ink supply
is exhausted.

Notice the variety
of glyphs that have
been formed in a
freewheeling attempt
to capture the folded
material on the
floor around the
seated figure. This
practically becomes
cursive script. The
energy level is high
in this type of
drawing, even when
the subject drawn is
peacefully at rest.
Rembrandt's many
small landscape
sketches or his
drawings of Saskia
sleeping are beautiful
examples of this.

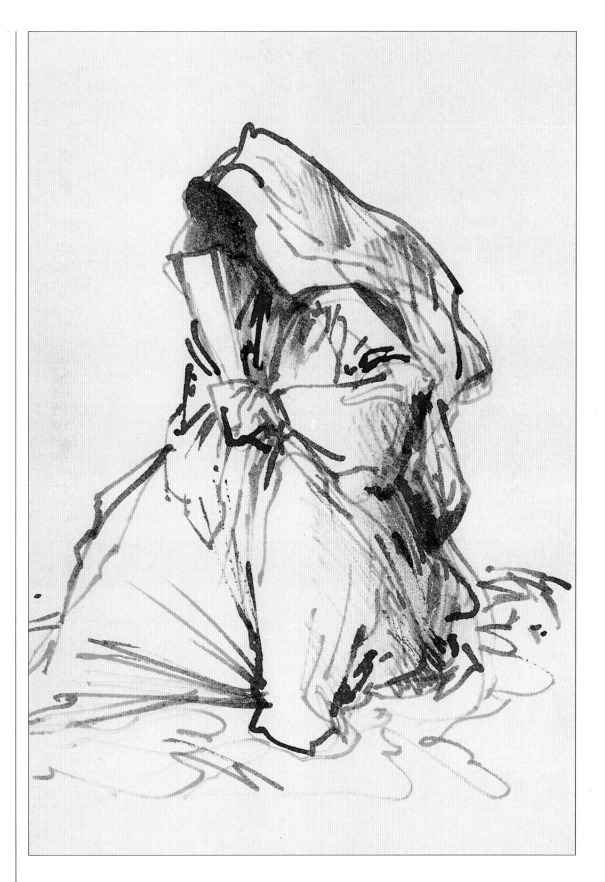

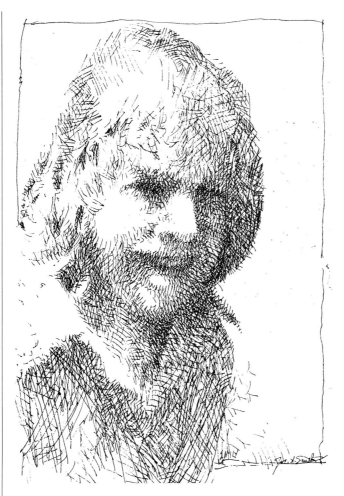

EMILY SMILING
Pelikan Souverän 250 EF
fountain pen; Pelikan fount india
ink; Twinrocker handmade
white laid stationery, 8 ¹/₄ × 6"
(21 × 15 cm).

Process-related line is determined by the artist's intent and not by the means necessary to record factual visual information. The expressive power of this type of line comes from our tactile and gestural associations. This is a function of texture. For the purposes of discussion, most drawing terms arbitrarily limit the consideration of an element to a single function. In actual use, the categories are blurred and each element performs many different functions.

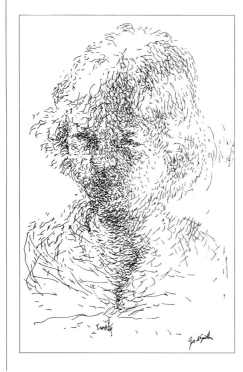

EMILY QUIET
Mecanorma technical pen 2×0;
Higgins Black Magic drawing ink;
Twinrocker handmade white
wove stationery, 8 ³/₄ × 6 ¹/₂"
(22 × 17 cm).

The lines in this version of the Emily portrait are less rigid than the rapidly done freehand hatching of Emily Smiling. *The marks are looser and more even in weight. Their directions collectively follow each other to flow around and across the forms, adding to a sense of the volumes. The marks create swirling movement paths for the viewer's eyes. The feeling is much softer.*

8. Will I use observational or process-related textures?
This decision is a matter of setting your place in the drawing dialogue. Your first step is to look—for the purpose of gathering information. As you begin to draw, you actively enter into the exchange by selecting what you will include and how it will be used. As the drawing progresses, you take fewer and fewer cues from the subject in nature, responding to what is happening on the paper. In drawings that use *observational textures*, the artist makes that first stage in the exchange the primary motivation. Instead of extracting form and using it expressively, the artist determines that the visual qualities of the subject's surface are an important part of the total message. Wood should look like wood, hair like hair, reflective surfaces such as water should be distinguishable from matte, and so on. The tactile qualities of the subject will be an important part of the drawing's effect.

This is equally true whether the subject is derived from nature or the imagination. The bark on an imaginary tree can be rendered with the same fidelity to the appearance of bark as the bark on a tree in your front yard.

Process-related textures result from a system that determines the type and density of marks. This can be as nonconceptual or intuitive as muscular movement preferences. In drawings of this type, the real subject is the feeling content of the marks and not the landscape, still life, or figure per se. At the extreme opposite end of this continuum, the textures may be rigidly determined. Numerical or mechanical constraints may be set in advance to limit the size, distribution, and occurrence of marks on the sheet. Here the concept itself is the primary subject matter, and the reference source in nature (if there is one) is only a vehicle for this.

If your drawing is nonrepresentational, the issue of texture is not one of observation versus process. There is nothing to observe and retain. Texture here is determined by the interaction of medium and support, scale, and your decision whether the drawing will be line, tone, or a combination. Grids are often a part of the structure of drawings in this category.

Pictures of this type are not pictures *of* something, but they are definitely pictures *about* something.

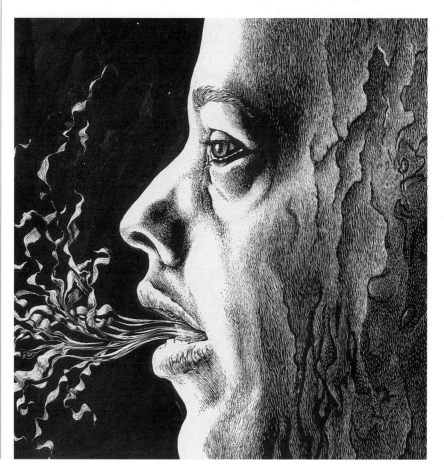

FILIGREE
Brush; Hunt scratch knives 112 and 113; Hunt 108 pen; Dr. Ph. Martin's Hicarb waterproof india ink; Essdee handmade British white scraperboard, 10 × 9 ¹/₂" (25 × 24 cm).

Observational textures are equally at home in drawings from life and drawings from imagination. The texture on the right side is bark from a pine tree.

DRAWING STRATEGIES

LANDSCAPE
Bamboo pen; Higgins waterproof drawing ink (diluted with water for some layers); Amalfi handmade paper, 8 ¹/₂ × 12" (22 × 30 cm).

This is an example of process-related texture in a drawing. Although the image is representational—landscape with trees—the textures are in no way descriptive of leaves, bark, and so on. They are interlocked glyphs, expressing foliage, but literally descriptive only of the rapid, continually shifting movement of my hand holding the pen. The broken, calligraphic fragments of line are all relatively short, which adds to the tangled quality of the textures. This is characteristic of a bamboo pen. These pens, like reed pens, discharge their ink supply very quickly. This gives a line that is heavy at first but within seconds lightens and becomes dry-brush. The need to redip the pen continually adds to the lively surface quality.

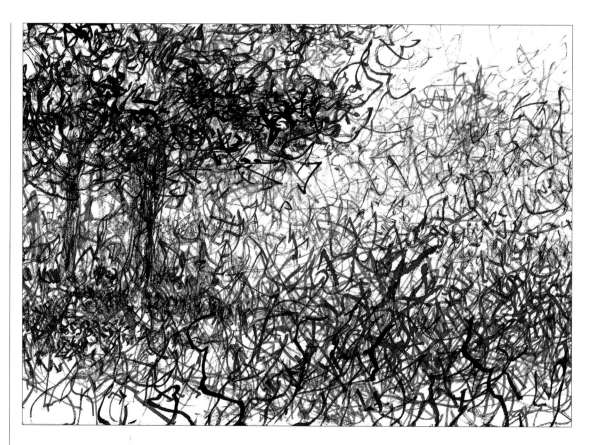

SEVEN DAYS
Rick A. Mallette
Brush; Higgins black india ink; New Temp gesso; Alphacolor Char-Kole; Berol charcoal pencil; Utrecht HP multipurpose watercolor roll, 100 percent rag, 51 ¹/₂ × 71" (131 × 180 cm).

An underlying grid structure acts as a foil for the high energy level and explosive movements in this large drawing. This architecturally stable skeleton is exposed in the central section and implicit in either side. The textures result from groupings of organic or geometric shapes and concentric curves.

from the Campanile Gune 1 1959 Florence

FROM THE CAMPANILE
(Florence, Italy, 1959)
Clare Romano
Flexible drawing pen; Pelikan
drawing ink; drawing paper,
11 3/4 × 15 1/2" (30 × 39 cm).

The textures in this drawing perform a double function. They capture the feeling of an expanse of buildings crowded in on each other extending into the distance, and they serve as decorative elements of great delicacy. They are descriptive in the sense of using straight lines, angles, and geometric shapes to designate architecture, and undulating streams of dots or broken lines for rolling hills and cloud forms. The choice of marks is the artist's. She has set the limits on the textures and determined what each would mean. This drawing beautifully demonstrates that consistency of approach does not mean a lack of variation and invention.

9. What will value change mean in the drawing? A shift from light to dark can have a variety of meanings in a drawing, and the artist must determine what a change of value will stand for. It can indicate form. This is simple modeling. Gradual light-to-dark change mimics the appearance of a curved surface. Abrupt change can be used to show an angular change of plane such as the interface between two planes that are oriented differently in space: a corner.

Value change can be used to indicate directional light falling on objects, creating and casting shadows. This use of value change adds intensity of light level as an expressive as well as form-producing element in the drawing. If the illusion is convincing, it is possible to indicate the existence of an object that is "offstage," outside the borders of the drawing, by including its cast shadow. This use of value appears more observational than conceptional, but with a thorough understanding of the forms you are drawing and of the properties of light, it is a simple matter to manipulate them in your mind. This lets you choose the optimum light, volume, and mood for your picture. A harsh light that creates dramatic lights and darks will add to the visual excitement in a drawing and give the artist a means of breaking objects into more complex and interesting shapes than would result from letting contours determine all the shapes.

Cast shadows can increase the depth tension in a drawing. A shadow from one object falling against another object defines the spatial relationship that exists between them. A very low level of light (subtle value shifts) can pull together unrelated shapes and forms by diminishing the impact of contour differences, unifying the drawing atmospherically.

Value change can make textures or patterns. It can also stand for color differences in a monochromatic drawing—but this information can be disruptive. This is a common drawing problem. Properly used, value changes to indicate color change can strengthen a form (stripes reinforce surface curves or undulations), but too often a change of value designating a color change weakens the effects of light and shadow that could model a stronger volume. This has an unintentional flattening effect.

It is not uncommon to see a student figure drawing that has weakened the volume of a head by needlessly showing color difference between skin and hair in a manner that overpowers the change between light and shadow within the hair. This is why so many master drawings of the human head treated the hair and skin as though they were equally colorless or white. Here value change is free to show the movement of light into shadow on the unified surface of a volume that just happens to include skin and hair as part of the journey around the form. Locks of hair can then be seen as textural groupings of smaller forms on the larger volume without losing a sense of the larger mass.

If you have difficulty seeing form independently of the color changes on its surface, imagine the object or model cast in plaster or spray-painted solid white. Colors are accidental surface phenomena unrelated to volume.

Value change can be a personal language for movement into depth. You are free to make your own rules, but you must be consistent in applying them if they are to make visual sense. Objects can become darker or lighter as they move farther from the viewer. This use of value is independent of observation but can be applied when drawing from observed objects.

As I stated earlier, no rules can guarantee that what you do will be great art, but an awareness of your options encourages more creative choices when you draw.

HEAD
Gillott 291 Superfine pen;
FW waterproof india ink;
Hayles handmade laid CP
stationery, 6 × 8 ¼"
(15 × 21 cm).

Value can be gradually changed to model form and give volume to a shape. It can also serve to define an edge by giving contrast, as in the background. When value change is used to show volume, it will imply a directional light source.

BEETLE HELMET
Staedtler Mars 700 technical pen;
Staedtler Marsmatic 745
drawing ink; acrylic gesso;
HMP Vail 140 lb. handmade paper,
19" (48 cm) in diameter.

The abrupt value contrasts that run vertically down the front of the figure and along the edges of the raised panels in the helmet and armor make a convincing abrupt change of plane. If the contours of those tonal areas are unambiguous, the jump of light to dark will not separate into foreground and background, but will meet at a common edge. If the common edge reads as the contour of only one shape but not the other, the two planes will separate spatially and appear as overlap.

AN ICARUS DREAM
X-Acto knife with a #16 blade,
Hunt crow-quill pen, Dr. Ph. Martin's
Hicarb waterproof india ink, Essdee
handmade English white scraperboard,
10 × 8" (25 × 20 cm).

A dramatic change of values can give the sensation of seeing the forms lit with a harsh light. This increases your chances to play with interesting shapes of light and shadow to break the restrictive boundary of an outside contour, which is the only contour that separates shapes into categories that have names. The drawing will be more interesting for you to do, and more interesting for the viewer to see, if the values break up the larger shapes more inventively.

DRAWING STRATEGIES

THE PATTERN
Mecanorma technical pen
2×0; FW nonclogging
waterproof india ink; Svecia
Antiqua laid stationery,
8 1/2 × 11" (22 × 28 cm).

The striped material behind the model, the evenly toned cloth behind her lower leg, and the bold floral pattern are all color-indicating value changes. This is consistent with the use of a deep value to indicate her dark hair color. I felt that it was important to exaggerate the range of light to dark in her hair in order to keep some sense of the volume. Despite the careful attention to modeling the form of her head, the contrasting darker shape of her hair weakens the sense of moving deeper into space from her knees to the plane of her torso.

IT'S ALL INSIDE OF ME
Staedtler Mars 700
technical pen 2×0; Higgins
Black Magic waterproof
india ink; Morilla 140 lb. R
watercolor block,
14 1/2 × 20" (37 × 51 cm).

Color indications in the clothes, skin, hair, and twig have been omitted in order to strengthen the depth tension that a change between light and shadow can give. I wanted the space under his lifted shirt to be as strong as possible.

COVER ART
For *Brother Moose*
by Betty Levin,
illust. by Jos. A. Smith
(Greenwillow Books,
1990). Winsor & Newton
series 7 watercolor
round; Speedball A-5 nib;
Rotring ArtistColor
transparent ink; Berol
Prismacolor pencils;
Arches 140 lb. HP
watercolor block,
24 × 18" (61 × 46 cm).

*The forest in the
background of this
illustration shows
how reduced value
contrast can unify
an area that would
otherwise be too
active. The use of
close value range can
be associated with
the effect of looking
through a dirty
window, a low light
level, or atmospheric
conditions such as
rain, snow, or haze.*

THE ELEMENTS OF DRAWING

If you describe a drawing verbally, you will find yourself listing the elements of drawing: line, value, texture, shape, volume, direction of movement, scale, color, and similarity groupings. These terms represent the basic phenomena of any piece of visual art. They are not limited to drawing with ink, or even to drawing itself. They are intrinsic to all visual phenomena, and at the same time they comprise the separate building blocks of any drawing.

Not all these elements will be consciously employed in each drawing. A drawing may be made of line with no value (or tone), or it may depend entirely on tonal change. Each of the elements is potentially a vehicle for compositional manipulation. The compositional use of drawing elements was discussed earlier in the section on drawing strategies. Now let's look at the elements themselves, one by one, and see how they exist within a drawing.

PARK HABITUÉ
Pelikan Souverän 250 fountain pen; Pelikan fount india ink; d'Arches 140 lb. HP watercolor block, 9 × 12" (23 × 30 cm).

This line drawing was done on location. The ink dots that can be seen at various points throughout the drawing are early placement and proportion indications that I use as a guide when I begin a quick drawing. This simple system is adequate preplanning and replaces a more involved preliminary pencil sketch. The dots free me to draw without the inhibiting need to stop and check relative scale when I am trying to let my hand respond instantly and in an uncalculated manner to what I am seeing.

LINE

Line is usually described as the track made by a moving point. Its principal dimension is length. Line can function as a directional factor, or it can define a boundary or edge. Although a drawing can be made without resorting to line, it is the element most often associated with drawing, just as color is usually considered the principal element in painting.

It isn't easy to isolate line entirely: Put a group of lines on a paper and you find yourself dealing with value. The cluster evokes a quality of darkness by virtue of the density of lines in that area of the drawing. Line has length, so scale is affected. Line tends to carry the eye along it, so movement is introduced. Line also separates areas of the paper and thus can read as contour or edge, which is an aspect of shape. The character of the lines drawn or their relationship to other lines around them creates texture. Line can even exist in a drawing by implication; see pages 60–61. Line is a deceptively simple element that becomes an infinitely complex entity in the context of drawing.

Experiment with line. Temporarily suspend consideration of the other elements in order to appreciate line for its own sake. Concern yourself with the power of line to evoke feeling. Let the expressive power of line be more important in these experiments than any accuracy or control in capturing likeness. This is not meant to imply that technical control is unimportant. Any increase in control is simultaneously an increase in freedom.

This experimentation asks you to set aside concern for one aspect of line use in order to explore another. Accuracy has a way of bypassing expression if it becomes the focus of our efforts too soon. We learn what lines can let us express by trying many different kinds. Proportion and accuracy will come with practice after you have acquired sensitivity to line. Explore what other materials (different nibs, brushes, paper surfaces) can contribute to your expressive line vocabulary.

When something interesting happens in line, be aware of its multiple functions. You don't have to learn everything there is to know about line before experimenting with value or texture. Enough lines cumulatively form an area of deeper value. A grouping of lines also creates texture. This is why we often find ourselves working with more than one element at a time, and all the elements are significant in drawing.

**BLIND CONTOUR DRAWING OF
A STUDIO WITH EASELS**
Mecanorma technical pen 2×0;
Koh-I-Noor Ultradraw waterproof
black india ink; sketchbook,
7 × 8" (18 × 20 cm).

This is a classic exercise. The paper is positioned out of sight behind the artist, who then draws without looking at the paper. (I prefer to cover the paper with a piece of cloth that hides the drawing so that I can keep it comfortably in front of me.) The tip of your drawing tool is used as though it were touching the exact spot where your eyes are focused. As your eyes follow the edges of the forms in front of you, the pen simultaneously records every pause, change of direction, or indentation.

I worked on this exercise for over two hours. If you do not allow yourself to fake or block in forms that

your eye is not tracing, the drawing will have a very convincing correspondence to perception. The lines cluster only where there are more intricate details or in sections that were redrawn because your point of focus returned there several times. These clustered lines create darks that are points of greater visual stress. This happens in most line drawings, even when you look at the paper while you draw. These darker patches should be part of your conscious awareness while you draw because they are active parts of the composition whether you like it or not.

VALUE

Value is the lightness or darkness of an area regardless of color—the light-to-dark information retained in a black-and-white photograph. A change of value that coincides with a boundary helps define form and space. When the values are equal or very close on both sides of a boundary, the separation is weakened or even lost.

Value can be used to give form and volume, to indicate the light falling on an object, to define space, to create pattern, to intensify the expression of an emotional state, and to indicate color change on an object. Even when you are drawing from life, value can be modified to make the subject of the drawing more expressive.

The juxtaposition of two different values next to each other is one of the strongest ways to define form. Line is the other. Value not only lets us model the form by evoking the effects of light, it is a tool for showing subtle surface changes. It can even indicate the nature of a surface: matte or shiny, reflective, opaque, or transparent.

Value is also a compositional device. It can be used to create emphasis, relate dissimilar shapes, weaken the attraction between repetitive shapes, or animate directional movement within a drawing.

When you first lay out a drawing, it can be helpful to group values in a more easily controlled system. After the larger compositional structure has been established, intermediate value steps or graded transitions can be added. This will simplify the drawing of complex subjects. A large number of subtle value shifts can disrupt the analytical seeing that is essential when you are drawing.

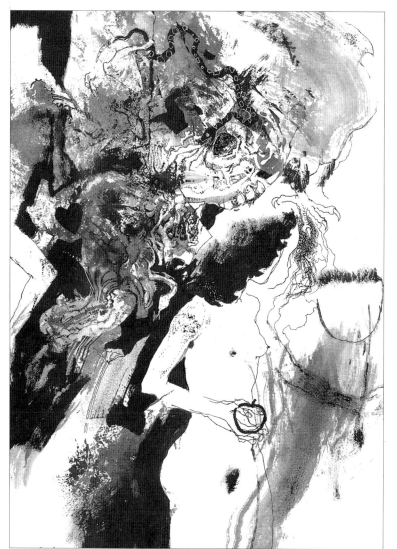

AN APPLE FOR SARAH
Paper towel; Mecanorma technical pen 2×0; Winsor & Newton series 7 watercolor round no. 6; Koh-I-Noor Ultradraw waterproof india ink; Speedball waterproof white drawing ink; water; Twinrocker handmade laid stationery; 8 1/4 × 6" (21 × 15 cm).

Value can organize an otherwise chaotic collection of shapes and textures. I started by printing diluted ink onto the paper with a crumpled paper towel. The objects, figure, fragments of bone, and so on are forms that the blotted ink suggested. They were drawn in line. As a final step, the solid blacks were added with a brush to pull the drawing together by using it on both positive and negative shapes that thread their way from the top left corner in a distorted N to the bottom edge of the sheet.

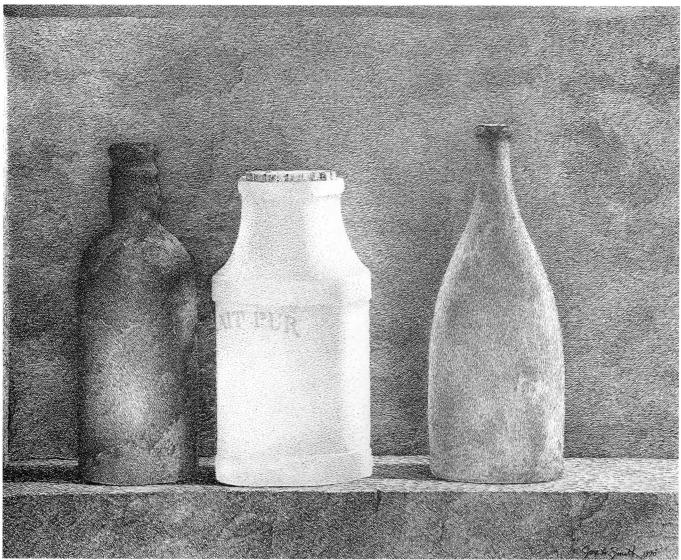

LAIT PUR
William Mitchell/Joseph Gillott 303 nib; Dr. Ph. Martin's Black Star waterproof india ink; Hodgkinson British Handmade book paper, laid surface, 13 3/4 × 17 1/2" (35 × 44 cm).

Limitation does not necessarily mean less. Lait Pur (pure milk) is an example of a severely restricted value range and the kind of power that can be found in a quiet statement. The milk bottle that holds center stage seems to glow. The lightest lights are restricted to the bottle itself and a tiny sliver of white at the top of the bottle on the far right. The French milk bottle is one that I have in my studio, and the only object in the drawing that was done from life. The darker bottles at either side and the boxlike structure that surrounds them are entirely done from imagination. The milk bottle glows because it was stippled with a tint of diluted india ink warmed in color by adding a small amount of bistre.

The other bottles and their enclosure were hatched with full-strength india ink. These grays are variations of a
narrow band of middle value. The background tone is lightened along the lit right side of the bottle to make light seem to bounce off the white glass. It reflects its light against the shadowed side of the bottle on the right. The darkest accent in the drawing is in the lip of this bottle to pull your eye temporarily away from the glowing white bottle.

The left-hand bottle is far less intrusive. Its values are closer to those of the wall around it. Its contour shifts. Unlike the other two, its edge varies, at times darker than its surrounding tone, at times lighter, and at several points the tone crosses the boundary of the form to soften its definition. Where the white bottle and its companion to the right are strongly defined as volumes, the dark bottle on the left almost merges with its background. This helps diminish the asymmetrical distribution of forms.

TEXTURE

In a graphic (or flat) art such as drawing, texture depends almost entirely on the memory connection in our minds between touch and appearance. Actual or physical texture in art is usually associated with sculpture or painting. Physical texture enters drawing through collage, where materials with a tactile quality may be added to the surface of the drawing, or through mediums that deposit a built-up layer as they are used.

In a drawing, visual texture can be one of three types: descriptive, expressive (arbitrary), or process-related. Descriptive texture simulates the appearance of a tactile quality. It depends on contrasts. The surface of an object is rough or smooth, reflective or matte, wet or dry, even hard or soft (this can apply to the material quality of the subject or to the focus with which it is seen). Texture used in this manner is an imitation of nature. This use has strengths and dangers for the artist. Successfully imitated textures can lend a sense of visual truth to a drawing.

The problem with descriptive texture is most apparent with students who possess a high degree of technical facility. A drawing can have a dazzling level of realistic rendering that masks a weak structure or composition.

Arbitrary or expressive texture is texture used for its evocative power. A figure that is drawn with a scratchy, brittle texture or a soft, fuzzy hatching is no less a figure. It conveys more than literal description. It expresses the artist's mood or reaction to some quality in the subject. Arbitrary texture can also be nonrepresentational—invented patterns or abstracted textures symbolic of real textures. Conventions such as the use of diagonal lines in a cartoon to depict glass are also textures in this category.

Process-related textures are developed through the act of drawing. A charcoal drawing has a different texture from a wash drawing. This is different in turn from a pen drawing. A slow, careful movement of the artist's hand will produce a different effect than a vigorous, rapid series of gestures.

EMILY, ST. VINCENT'S HOSPITAL, 4/24/81
Parker ballpoint pen; Sennelier sketchbook, 9 1/4 × 12 1/4" (23 × 31 cm).

Descriptive texture uses the distinctive characteristics of materials. Even a drawing that is done very rapidly can fall into this category if the marks, as marks, are not the primary interest of the artist. The appearance of my daughter's sweat-soaked hair against the angular folds of the starched sheet were important bits of visual data during a long, anxiety-filled night.

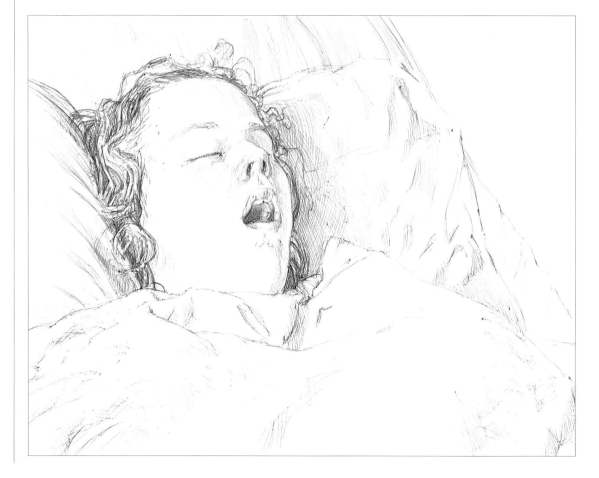

EROTIC SILHOUETTE
Koh-I-Noor Rapidograph
technical pen 2×0;
Koh-I-Noor Ultradraw
waterproof black india ink;
Twinrocker handmade
white wove stationery,
8 3/4 × 5 1/2" (22 × 14 cm).

*A drawing's texture
does not have to be
the visible track of a
barely controlled
series of movements
to be expressive. This
silhouetted head and
shoulders enclose a
tangle of forms that
are modeled with fine
hatching to capture a
soft, visceral, tactile
quality.*

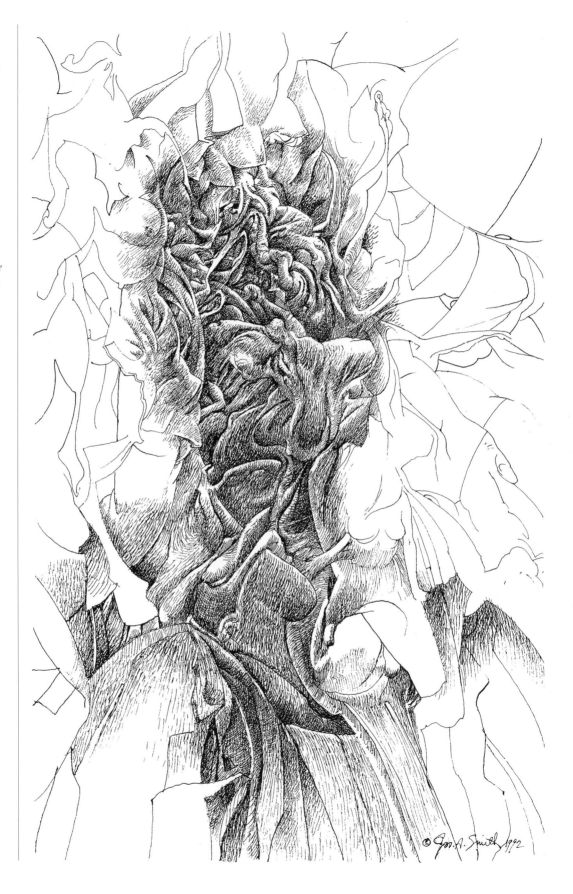

SHAPE

When a drawing includes an area that is in some way distinct from its surroundings, the element of shape is introduced. Shape is a condition of area. The shaped area can be created by a line doubling back on itself to form an enclosure. It is also created whenever there is a distinct change of texture or value. The area covered by

FIRE EATER
Pelikan Souverän 250 fountain pen; Higgins fountain pen india ink; Strathmore 400 drawing paper, 100 lb., 12 ½ × 9 ½" (32 × 24 cm).

Any area that is distinct from its surroundings is a shape. It can be set apart by contrasting texture, value, or an outline that forms an enclosure. The shapes of the torsos in the two figures are roughly rectangular. There is a progression of scale from the large black rectangle in the background through the central figure and into the child. The clusters of small details (flames, smoke, and so on) work as three separate shaped areas because the affinities within each group are stronger than those between groups.

each different value has a shape even when no shape is intended.

Shape has two dimensions: height and width. It can be geometric or organic. Geometric shapes are the product of mathematical laws: squares, rectangles, triangles, circles, and so on. Organic shapes are free-form, less regular shapes.

Repetition can create shape. When the repeated elements refer to one another more strongly than to the things around them, we link them to form metashapes in the drawing. (This is a form of closure, the mental completion of incomplete simple geometric shapes.)

As graphic elements in a drawing, shapes can be limited exclusively to geometric or organic, or they can be combined. No matter how shapes are used, they cannot be ignored. Shape is one of the basic building blocks of structure and composition.

Shapes can imitate objects in the real world. Recognizable shape serves two functions. It tells us what an object is, and then it tells us what that object is doing.

When the first shape is created on a paper, it immediately creates another—the shape of the field that contains it. This perceptual phenomenon is known as figure/ground. Another term for this distinction is positive/negative (somethingness versus nothingness). This second set of terms is unfortunately value-laden.

There is a tendency for the artist, especially the art student, to concentrate on the manipulation of the drawn (positive) shape to such a degree that the surrounding field is ignored. In daily life we use vision primarily to pick out and relate to things. The spaces between things are merely empty areas where the things aren't there. To make ourselves aware of the shape of those empty areas requires an unnatural use of our vision. If an empty space is looked at, it is usually only looked *into* or *through*. We still do not respond to the shape of that space. This is a problem when it is manifested in drawing. On the paper, shape awareness can be limited to the drawn shape. If that shape has an object identity, this is even more likely to happen. The artist must never ignore the "empty" parts of a drawing. Every shape in the drawing affects its meaning even if that shape is an area of untouched paper.

Since a shape is any area that has a boundary (created by line, value, or both), there can be

shapes within shapes. Internal divisions create shapes within a larger shape. Edges of clothes, changes of value or color, and areas of shadow can all create smaller defined shapes.

The simpler an area is, the more important its edges become. The silhouette is stronger. It is more difficult for the eye to read the boundary of a shape if its internal area is made up of active textures or strong patterns. (This is the basis of camouflage: The busier the interior, the less attention is given to the outer contour of a shape.) Clarity in a drawing depends on the major shapes having sufficient strength to carry texture, changes of value, or modeling.

The artist may want to avoid making contours or outlines a primary compositional factor in a drawing. Softness of edge can be an effective conveyor of certain moods, but even so, an awareness of the shape character defined by contours must still be part of the artist's thinking.

When you draw from life, you are translating objects existing in real space onto a flat surface. If the subject is made up of complex volumes, many viewed from odd angles, you must mentally flatten the tilted planes in order to see the individual shapes clearly. Only then can you control the drawing. This does not mean that you change their spatial orientation, but that you make yourself aware of the shape of the contour you actually see.

Any uniform use of value, texture, color, scale, or outline reinforces the flatness of a shape. Variation of any of these elements can give a sense of dimension to a shape by seeming to tilt it, making it move diagonally into the picture plane. Shapes that function as a tilted plane introduce three-dimensionality or volume.

MONITOR LIZARD
Staedtler Mars 700 technical pen;
Hunt crow-quill pen; Staedtler
Marsmatic 745R drawing ink; Pelikan
sepia drawing ink A; Hodgkinson & Co.
British Handmade laid paper,
7 3/4 × 8 1/4" (20 × 21 cm).

CAT FAMILIAR
Illustration from *Witches* by Erica
Jong, illust. by Jos. A. Smith
(New York: Harry N. Abrams, 1981).
Staedtler Mars 700 2×0 technical
pen; Higgins Black Magic waterproof india
ink; acrylic gesso; HMP Vail handmade
paper, 19" (48 cm) in diameter.

The lizard head reads as a unit even though it is broken into distinct shaped areas. This is because the background is a unified field. Areas with homogeneous textures or patterns are set apart. The shifts of color between black and sepia occurring throughout the drawing are not strong enough to weaken the sense of continuous surface created by the repetition of tiny similar shapes in each distinct section.

It is possible to subdue a boundary to lessen its compositional effect. Although a pen line is not a soft line, pen techniques for diminishing an edge include broken lines and lines crossed by hatching. Another method of softening an edge is to echo it with repetitions. This gives the interior forms greater importance.

STANDING MAN
Jacob Landau
Esterbrook drawing
pen; nonwaterproof
india ink, 12 × 9"
(30 × 23 cm).

This figure defies a complacent reading. There are no predictable treatments for any part of the body. Frontal figures are often given symmetrical solutions as a substitute for creative seeing. In this drawing, one leg advances, its muscles bunching to support the body's weight. The surface furrows of the abdomen are occasions for invention. The shoulders function as shaping lines to carve pieces out of the untouched portions of the paper and not merely to join the arms to the torso. Each section of uninflected ground around the figure is a shape that works actively with the figure's internal shapes.

SHROUDED SENTINEL
Hand-ground sumi ink;
Dr. Ph. Martin's
Pen-White; pencil;
Twinrocker handmade
tan wove stationery,
10 × 7" (25 × 18 cm).

Shapes within shapes can add form and interest in a drawing. Whenever the contour leaves the outer edge and moves across the interior of a form, it may become the boundary of a subshape. The stronger these subshapes become, the less concentration is given to the outer boundary. This is the perceptual basis of camouflage.

The black background gives the figure a stark outer border. The inner shapes, heightened by white, are strong enough to give the figure volume by pulling the eye away from the edge. This prevents the powerful contrast around the outer edge from acting like a cookie cutter and reducing the figure to a flat silhouette.

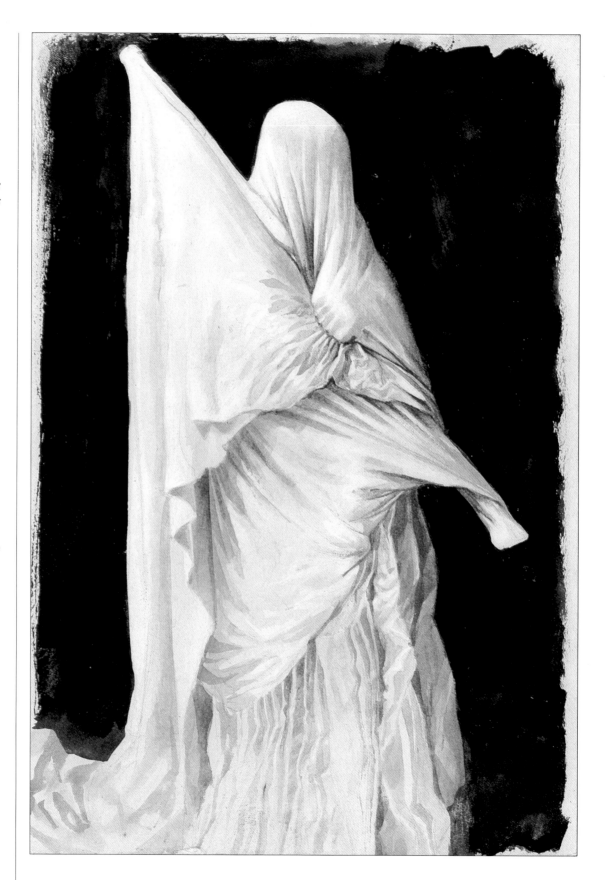

VOLUME

The perceptual appearance of three-dimensional qualities on a two-dimensional surface gives volume. Shapes are flat. Shapes become volumes only when they are read as planes that are not parallel to the surface of the paper. This is done by the interaction of two or three combined shapes or by modeling. Modeling gives the appearance of three dimensions through contrast in lighting, color, value, or texture within the shape.

Two or three geometric shapes (having height and width) form a geometric volume (height, width, and depth) when they share common edges that read as joining rather than overlapping.

Modeling is the second means of creating volume. Modeling uses value change on a surface to make it appear tilted, curved, or rounded. It can also be used to indicate light and shadow, which is a strong visual clue to seeing volume.

Since a volume cannot exist without a space to contain it, the use of volume in a drawing is an effective means of breaking the flat plane of the paper. For more about the varieties of space in drawing, see pages 110–115.

HOMELESS MAN
Bamboo pen; brush; Pelikan sepia drawing ink A; pencil; Twinrocker handmade wove stationery, 7 × 10" (18 × 25 cm).

The boxlike space reinforces the volume of the figure by creating a container to hold it. The fragment of architectural detail on the left is a stepping-off point on the surface of the paper to reinforce the drop back into space around the figure.

The shadowed interior of the doorway was blocked in after the pen lines were complete. It was done with a wash of undiluted ink on the darker left side and then spread across the top section of the drawing by thinning the mixture with water. This meant that a large area of the paper sheet was wetted while I worked. Twinrocker papers have sufficient sizing that, even unstretched, there is negligible buckling from shrinkage.

SKULL FRAGMENT
Waterman ballpoint pen;
sketchbook paper,
10 × 6 ½" (25 × 17 cm).

I used controlled modeling with a ballpoint pen to record the rounded forms. Modeling is the most effective nonlinear method of creating volume, and since volume requires a space to contain it, a believable volume will either open the space around it or (if the entire object is modeled) it will be seen as sitting on the plane of the paper. In either case, depth rather than lateral tension is the operating illusion.

ICARUS
Winsor & Newton colored inks,
Winsor & Newton Series 7 watercolor
brush, Caran d'Ache watercolor
pencils on Arches 140 lb. HP paper,
18 × 24" (46 × 61 cm).

In this drawing I was interested in showing the convex surface of the individual feathers to heighten the feeling of overlap in their layers. This was done by focusing on the linear strands that grow out from the shaft and give the feather its form. These fine parallel lines and the occasional sliver of space where they have separated act as internal contours that indicate the curvature of the surface. This is strengthened by a slight change of value in some of the feathers to suggest a soft, raking light.

DIRECTION AND MOVEMENT

Movement in a static, two-dimensional artwork is the result of the interaction among drawing elements. Line, value, repetition, and shape can all be used to impart movement in a drawing if there is a sense of continuity between their positions in the pictorial field or across the picture plane. Direct repetition or a more subtle variation of repetition—similarities—can direct the viewer's eye and impart movement.

Subject matter is also a source of movement. A gesture, the anticipated pathway through space that an action must follow in order to reach completion, even the implied line of sight of a figure in the drawing can impel the viewer's eye from one point to another.

Compositional movement imparted through the drawing elements can reinforce the depicted movement in the subject, or it can be used independently, in counterpoint. The character of this compositional movement is part of the feeling of the drawing. The speed, flow, regularity or disjointedness, subtlety or violence of the journey taken by the viewer's eye when reading a drawing creates much of its emotional content.

Irregular shapes can be used for compositional movement. Any shape that is not a simple geometric one (such as a circle, square, or equilateral triangle) is inherently directional. If one of the dimensional axes of a shape is clearly longer, it acts like a directional arrow to lead the eye. Groups of directional shapes working together form pathways through a composition.

Repetition creates movement. We have a tendency to group together things that have similar qualities. When an element is repeated, the repeat relates those separated parts of the drawing. The viewer's eye tends to jump from one similar element to another. This creates a tensional direction between the repeated points. It can shift the attention from part to part.

Movement in the drawing is linear and can be curved or straight. It even has a specific pace. The more similar the repeated elements are, the more rapidly the viewer's eye moves across them. The more variation in the elements (the more dissimilar they appear), the more slowly the eye moves along their path. We focus in a narrower cone of vision (1 degree of an arc rather than 12 degrees) when we perceive the presence of more "information." This more intense scanning means that our eyes take more real time to study the same area, so that the directional energy imparted by the repetition is less.

Directional relationships exist in every drawing. We risk having them work at odds with our intent if we are not aware of them and do not use them to our advantage.

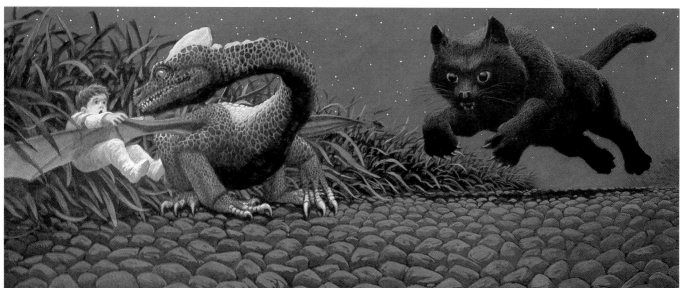

A DRAGON WING KNOCKED HIM SPRAWLING . . .
Illustration for *Matthew's Dragon* by Susan Cooper, illust. by Jos. A. Smith (New York: Macmillan, Margaret K. McElderry Books, 1991). Hunt drawing pen #99, sable watercolor rounds, Rotring ArtistColor, Prismacolor pencils, Dr. Ph. Martin's Black Star waterproof india ink matte, Morilla watercolor block 140 lb. R, 9 1/2 × 22 1/2" (24 × 57 cm).

A plane can be tilted in relation to the picture plane by sequentially changing the value level, texture density, scale, or color of details on its surface. This is an effective method of introducing the illusion of three-dimensional space or depth tension.

I used consecutive scale reduction in the blades of grass (reinforcing the converging perspective lines) and the stones on the path to tilt those planes back into space. This set up a movement into depth counter to the direction of the cat's leap, making it more dramatic.

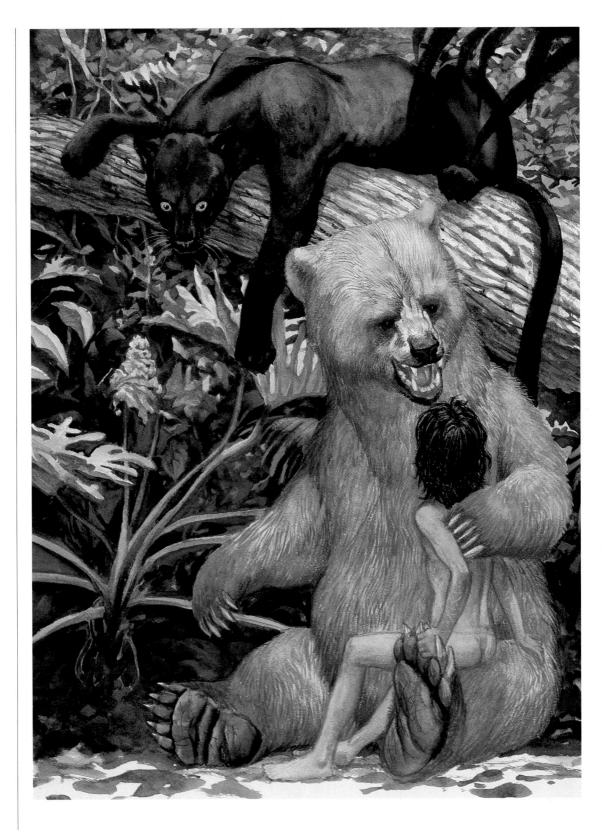

WHEN BALOO WAS TEACHING MOWGLI
Illustration for *Tales from the Jungle Book* by Rudyard Kipling, adapted by Robin McKinley, illust. by Jos. A. Smith (New York: Random House, 1985). Illustration copyright ©1985 by Jos. A. Smith. Reprinted by permission of Random House, Inc. Crow-quill pen; watercolor round brushes; Pelikan colored drawing ink; india ink; Holbein watercolors; Winsor & Newton watercolors; Derwent watercolor pencils; T. H. Saunders CP watercolor board 181 by Bainbridge, 15 × 12" (38 × 30 cm).

The direction implied by a subject's gaze is a device for adding movement to a drawing. There is a tendency for our eyes to move from the leopard's eyes to the boy and also along the direction of sight between the bear's eyes and Mowgli's upturned head. Even though we cannot see the boy's face, we feel the connection between him and the bear because we are aware of his directed attention. This is enough to cause the viewer to look back and forth among them—movement!

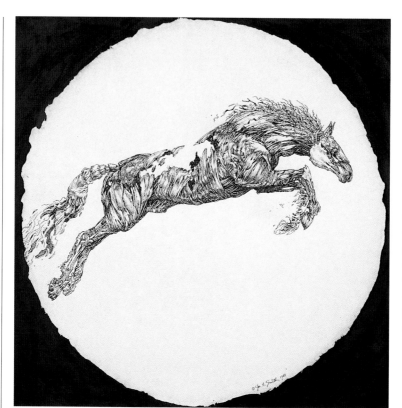

HORSE FAMILIAR
Illustration from *Witches* by Erica
Jong, illust. by Jos. A. Smith
(New York: Harry N. Abrams, 1981).
Staedtler Mars 700 technical pen 2×0;
acrylic gesso; Higgins Black Magic
waterproof india ink; HMP Vail handmade
paper, 19" (48 cm) in diameter.

*The literal content of a subject
can add the element of movement
to an image. A gesture or a pose
that we recognize as a moment
taken from something or someone
in the act of moving will add
directional tension. We sense the
next position in the movement's
flow. Even with the fantasy
treatment of the horse, it is
identifiable as a horse in mid
leap, and this superimposes a
psychological thrust on the static
shapes in the drawing.*

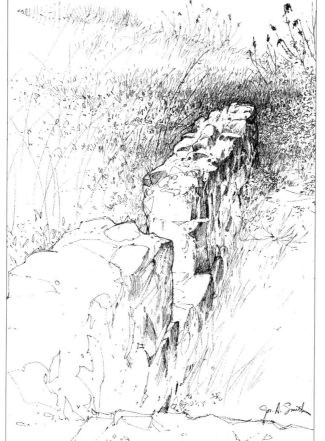

**STATEN ISLAND
FOUNDATION REMNANT**
Koh-I-Noor Rapidograph 2×0
technical pen; Koh-I-Noor
Ultradraw waterproof drawing
ink for paper; Morilla 140 lb. R
watercolor block, 14 × 10"
(36 × 25 cm).

*This was done on location. The strong
movement results from the composition. The
point of view was selected to make the wall a
diagonal thrust from lower left to upper right.
This uses our tendency to "read" the visual
field from left to right. The wall is like a finger
pointing upward from the massive form in
the lower left foreground. Textural detail and
value contrast are increased as your eye moves
deeper into the space of the drawing. Parallels
to the edge of the wall across the base of the
composition can be found in the band of
hatched tones in the weeds above.*

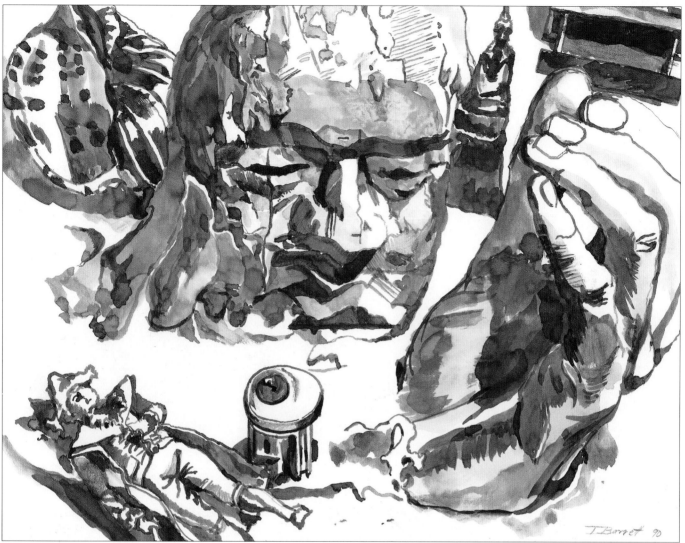

UNTITLED
Irving Barrett
Brush; quill pen;
hand-ground sumi
ink; paper, 9 × 12"
(23 × 30 cm).

This drawing, one of a series by the artist, clearly shows the strength of linear forms to propel the eye along their implied extension in space, like a pointing finger. The circular movement culminates in the large head fragment where our eye pauses before being drawn around the composition once more. Notice how small forms with contrasting alignments are inserted into the circular path at the lower center and again between the fingertips and the head to give a break to the continuity of the movement without any loss of clarity.

SCALE

The sense of relative size in the pictorial field is imparted by the contrast or similarity of elements in the drawing. If there is little or no size variation in a picture between like or unlike elements, including the negative spaces, the drawing works as a uniform field. Overall pattern is easily developed, and small changes become more important as pictorial events.

Greater size contrast allows for compositional dominance to become a factor. If two elements are similar except for size, the larger will be dominant because it will have greater visual weight. This factor must be considered in compositional balance. Spatial relationships are also altered in this situation: The smaller of two like elements will appear to be farther away from the viewer.

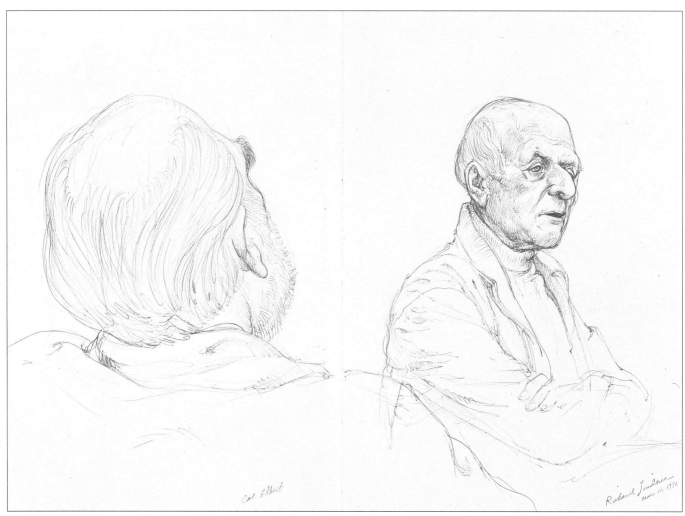

CALVIN ALBERT AND RICHARD LINDNER, MAR. 10, 1976
Parker pen; Winsor & Newton Black + White sketchbook bond paper, 11 ¹/₂ × 16" (29 × 41 cm).

Where two similar objects are different in size, the larger size will usually seem to have greater weight and can throw a drawing off balance. The head on the left is much closer and therefore larger. To compensate for a drastically lopsided weight distribution, I concentrated the strongest value contrasts and most rendered detail in the smaller figure. That figure is given additional graphic weight because the viewer is in the position of looking over the shoulder of the near figure, and following his gaze we also cross the space to the focus of his attention. Lindner is given compositional weight by our attention.

THE MUSEUM AT NIGHT
Gillott 303 extra fine pen;
Pelikan Souverän
series 250 fountain pen;
FW waterproof india ink;
Pelikan fount india ink;
d'Arches 140 lb. HP
watercolor block;
12 1/4 × 9" (31 × 23 cm).

This grid-structured drawing is filled with small elements with no large, restful areas. This develops an overall pattern in which the small visual elements take on an exaggerated importance. Forms link to create movements. Changes of tone open small spaces in the crowded surface. Even meaningless shapes give the appearance of information and force the eye to scan more carefully. (The early stages of the drawing are left uncovered at the bottom to show how grid preceded movement, which then took on shape, identity, and finally volume.)

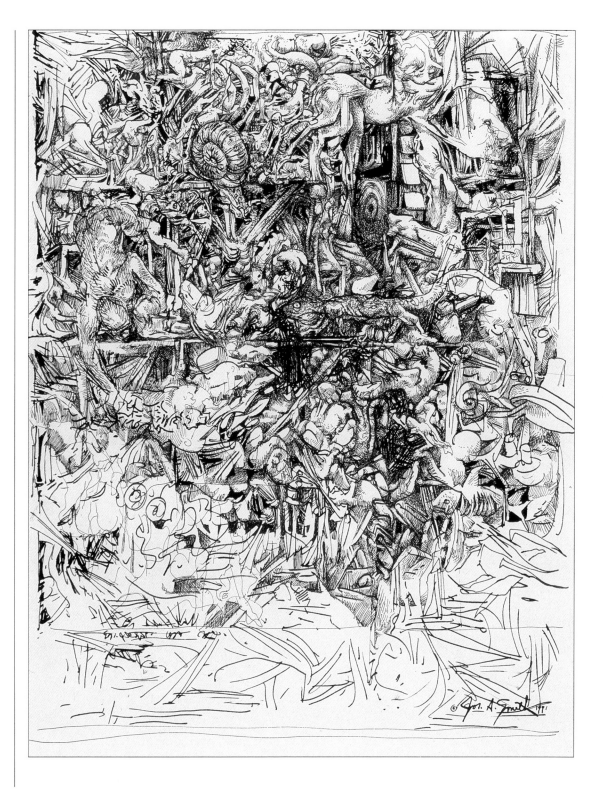

RHYTHM

Any sequential use of an element, where there seems to be a pattern of occurrence, introduces rhythm. It can be a rigidly followed system of repeated visual events, or an informal structure of recurrences with variation. A checkerboard and a series of uniform dots are examples of rigidly regulated rhythms. Interval is an important aspect of rhythm. Uniform intervals create a beat, a fixed tempo. When the intervals between repeated elements are varied, emphasis can be given to selected parts. Rhythm is strengthened by more repetitions, but its energy level can be increased or decreased by changing its intervals (its tempo) as it moves across the picture. Some variation in the intervals adds visual interest by decreasing predictability.

Directional movements that channel the path followed by the viewer's eye can be part of a rhythmic system. Compound curves such as esses or sine waves are rhythmic movements. Rhythms made from repeated details can create this kind of movement.

Rhythm is a compositional unifier. In the most interesting drawings, all parts of the composition—including the spaces—are part of one or more rhythmic sequences.

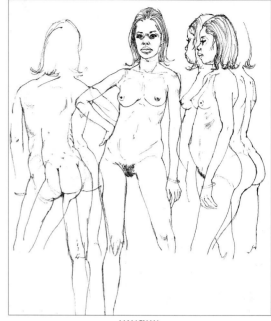

NANCY W.
Pentel rolling-ball pen; white drawing paper,
10 ³/₄ × 8 ³/₄" (27 × 22 cm).

Subtle rhythms are formed by the sequentially repeated body parts. This repetition with variation is based on the changing views drawn while I walked around the model.

**THE COSMIC WORM
(KURT VONNEGUT, JR.)**
Copyright © Jos. A. Smith
by *Harper's Magazine*.
All right reserved.
Reprinted from the July
1974 issue by special
permission. Staedtler Mars
700 technical pen 2×0;
india ink; Strathmore kid
1-ply bristol, 11 ¹/₂ × 15"
(29 × 38 cm).

This illustration is built out of rhythms. The curved linear shapes of each segment are rhythmic repetitions. Their tempo increases from the open, partial beats at the head. There is an echoing rhythm in the creased forehead. A second smaller rhythmic motif runs through the undulations in his hair into the space around him.

FASTFOODSCAPE
This illustration appeared in *New Times* Magazine.
Pelikan MC120 sketch pen; Pelikan fount india ink;
Winsor & Newton watercolor; Prismacolor pencils;
white drawing paper, 14 × 11" (36 × 28 cm).

The zigzag line of the road is a rhythmic motif that ties the illustration together from bottom to top. The curves are consistent in size but broken up by overlapping forms to avoid a mechanical sameness in the repetition.

COLOR

Although most drawings are monochromatic, a wide variety of colored media can be used in drawing. Crayons, pastels, watercolors, colored pencils, collage materials, and an expanding list of colored inks all can blur the distinction between painting and drawing. The subject of color is too complex to cover here. In the context of this book I will only briefly suggest the role of color as a drawing element. Books dealing with color should be part of every artist's library.

The color to be used in a monochromatic drawing, or the color of the paper to be drawn on, can add energy to the expression of the drawing, but you are essentially doing a black-and-white drawing with a more limited value range. No color will produce as deep a value as black ink, and many colors such as the yellows at full strength will give only the equivalent of light gray for the darkest areas. This means that any drawing done in a color other than black will have less extreme potential for dark-to-light contrast. On the other hand, a warm color such as burnt sienna can give the drawing a glowing, sun-filled feeling.

With a mixed palette, the dominant color is the chief agent in creating a mood. A drawing whose surface area is predominantly red is far more aggressive or visually exciting than one of mostly blues or blue-grays. The variety of colors that are used in combination, as well as their purity or chromatic intensity, helps determine the level of energy and excitement. Muted colors can imbue the drawing with a feeling of quiet or even sadness.

A well-placed spot of color can be used to enliven a drawing or divert attention from an otherwise weak drawing. This is a common problem in student drawings because it can allow the artist to avoid confronting more basic problems of control. The color, if used, should be an integral part of the drawing. It should be given the same consideration from the beginning that is given any of the other elements. If this is not done, the color becomes an afterthought and has no more structural relationship to the drawing than the color on a coloring book page. It is decoration and nothing more.

Color has its own space. Warm colors (reds through orange into yellows) excite nerve cells on the retina outside of the cells that directly receive the image. This peripheral nerve excitement causes us to see warm colors as spreading or advancing. Cool colors (greens through blues) do not have this effect, and so are referred to as receding colors.

Color in a drawing must have its own structure, just as it does in a painting. It can be used to give focal emphasis to a section of the picture, or direct the eye from one point to another.

Color also has associational capacities. Even a nonrepresentational picture done with the lush greens of new plant growth is not going to evoke the same unconscious associations as one that is done in the browns and yellows of withered, dry grass and parched soil.

This is only a suggestion of the issue of color and its role in drawing. You will learn most from a careful study of work whose primary concern is color. Look at paintings, and whenever possible, original works rather than printed reproductions. We learn from seeing.

**UNTITLED—STUDENT
DRAWING**
Colored drawing inks;
sketchbook paper,
14 × 11" (36 × 28 cm).

This drawing was started with a sienna ink and worked into with red. The red does not merely restate the sienna but contributes unique elements, leaving major areas of the first color untouched. The colors reinforce each other rather than cover the same territory twice. The color selection adds emotional resonance to an already strange figure.

UNTITLED
Gregory Benton
Watercolor brush;
Speedball neutral
half-tint ink; watercolor;
notebook paper,
9 1/2 × 6" (24 × 15 cm).

The artist has incorporated a very subtle use of color into the ink washes in a well-integrated fashion. Although the drawing is structured by a strong black-and-white scale, the color emerges out of the grays as part of the same scale. At points in the drawing the color is used with greater intensity to add a meaningful structural element to the total image. This is much more effective than color applied to a black-and-white drawing as decorative afterthought.

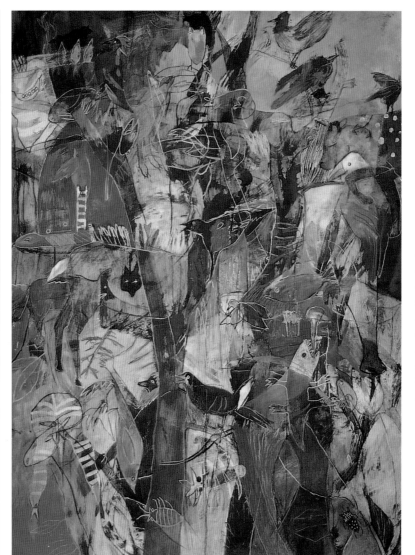

THE FOREST
Diana Kingman
Higgins india ink; gesso;
Rembrandt pastels; Winsor & Newton
and Grumbacher gouache; charcoal;
Conté crayon; Dr. Ph. Martin's
concentrated watercolors; paper,
60 × 44" (152 × 112 cm).

*The cool blues and greens
literally create an environment
in which the reds and browns
appear as rich accents. Despite
the generally high-key use
of color, there is a feeling of
lush growth and abundance.
The artist works intuitively
with her theme, beginning with
broad strokes of india ink
applied with a fairly large
brush. She then paints over
and into the ink with gesso,
then adds lines with charcoal
and white pastel and washes
of colored inks. The shapes
are developed from forms that
were suggested when viewed
through squinted eyes.*

UNTITLED
Hunt 108 pen; Isabey 6228 pure
kolinsky sable watercolor round no. 5;
FW waterproof india ink;
Winsor & Newton watercolors;
Twinrocker handmade stationery,
5 1/2 × 8 1/2" (14 × 22 cm).

*In this drawing, the three
colors each have separate
movements and different
proportions in relation to the
format, and this sets up
relationships that would not
exist if the drawing were
reproduced in black-and-white
line. Also, the dominant blues
and greens add landscape
references that are completely
independent of the shapes.*

SIMILARITY AND PROXIMITY GROUPINGS

Composition is the use of drawing elements to give order. Even very different forms can be grouped if one of its elements—say, line quality—is similar to the line quality of the other forms. Each element can be used in this way. Several dark, unrelated shapes in a field of light shapes will be linked to one another by value similarity even if some of them are more like the lighter shapes in all other respects. Scale, texture, line, shape, volume, direction, or color can all be used as the grouping agent. In this way elements can be made to join with others far across the paper.

Another means of making unlike elements belong together is through contrast with other elements. Elements that are not alike will be grouped if they are contrasted with surrounding elements that are clearly even more dissimilar from all of them than they are from each other.

Position also groups dissimilar forms if they occupy corresponding points on either side of the drawing's center. In this way, very different forms can balance each other and will be grouped because of their echoing structural function.

A dense cluster of unlike forms is unified if the cluster is surrounded by forms whose elements contrast with the cluster. A group of stars, spirals, and triangles in a field of circles will be seen as belonging together. Their proximity reinforces their collective contrast with the surrounding forms even more, further unifying them.

At the same time, individual drawing elements within the cluster can be united with distant forms either by repeating other drawing elements or by using a compositionally balancing form. Any visual characteristic similar to one elsewhere on the drawing gives us a means of grouping otherwise dissimilar forms.

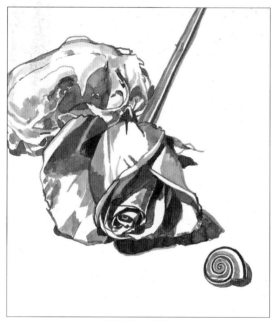

UNTITLED—1989
Irving Barrett
Quill pen; brush; hand-ground sumi ink;
white drawing paper, 10 × 8" (25 × 20 cm).

A cat skull, a rose, and a tree snail belong to no common category, and yet they have been pictorially combined through similarities of scale, shape, and light/shadow range. The skull is almost inextricable from the curved planes of the rose petals. The snail shell is set physically apart, but a double set of similarities welds it into the composition. The curved right border of the shell restates the rolled edge of the rose petal closest to it, and the spiral of the shell is almost identical in size and movement to the rolled petals at the center of the rose. This drawing rewards the time taken to study it carefully.

INTERIOR WITH MODEL AND DOG
Mecanorma technical pen 2×0; Koh-I-Noor
Ultradraw waterproof black india ink; paper towel; water;
Svecia Antiqua stationery, 11 × 8" (28 × 20 cm).

The upper left and right corners show how dissimilar forms can relate if they occupy corresponding positions in the structure of a drawing. The left corner is a positive form: a bird's wing and texture similar to foliage. The right corner is a negative form: an open window looking into a deeper space. The fact that they are similar in size, have parallel diagonals, and are light areas surrounded by darks also unifies these differences.

INTUITIVE DRAWING

The drawing strategies discussed earlier present one major function of drawing: the conceptual structuring of graphic elements to communicate by giving conscious direction a greater role in the relationship between intent and means. Drawing also serves as a vitally important means of personal exploration and definition for the artist. This is drawing as revelation and transformation of the self. The transformative use of drawing can be difficult and even unsettling, but it carries rich rewards.

We live our lives in a matrix of social attitudes so pervasive that we mistakenly accept them as reality rather than as models of reality. Our ideas of art and beauty may feel objective, but they are the result of ideas of What Art Is that have been poured into us from outside. Teachers, influential friends, family background, and—most insidious because of the pressure for official recognition—art "experts," all of whom represent potential constraints on our ability to evolve a genuinely personal and ultimately more satisfying visual language. Our art teachers reward us with grades, critics reward us with recognition, and buyers reward us with money. That's one hell of a set of hurdles confronting any artist who cares about expressing self in addition to successfully surviving as an artist.

There is no conflict between resonance and craft. When both are present in a drawing the combination gives added expressive power. Whenever conflict does exist, it lies in the mutually exclusive processes needed for the development of either one. This means that they must be given separate periods of time. As the focus of our attention, they can be parallel but not simultaneous pursuits.

Craft requires an awareness of the past. Art history is a showcase of technical and formal possibilities for a sense of the wealth of options available to us. It gives us a language for evaluating what has taken place on our paper or canvas.

Sometimes that language blinds us to what is taking place right in front of us while we draw. Intent is a powerful tool when we set out to make a drawing. However, intent can also mask or bury elements that could offer a gateway to real depth in our future drawings.

As we work, possibilities emerge and are covered over without ever having registered in our conscious awareness. An odd mark, a chance placement, an unexpected and unconscious stress or shape emerges. Our critical faculty is quick to judge it as foreign or out of place. It is almost as quickly edited or buried in the interest of continuity and consistency. It is a victim to successful style without our ever having truly seen it.

That "accident" may have been accidental only within the context of our intent. It was also evidence of choice on our part. Every blot, line, color, texture, and so on that finds itself on the paper is the result of choice on some level—choice to do or not to do, evidence of some momentary preference on the part of the artist within. The existence of any mark or the continued presence of an untouched area of white paper is indisputable evidence that a choice has occurred. What does it mean? What might it offer us in terms of an expansion of our personal ideas about art or beauty? The only way to find out is to allow it. Allow it to happen. Allow it to remain.

If we are to open ourselves for this blurring of our boundaries to include more possibilities, we must periodically set aside some time for precisely this kind of unpremeditated, playful exploration. We must make the time to suspend the definitions that other people have given us to see what comes up when given a chance. Aesthetic judgment is not wanted during this type of drawing. We will call on that faculty later to assist us in using what we have discovered through intuitive drawing.

What is the process?

Don't judge, allow.

Don't fix it. Nothing is broken; it's just new and different.

Don't throw it away. Put it up and live with it for a while.

Don't worry if it doesn't fit in with your ideas about what art is, because they are really other people's opinions.

Don't ask for anyone else's opinion until you feel that you are secure in your own feelings about what it might express, and how you like it.

It is not uncommon for an artist to feel that something different or additional in either imagery or handling would be beneficial in his or her work. That is a point you can expect to reach more than once in the evolution of your art. There is a great difference between having this awareness or even preferring some such change to take place in your work and accomplishing it.

Everyone experiences some anxiety when confronting a new situation. Some people are

able to see it as a challenge, but most prefer the comfort of the familiar, the tried and true, and they retreat back into its safety. No matter which group you fit into, the knowledge that something more or new in your work would make it richer may nag at you from time to time. Acting on that impulse offers an opportunity to do something no less profound than redefining who you are as a human being and an artist.

It would seem logical for this kind of self-dissatisfaction to arise when you are grappling with problems that seem to defy resolution. Some elusive quality of form or light or expression, however, is what sets the goals that bring us back to our studios day after day and gives our lives meaning. Drawing is the attempt to embody some aspect or essence that may too often remain tantalizingly just out of reach.

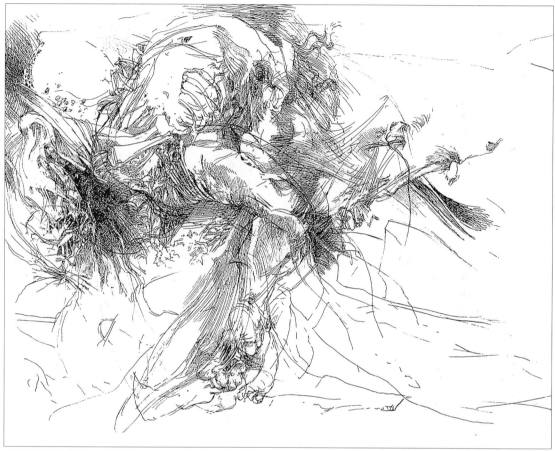

MOUNTED TORSO
Joseph Gillott extra fine 303 nib; FW nonclogging waterproof india ink; Svecia Antiqua laid paper, 8 1/2 × 11" (22 × 28 cm).

This is an example of an intuitive drawing. When I work this way, I begin by making a series of random marks. These are relatively long strokes at varied intervals, directions, and thicknesses across the format. Some lines are broken, which are open to a variety of form resolutions later. Clusters of marks, textures, even small details that are unexplained in a literal sense are added at whim. Forms are drawn over others in transparent layers. There is no place in this process for judgmental thinking. The purpose is to be open to any possibilities that may be concealed in an accidental configuration. As an image begins to suggest itself, I may pursue it or ignore it.

The paper is turned often during the early stages. Some areas are worked horizontally and others are done with the paper vertically aligned. I try to respond to whatever I find most visually exciting. In this case when the figure became apparent, I stopped turning the paper. This drawing process may not end with a completely resolved drawing. That is not why you do it. You may have a drawing that excites you, or you might have a drawing that will be the basis of a more considered drawing. At the very least, you will have slipped out of tired drawing habits (the ones your teachers urged on you) and gotten a glimpse of some drawing qualities that are your own.

INTUITIVE DRAWING

A sense of the need for a major change in your work usually does not occur when you are struggling with your work, but when you are most secure and in command. It is at this level of confidence and competence that the act of drawing or painting threatens to become a repetitive performance. When you find yourself easily satisfying your expectations or the demands of others is the time when you begin to question whether you are truly expressing or challenging your inner self. In an odd way, it boils down to the question of whether or not you are really having fun. Unfortunately, giving yourself the permission and the conditions for having fun can be anxiety-producing if not downright scary when you first try it.

It's not easy to do something really new. If something is to be really new for you, there must be no existing rules or guidelines that take you by the hand and lead you through it. We like what we can predict. It's also possible to like what you can't predict.

Edward DeBono, considered by many to be the leading authority in the direct teaching of thinking as a skill, has coined the phrase "lateral thinking" to describe an approach to problem solving that suspends all judgment. This is precisely the approach that pays rewards when you engage in intuitive drawing. Anything goes. Lateral thinking never blocks a possibility or rejects an idea, no matter how absurd, impossible, or impractical it may seem at first viewing. In fact, one of your most effective tools is a sense of humor. Have the confidence not only to tolerate the absurd but to let yourself actively generate it. Evaluation will come later. Remember, you can't evaluate what you never permitted to happen.

Set aside an occasional block of time for this creative play. Twenty minutes here and there is not sufficient. An afternoon is good, a day is better, and a period of several days can reap rich rewards. Think of this period as a time for true recreation in the sense of re-creation. You make time to step back, to give up control and let the inner you reach the light of day. The results might be disorienting at first, even shocking. That's perfectly fine. Tell yourself at the outset of each period of intuitive work that no one else will see it. This is an activity in which you are the only audience that matters.

The more doors you open to your inner self, the more you can push back the arbitrary borders that have been set up to define you. As an artist and as a person you gain in complexity. Drawing in this way is not only expanding, but can be a means of transformation.

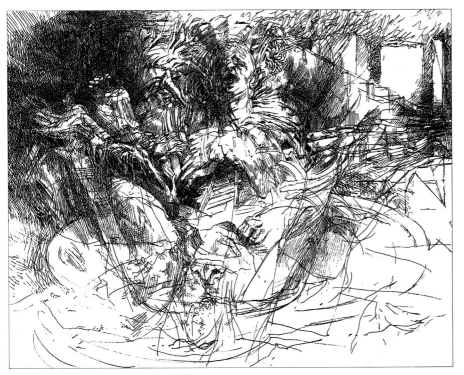

THE CUP
Joseph Gillott extra fine 303 nib;
FW nonclogging waterproof india ink;
Svecia Antiqua laid paper,
8 ½ × 11" (22 × 28 cm).

I started this drawing in the same manner as Mounted Torso, *but stayed with it much longer. I spent more time hatching and cross-hatching to darken entire areas, modeling small forms that were suggested in groups of marks, and giving shape to larger forms.*

By playing with configurations that were sometimes clustered in a small area and at other times widely separated on the page, I created overlapped images that shift scale independently. The hatched darks are a means of treating the entire collection of pieces as a single unity. This can make very complex aggregates work together in surprising ways. The cup and saucer fill the paper, a dog's snout emerges below the railroad track that tunnels under the arch formed by the man's ribcage, and his upraised hand on the far left is tensionally opposed by the convergence of perspectivelike lines at the far right.

What you already know acts as a map to guide you from here to there. The problem arises when the map becomes a set of rigidly followed laws. What you already know too easily becomes a habitual sequence of steps leading to the same destination—the same solution. For the duration of these exercises, try not to know in advance where you are going. Then the habitual map is irrelevant. Even more to the point, there can be countless destinations of interest that are not included on your map. You must step off the path and get lost for a while from time to time in order to expand your world.

The following exercises will suggest the nature of the intuitive drawing process. This is just a starting point to which you can freely add exercises of your own devising.

RELAX

No matter what the tradition, every inner journey begins with some form of induced relaxation. Take a breather from your habitual way of doing things. Take time to step off the conveyor belt of life. Change your surroundings, even if it's only to get our of your studio for a time. Read some new poetry. Sit and close your eyes. Your mind is constantly generating imagery, and most of it is ignored or lost in the crush of daily routine. Give yourself time to silence everything and watch the picture show. Don't try to rush it, and don't direct it. If you do, you will only channel it into old ruts.

Your mind is a never-ending movie. Dreaming doesn't happen only while you sleep; it is continually taking place. We just can't see it if we blot it out with everyday concerns. After a while, make some random marks on a paper and let them grow at their own pace. No editing. No judging. Tell yourself that no one but you will ever see the drawings.

LOOK

This means really look. Meander where you ordinarily walk with purpose. If you spend an hour going a distance that would normally take ten minutes, you will find yourself noticing colors and shapes and details that had no room to exist in your consciousness before. There is a Tibetan meditation where you walk as slowly as possible but always have some part of you moving forward. Never completely stop. It is amazing how focused you become in taking twenty minutes to cross five feet of floor space without ever completely stopping.

PAY ATTENTION

Tune in to senses other than the visual. What are you feeling? What sounds are you aware of if you begin listening to the sounds of your own body? Gradually expand that awareness to focus on the sounds of your immediate physical surroundings. Now listen to the sounds from beyond the room in which you are sitting. Finally open up to the most distant sounds that reach you. Try to go beyond your limits. Can you become aware of the murmur of people carrying out their lives in all of the buildings and cars and airplanes between you and the horizon in all directions? Does it include natural sounds like water running or wind whispering through the trees and grass? Now begin to make marks that give form to those sounds or feelings. You are not drawing pictures of the *activities* you have sensed; give body to the *sensations*. Use yourself like a seismograph to record the qualities and differences between the immaterial sensations.

DON'T MAKE ART

Whatever happens in these drawings is to be accepted happily. Open yourself to novelty. If you find yourself trying to make it look good, remember, all you are doing is trying to make it look like what you are used to doing. That means employing what others have told you. This is a time for pure exploration and discovery. Later you can study the drawings, see what the possibilities are, and add those possibilities to the arsenal that defines who you are as an artist.

DRAW DREAMS

Keep a sketchbook by your bed and use it. Capture those fleeting images that pop into mind when you are first drifting at the edges of sleep. When you awaken during the night or in the morning, make notations in the form of quick sketches accompanied by verbal descriptions of color, mood, and so on.

TRUST YOURSELF

There is no wrong way to do these exercises. There is no such thing as a bad intuitive drawing. Whatever comes up is a gift from the normally hidden you. Accept it gracefully and your inner artist will find it easier to give you more. There is no exhausting this well. Among these images and feelings can ultimately be discovered the most personally creative materials to enrich your outer-world artist.

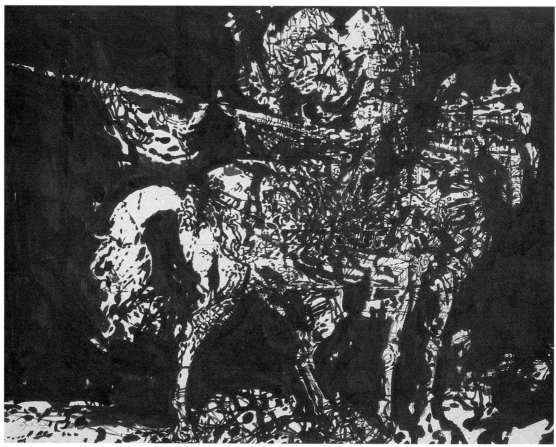

WINDBLOWN RIDER #1
Mecanorma technical
pen 2×0; Holbein Saishiki
G1210-M brush;
Higgins Black Magic drawing
ink; Arches 140 lb. HP
watercolor block,
18 × 24" (46 × 61 cm).

This drawing was started with no preliminary image in mind. The first stage is simply to activate the blank paper. The initial marks have a profound impact on any drawing that will develop from them, so I try to begin in a manner that is unfamiliar. Since my imagery rarely deals with controlled geometric volumes, that would be my challenge this time. I selected a technical pen and a steel straightedge to maintain mechanical precision, and began drawing transparent volumes and angled planes that appeared to recede into space behind the picture plane.

In order to keep the possibilities open and prevent the emerging image from resembling a crystal still life, I shifted the perspective vanishing point of each new form. The resulting ambiguous space helped me avoid the temptation to pursue any consistently developing spatial construct. To reinforce this, I arbitrarily overlapped volumes as I drew them. This built up a delicate linear latticework of interpenetrating, open forms.

For the second step, I switched to a watercolor brush and india ink. I emptied my mind and without conceptualizing my choices, I added spots and small organic shapes of solid black at any point on the paper that seemed to need some kind of heavier visual stress. Gradually these marks joined into clusters and chains. I continued until they formed larger islands of solid black.

I used Leonardo da Vinci's advice to the would-be artist: to look at dirtied and stained walls or mixtures of different kinds of stones when you wish to invent a scene. In this, he pointed out, you will see "an infinite number of things which you can then reduce into separate, well-conceived form." (Leonardo da Vinci, Treatise on Painting, *translated by A. Philip McMahon, Princeton, 1956, page 76.) I saw billowing drapery, a pole or lance, and fragments of a horse's hind quarters. The image was resolved by inking in all white shapes that were not within the contour. A band along the base serves as a ground plane.*

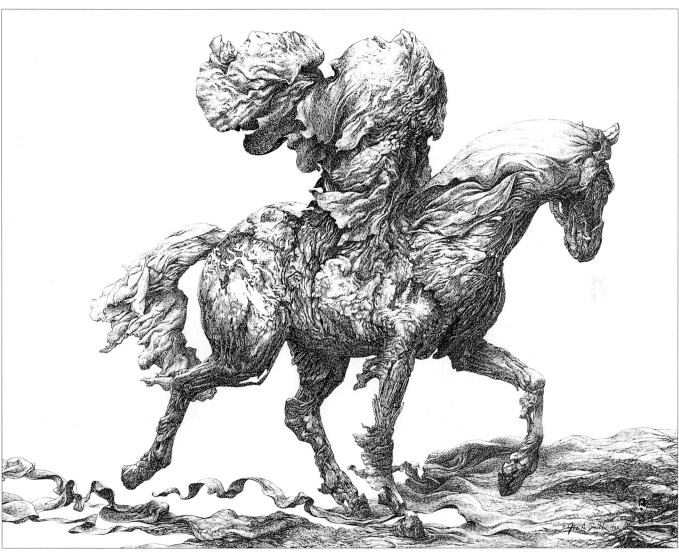

WINDBLOWN RIDER
Gillott 303 pen; brush;
Dr. Ph. Martin's Black Star
matte waterproof india ink;
Arches HP watercolor block,
18 × 24" (46 × 61 cm).

I used Windblown Rider #1 *as a still life for this more developed drawing. Here I freely selected, deleted, or altered the forms suggested in the first version in order to animate it, strengthen the suggestion of sculptural volume, and give it more of a feeling of rippling movement over the surfaces.*

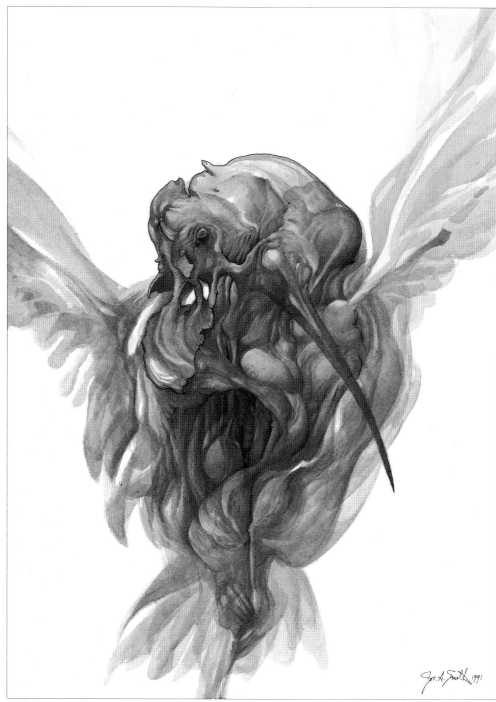

HUMMINGBIRD
Chinese wolf-hair sumi
watercolor rounds
nos. 3 and 5; Gillott 303 pen;
hand-ground sumi ink;
Higgins nonwaterproof
drawing ink; Arches 140 lb.
HP watercolor block,
12 × 9" (30 × 23 cm).

This drawing was started with a few random brush marks using a very diluted sumi ink. I went back over the initial spots, deepening the value with each layer. Occasionally I made strokes with clean water and wiped off some of the loosened sumi ink with a clean facial tissue. Sumi ink is such a controllable medium that it lends itself to subtle modeling. I used the diluted gray wash to develop and refine any small accidental shape that interested me. When the image suggested a bird in flight, I stayed with that subject. The pen and india ink were used at the very end to define some edges, leaving most to the softer focus of the washes.

TIGHTROPE WALKER
Rapidograph technical
pen 3×0; Koh-I-Noor
Rapidograph Ultradraw
nonclogging waterproof
india ink; T. H. Saunders
HP watercolor paper,
30 3/4 × 23" (78 × 58 cm).

Tightrope Walker
came from a dream.
The man in my
dream was slender,
an "athlete" wearing
tights , and carrying
a plain pole. The
child towing him was
not in the dream. The
changes entered while
drawing.

After sketching the
image lightly in pencil,
I sat back, relaxed,
and free-associated.

Starting at the top,
I focused the walker's
right eye on his goal,
but turned his left eye
to gaze at the viewer.
The wings on the pole
were added because
they seemed apt for
floating.

Subtle value
shifts in the thigh
stippling suggested
folds. I saw the fabric
flapping in the wind
with no legs beneath
the cloth. Any effect
of weight lost through
this change was
recaptured by pressing
his feet into the rope.

The dream did
not show what held
the rope so I cut it at
both ends. From there
it was a short step to
making it become a
parade float.

Only the rope-
walker knows his
destination, so that
communication is cut
between his guide
and the outer world.

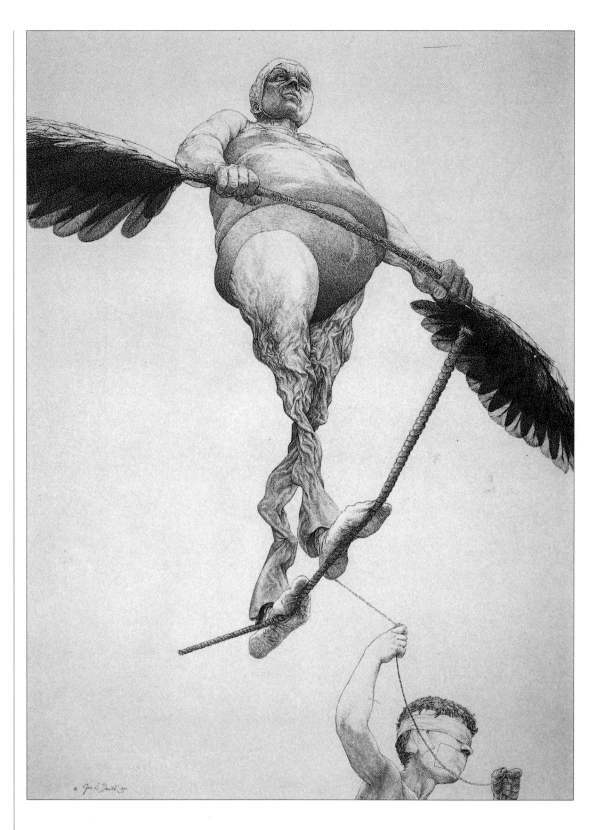

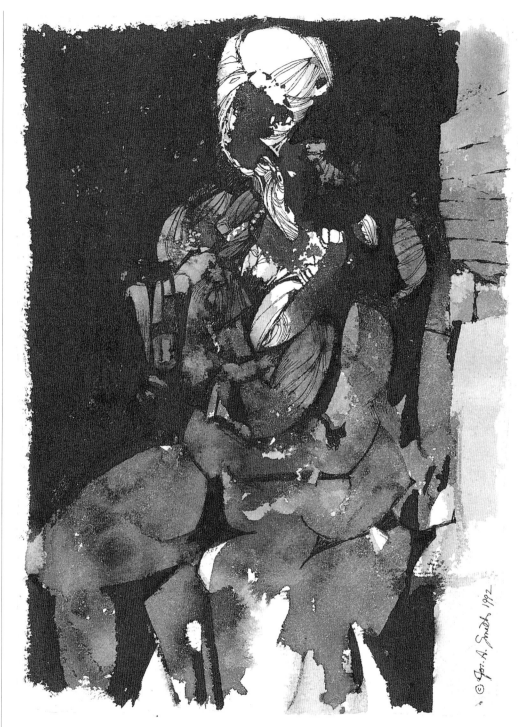

THE TURBAN
Gillott 303 pen, Winsor & Newton
series 7 no. 4 watercolor round; paper
towel; FW nonwaterproof india ink;
water; Indian Village handmade paper,
7 1/4 × 5 1/4" (17 × 13 cm).

*I dipped a paper towel in water, then in ink, and then blotted it on the
drawing paper. These random darks and lights suggested shapes that were
refined with a Gillott 303 drawing pen. In the final stage of the drawing,
I used the brush to cover selected areas of the paper with undiluted ink.*

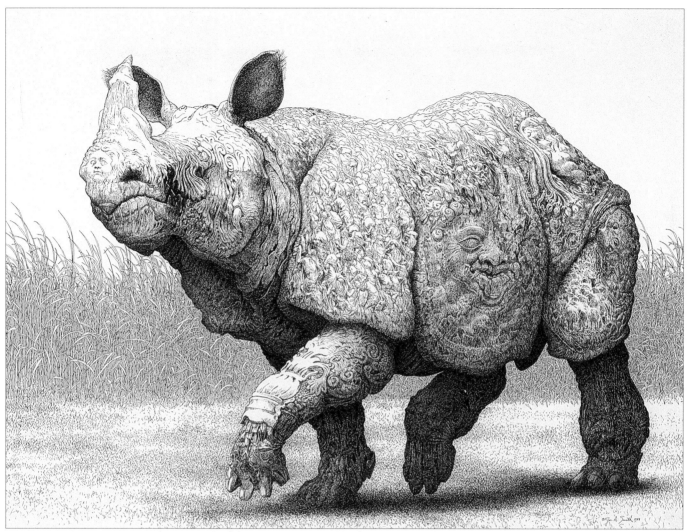

THE RHINOCEROS
Staedtler Mars 700 technical pen with 0, 2×0, and 3×0 points; FW nonclogging waterproof india ink; T. H. Saunders 140 lb. HP watercolor paper, 22 × 30" (56 × 76 cm).

I obtained the image for this drawing using my adaptation of a visualization meditation technique. This involves looking at a photo for sixty seconds and then closing the book and holding the image in my mind's eye for thirty minutes. At the end of the meditation I do not look at the original again, but depend on visual memory.

The source of this image is a small photograph of an Indian rhinoceros photographed by J-P. Ferrero and published in Michael Freeman's The Complete Book of Wildlife and Nature Photography *(New York: Simon & Schuster, 1981), p. 212. In this particular photograph, the rhino's image was approximately 1 ¹/₂" (4 cm) from nose to tail, so fine detail was at a minimum. This allowed for more intrusion of unconscious images.*

Several aspects of shape are worth noting. The spaces between the legs are more interesting as shapes than the legs themselves. These spaces are not empty. Each of them is divided into smaller shapes by the value change from stippled marks to the linear pattern of the reeds above. The dark of the legs gives the outer boundary of these spaces the strength and clarity to unify them. The darker stresses

in the folds of the rhino's hide also separate clusters of small, complex shapes into large, simple ones.

I treated the large torso divisions as convex "mother planes." Any smaller shape within a mother plane is seen as a textural element whose value level is determined by the light or shadow on that part of the larger plane.

The drawing strategies set in advance include: (1) This is a combination of divergent and spontaneous drawing. (2) The format is horizontal even though the source photograph is vertical. (3) The rhino's space is continuous with the viewer's. (4) I use a deep space to let the rhino exist within rather than on the paper, but I limit the deepest space in the drawing. (5) I want the rhino to assert itself, filling the space. (6) The drawing is a combination of line and tone. (7) The line is descriptive. (8) The textures are observational. (I did not refer to the photograph at any time after I started the visualization.) (9) There is a full value range from white to black in the drawing, but the darkest darks are confined to the rhino and his shadow. The limited value range in the background also acts as aerial perspective.

LIST OF SUPPLIERS

Most of the drawing materials mentioned in this book can be found at any reasonably well stocked art supply store, or even at many office supply outlets. Fine art papers are a different matter. There are relatively few suppliers that stock more than the sheets and boards produced by the largest commercial manufacturers. Some of the most interesting papers come from small mills. Below I have listed a few suppliers that carry a wide selection of pens, papers, or both; that have a large volume of mail-order business; and (not the least of my reasons for including them) that have excellent and informative catalogues that should be a part of any artist's library. Except for Daniel Smith, they are based in New York—because I am.

PENS AND INKS

Arthur Brown & Bro., Inc., The International Pen Shop, 2 West 46 Street, New York, NY 10036. (718) 628-0600. Toll-free: (800) 237-0619. Arthur Brown is widely known for its selection of fine writing instruments and inks, although the selection of drawing pens and inks is limited. Free catalogue available.

PENS, INKS, AND PAPERS

Pearl Paint, 308 Canal Street, New York, NY 10013. (212) 431-7932. Toll-free: (800) 221-6845. Pearl Paint is a chain of art supply stores throughout the East Coast. It offers a wide selection of art materials, drafting and craft supplies, and a wide range of boards and papers at discount prices. Its pen department is excellent. Catalogue available.

New York Central Art Supply Co., 62 Third Avenue, New York, NY 10003. Store: (212) 473-7705. Order desk: toll-free 1-800-950-6111, or in New York state (212) 477-0400. 24-hour fax: (212) 475-2513. New York Central is in a class by itself. The paper department is internationally known for its diverse selection, and the store carries a full range of art supplies and will obtain what may not be stocked. The store produces separate catalogues for studio supplies and papers, and the paper catalogue is so extensive and informative that it is a valuable reference book for any serious artist. I recommend that you order both catalogues.

Sam Flax, 39 West 19th Street, New York, NY 10011. (212) 620-3000. A New York City art supply company with six locations in Manhattan at present, Sam Flax carries art materials, papers, and a wide range of supplies for design studios. It has a well-produced catalogue.

Daniel Smith Inc., 4130 First Avenue South, Seattle, WA 98134-2302. Toll-free: (800) 426-6740. Daniel Smith carries an extensive line of high-quality printmaking supplies, as well as of painting and drawing materials other than pens and drawing inks. The prices are at or below list price. Daniel Smith's catalogues are good sources for a wide selection of papers, boards, and brushes, and they are full of well-written and informative articles on the high-quality materials they carry. The catalogues are worth ordering for their own sake. Daniel Smith is primarily a mail-order business and will promptly ship orders of any quantity.

INDEX

Rotring
 fountain pens, 19–20, *20*
 inks, 25, *25*, 32, *32*, 35, *36*
 technical pens, 18, *18*
Round Hand pens, 14, 15,
 15
Ruling pens, 118

Sable brushes, *22, 22*, 64
Sakura Co., 21
Saunders (T.H.) paper, 39, *39*,
 41, *42*
Scale, 116–21, 154–55
Schoellerhammer board, 43
Scratchboard, 48–49
Scratchboard techniques,
 80–83
Sculptural space, 111
Senator fountain pen, 20, *20*
Sepia ink, 29
Shadows, cast, 110, 134
Shapes
 directional, 150
 geometric/organic, 144, 148
 grouping, 161
 positive/negative, 144
 within shapes, 145, 147
Sheaffer fountain pens, 20,
 20, 26
Similarity groupings, 161
Sizing, of paper, 42
Slate ink stones, 28

Soho paper, 39
Spattering, 62–63
Speedball
 inks, 23, 25, 32, *32*, 36, *36*
 metalpoint pens, 14, *15*
Spontaneous drawing, 96, *97*
Staedtler Marsmatic 700 pen,
 18, *18*
Stationery papers, 46–47, *47*
Steig inks, 24, *24*, 31, 32, *32,
 34*, 34–35, *35*
Stippling, 61, 126
Stonehenge paper, 45, *45*
Strathmore paper, 39, *39*, 40,
 40, 41, 42, 43
Sumi brush, *22*
Sumi ink, *28*, 28–29
Sumi ink drawing, 91, 95, 102,
 169
Supports
 boards, 43–44, 48–49
 drafting film, 49
 selecting, 101–2
 See also Papers
Svecia Antiqua paper, 46, *46*

Talens inks, 34, *34*, 35, 36, *36*
Technical pens, 17–18, *18*, 23,
 26, 122
Text papers, 46–47
Texture
 line and, 138

observational *vs* process-
 related, 131–33, 142
 physical, 142
 value change and, 134
 visual, 142–43
TGI-S technical pen, 18
Tombo Co., 21
Tombow PGS technical pen,
 18
Tone, 122–27
Torinoko paper, 48
Tracing paper, 48
Turner papers, 40
Twinrocker papers, 40, 42, 47,
 47

Value, 125, 126
 change, 55, 134–37, 148
 function of, 140
 mood and, 122
 restricted range of, 137, 141
Van Gogh, Vincent, 12, 29
Vanishing point, 108
Vellum, 17, 24, 48
Vertical format, 104
Viewer, relation to drawing,
 106–9
Viewing angle, 108, 109
Visualization meditation
 technique, 171
Volume, 121, 122, 126, 145, 147
 modeling, 148–49

Wadsworth, Peter, 72
Wash
 colored ink, 72, 81, 83
 laying, 64, 67–69, 102
 with mixed media, 74
Watercolor
 and ink, 74, *75*
 vs ink, 23
Watercolor board, 43
Watercolor paper, 40–42, *41,
 42*, 102
 scratchboard on, 81
Waterleaf papers, 44–45
Waterman fountain pens, 20,
 20, 26
Waterproof ink, 19, 30, 102
 india, 23–25, *24, 25*
Westport papers, 42
Wet-in-wet technique, 72,
 74
Whatman papers, 42, 43
White ink, 30–32, *31, 32*
White ink drawing
 on toned paper, 70–71
 with transparent color, 73
William Mitchell metalpoint
 pens, 13, 14, *15*
Winsor & Newton
 brushes, *22*
 inks, 25, 30, 32, *32*, 36, *36*
Witch pens, 14
Wove papers, 46

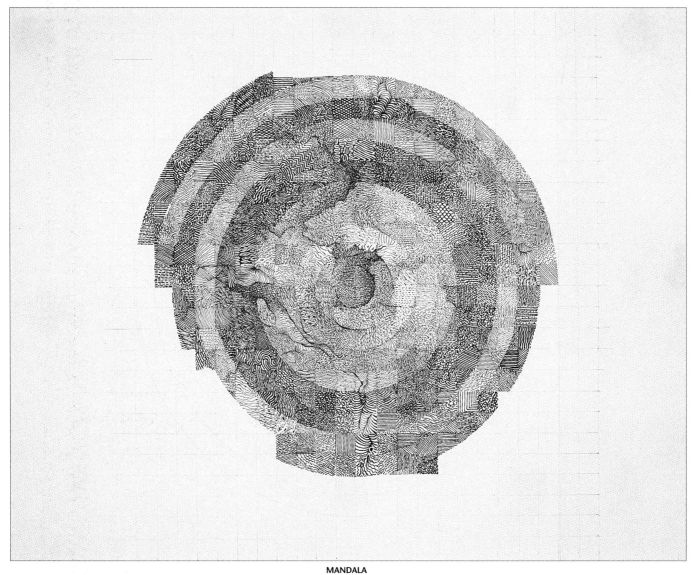

MANDALA
A variety of pens and nibs;
Higgins Black Magic waterproof
drawing ink; Hodgkinson & Co.
British Handmade laid paper,
13 3/4 × 17 1/2" (35 × 44 cm).

Senior Editor: Candace Raney
Associate Editor: Janet Frick
Designer: Areta Buk
Graphic Production: Hector Campbell
Text set in Caslon 540